HOW TO DRAW
ALMOST EVERY DAY

Quarto
Knows

Inspiring | Educating | Creating | Entertaining

Brimming with creative inspiration, how-to projects, and useful
information to enrich your everyday life, Quarto Knows is a favorite
destination for those pursuing their interests and passions. Visit our
site and dig deeper with our books into your area of interest:
Quarto Creates, Quarto Cooks, Quarto Homes, Quarto Lives,
Quarto Drives, Quarto Explores, Quarto Gifts, or Quarto Kids.

First published in the United States of America in 2017 by
Quarry Books, an imprint of
The Quarto Group
100 Cummings Center
Suite 265-D
Beverly, Massachusetts 01915-6101
Telephone: (978) 282-9590
Fax: (978) 283-2742
QuartoKnows.com

Quarry Books titles are also available at discount for retail, wholesale, promotional, and bulk purchase.
For details, contact the Special Sales Manager by email at specialsales@quarto.com or by mail at The
Quarto Group, Attn: Special Sales Manager, 100 Cummings Center, Suite 265-D, Beverly, MA 01915-
6101. USA.

15 14 13 12 11 10 9

ISBN: 978-1-63159-377-2

Translator: Ai Toyoda Jirka
English Language Editor: Lindsay Fair

Printed in China

HOW TO DRAW
ALMOST EVERY DAY

AN iLLUSTRATED SOURCEBOOK

KAMO

WELCOME!

Are you interested in improving your drawing skills? Are you looking for some illustration inspiration? Or maybe you're in need of a fun and creative way to stay organized?

If you answered yes to any of the above questions, then this is the book for you! My goal with this book is to challenge and inspire you to draw one simple illustration each day of the year.

This prospect might seem intimidating at first, but if you set aside just a few minutes each day, you'll be amazed at what you can accomplish by the end of the year!

KAMO

CONTENTS

WINTER...14

SPRING...66

SUMMER...120

FALL...172

Materials

You don't need fancy art supplies to create great illustrations. All of the art in this book was created using a black ballpoint pen and ten different markers. Once you're comfortable drawing, feel free to experiment with different types of markers and pens of varying thicknesses. The following guide shows my favorite materials, but always use what feels best to you!

Ballpoint Pen

Use pen to outline illustrations and add details. Ballpoint pens are available in a variety of different thicknesses. Personally, I prefer a 0.28 mm pen. Different thicknesses can be used to create different impressions within your illustrations.

If you plan to add color to your illustrations, use a dark pen, such as black, brown or navy. It's important to use a water-resistant pen if you plan on adding color with markers.

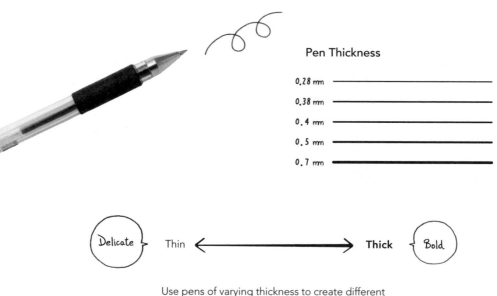

Pen Thickness

0.28 mm	————————————
0.38 mm	————————————
0.4 mm	————————————
0.5 mm	————————————
0.7 mm	————————————

Delicate ⊢ Thin ⟵—————⟶ Thick ⊣ Bold

Use pens of varying thickness to create different impressions within your illustrations.

Markers

I used ten basic colors for all the illustrations in this book, but feel free to use as many as you want. Color your illustrations quickly to prevent streaks and be careful not to oversaturate; otherwise, the ink will bleed through the paper.

I love the look of Copic Markers. These dual-tip markers have a broad nib for thick strokes and a brush tip for small, detailed illustrations.

HOW TO STORE PENS & MARKERS

Opinions are divided, but I think it's best to store pens and markers on their sides, rather than upright.

Art Supplies Used in This Book

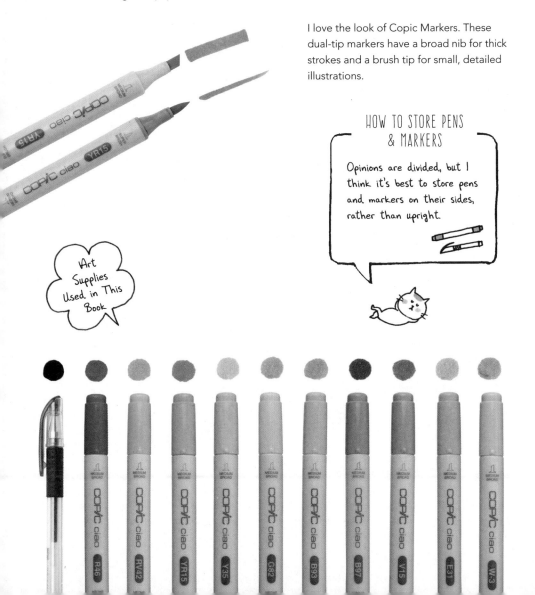

Drawing People

Many new artists are intimidated by the prospect of drawing people, but it's actually quite simple when you break it down into steps. Plus, once you're comfortable drawing people, you'll be able to create more complex and dynamic illustrations.

Face

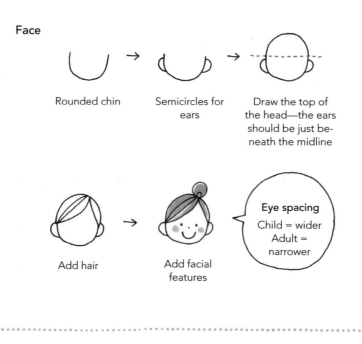

Rounded chin

Semicircles for ears

Draw the top of the head—the ears should be just beneath the midline

Add hair

Add facial features

Eye spacing
Child = wider
Adult = narrower

Drawing People in Action

For natural looking movements, focus on placing the joints in the correct spot and bending the limbs in the proper direction.

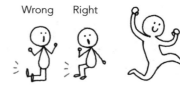

Wrong Right

Don't worry if your drawings aren't precise, just focus on the overall movement.

Body

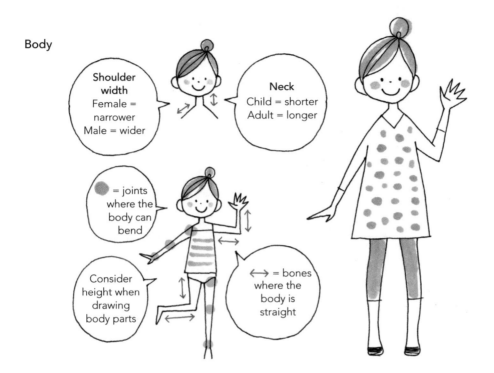

Shoulder width
Female = narrower
Male = wider

Neck
Child = shorter
Adult = longer

= joints where the body can bend

Consider height when drawing body parts

⟷ = bones where the body is straight

Hand

Draw the thumb

Use zigzags for 4 other fingers and the wrist

Add a horizontal line extending from the thumb

GOOD

Use circles and lines to represent a closed hand

Keep an eye out for me throughout the book. I'll share helpful tips and tricks.

Drawing Animals

Animals pose another challenge for new artists. The following guide introduces the basic steps for drawing a cat. Use this technique for drawing other four-legged friends, but change the details, such as the ears or nose, to match the specific animal.

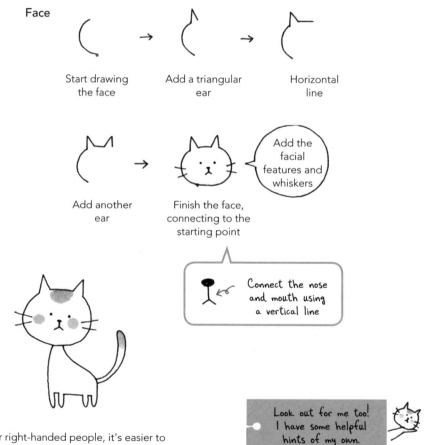

Face

Start drawing the face → Add a triangular ear → Horizontal line

Add another ear → Finish the face, connecting to the starting point

Add the facial features and whiskers

Connect the nose and mouth using a vertical line

For right-handed people, it's easier to draw the cat facing left, while for lefties, it's easier to draw him facing right!

Look out for me too! I have some helpful hints of my own.

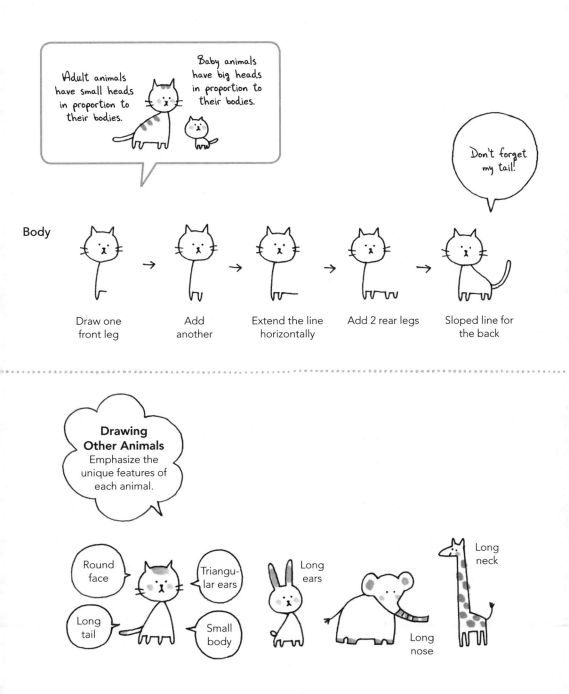

Adult animals have small heads in proportion to their bodies.

Baby animals have big heads in proportion to their bodies.

Don't forget my tail!

Body

Draw one front leg

Add another

Extend the line horizontally

Add 2 rear legs

Sloped line for the back

Drawing Other Animals
Emphasize the unique features of each animal.

Round face

Triangular ears

Long tail

Small body

Long ears

Long neck

Long nose

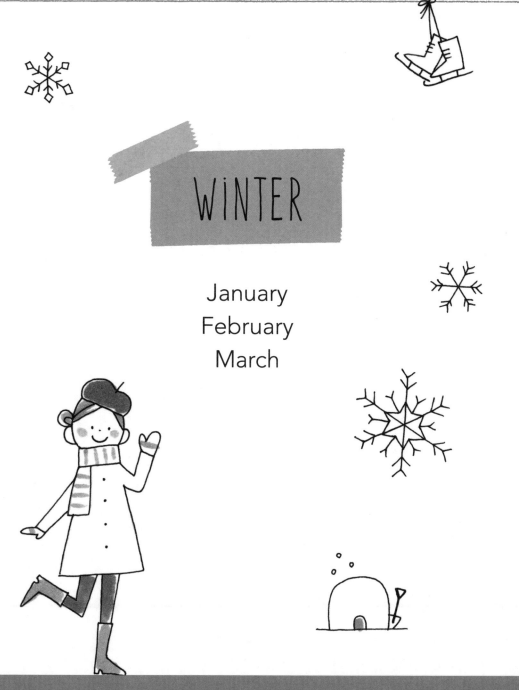

WINTER

January
February
March

January

1 / 1

We went to my dad's favorite restaurant for a special New Year's Eve dinner last night. I drank too much sake and woke up with a headache!

Sake Bottle

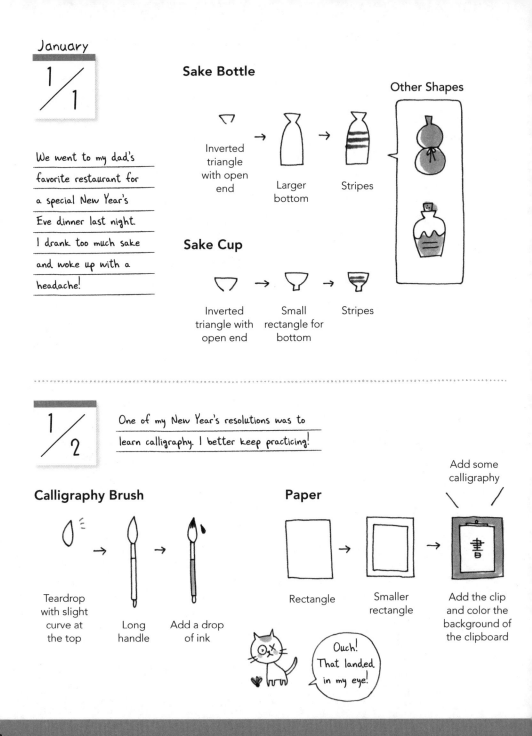

Inverted triangle with open end → Larger bottom → Stripes

Other Shapes

Sake Cup

Inverted triangle with open end → Small rectangle for bottom → Stripes

1 / 2

One of my New Year's resolutions was to learn calligraphy. I better keep practicing!

Calligraphy Brush

Teardrop with slight curve at the top → Long handle → Add a drop of ink

Paper

Rectangle → Smaller rectangle → Add the clip and color the background of the clipboard

Add some calligraphy

Ouch! That landed in my eye!

/ 1 / 3 | / 1 / 4

I forgot to send out holiday cards last month. I'm going to make some winter-themed cards and send them out to my family and friends to celebrate the new year.

See page 26 to learn how to draw a snowflake.

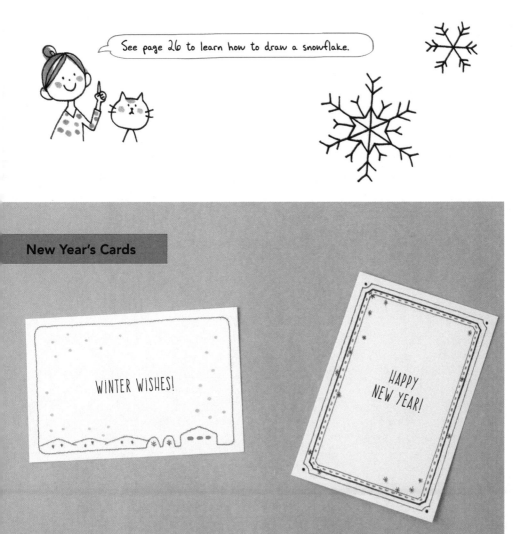

New Year's Cards

WINTER WISHES!

HAPPY NEW YEAR!

My little cousins came over to visit. I spent all day playing games and flying kites with them. It was more fun than I expected!

Kite

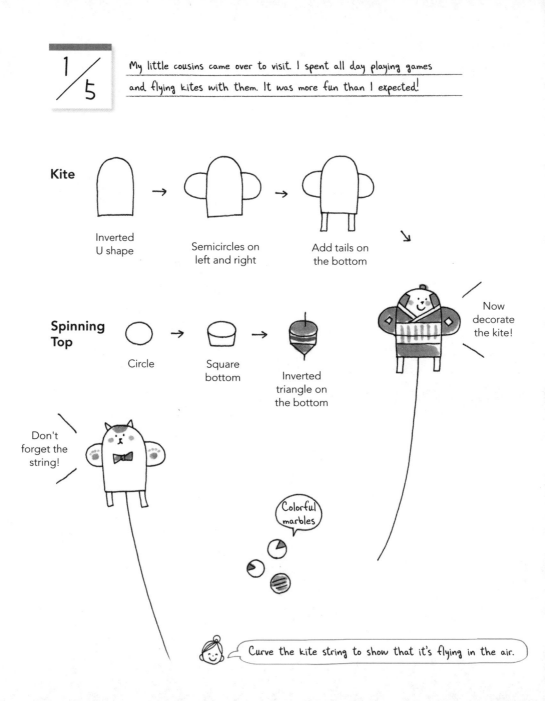

Inverted
U shape

Semicircles on
left and right

Add tails on
the bottom

Now
decorate
the kite!

**Spinning
Top**

Circle

Square
bottom

Inverted
triangle on
the bottom

Don't
forget the
string!

Colorful
marbles

Curve the kite string to show that it's flying in the air.

1/6

It was so cold outside that I spent most of the day curled up on the couch with my cat Mi-chan.

Sleeping Cat

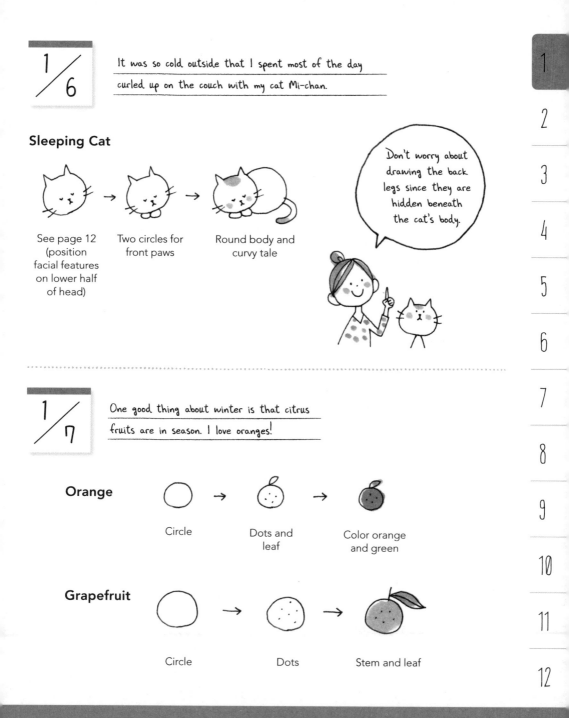

See page 12 (position facial features on lower half of head)

Two circles for front paws

Round body and curvy tale

Don't worry about drawing the back legs since they are hidden beneath the cat's body.

1/7

One good thing about winter is that citrus fruits are in season. I love oranges!

Orange

Circle

Dots and leaf

Color orange and green

Grapefruit

Circle

Dots

Stem and leaf

Vacation is almost over. We visited my aunt and ate traditional rice cake—yum!

Rice Cake Ornament

In Japan, rice cakes are eaten at the beginning of the year to bring good luck.

2 rectangles → Puffy rice cakes → Add orange on the top

- -

1/10

Winter break is ending soon, so I need to pack up all my school supplies. I hope I don't forget anything.

Notebook

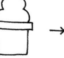

Curve at the top → Connect two → Add lines

NOTE BOOK — Draw a rectangle for the front cover

Sticky note

Binder rings

1/11

I saw girls in traditional kimonos on the train today. They looked so pretty!

Kimono

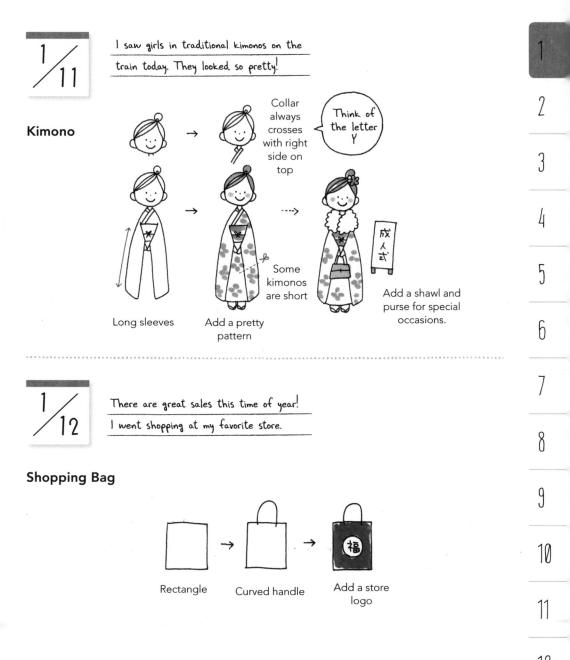

Collar always crosses with right side on top

Think of the letter Y

Long sleeves

Add a pretty pattern

Some kimonos are short

Add a shawl and purse for special occasions.

成人式

1/12

There are great sales this time of year! I went shopping at my favorite store.

Shopping Bag

Rectangle → Curved handle → Add a store logo

福

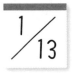

1 / 13

I had a big biology test today at school. I hope I did well! I stayed up late last night studying.

Pencil

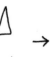

Triangle

→

Rectangle with lines

Eraser

Half circle

→

Rectangle underneath

Test Paper

Rectangle

→

TEST

Add some writing

Good luck!

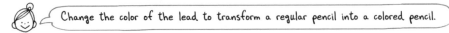

Change the color of the lead to transform a regular pencil into a colored pencil.

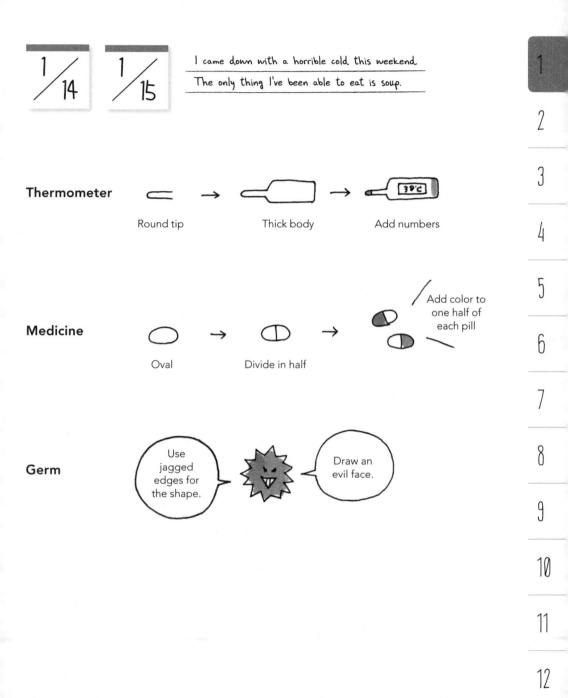

Thermometer

Round tip → Thick body → Add numbers
39°C

Medicine

Oval → Divide in half → Add color to one half of each pill

Germ

Use jagged edges for the shape. Draw an evil face.

1/14 1/15 I came down with a horrible cold this weekend.
The only thing I've been able to eat is soup.

1 / 16

It was so cold and windy today.
At least I got to wear my favorite scarf.

Scarf

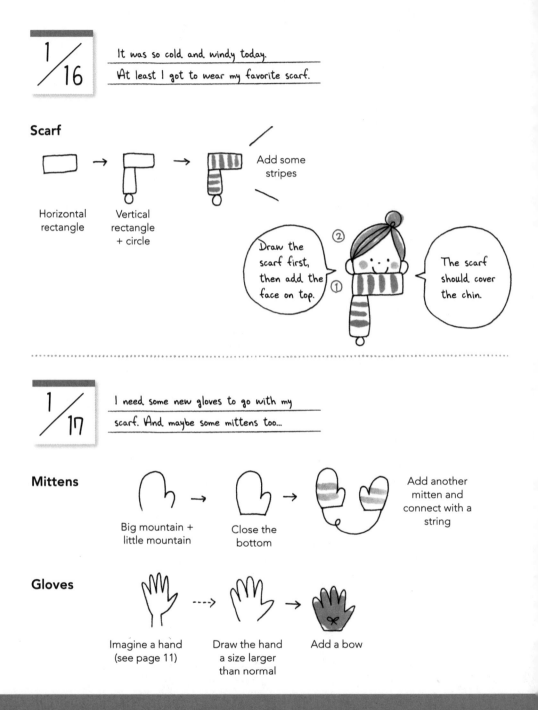

Horizontal rectangle → Vertical rectangle + circle → Add some stripes

Draw the scarf first, then add the face on top. ②

① The scarf should cover the chin.

1 / 17

I need some new gloves to go with my scarf. And maybe some mittens too...

Mittens

Big mountain + little mountain → Close the bottom → Add another mitten and connect with a string

Gloves

Imagine a hand (see page 11) ---> Draw the hand a size larger than normal → Add a bow

24

Accessories are a must for a stylish winter ensemble. Plus, they keep you warm!

Hat

Imagine a head (see page 10)

Draw a hat slightly larger than the head

Add long hair for a girl

Boots

Regular shoe

How tall are your boots?

Add some details

I bought a beautiful new coat at the post-holiday sales. Now my winter look is complete.

Coat

Silhouette \ Collar	⋈	⫐
A-line		
X-line		

Do you like my outfit?

Coats have similar shapes to dresses. Add some buttons to differentiate between the two.

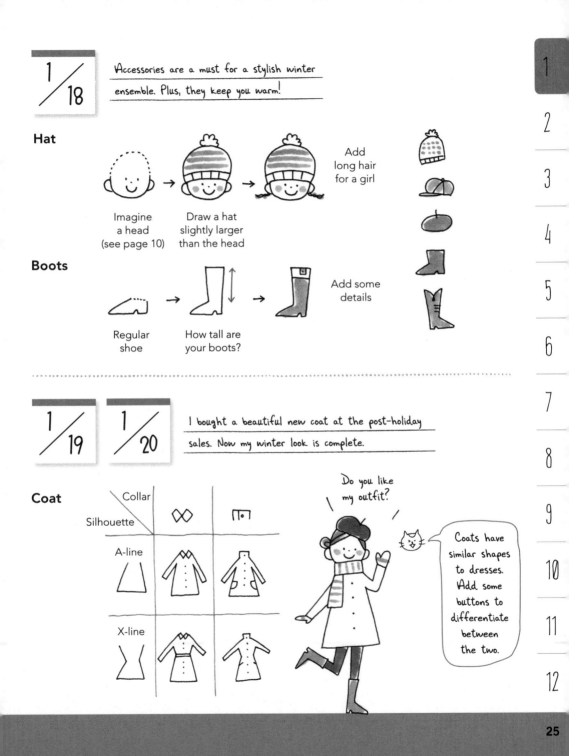

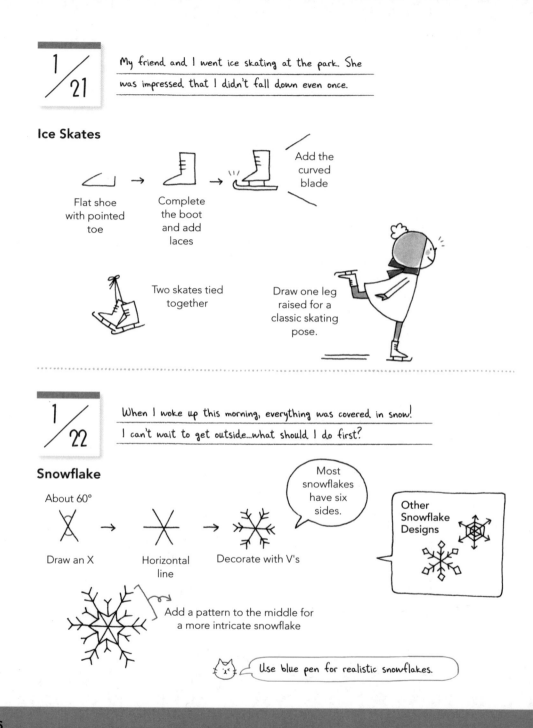

1 / 21

My friend and I went ice skating at the park. She was impressed that I didn't fall down even once.

Ice Skates

Flat shoe with pointed toe

Complete the boot and add laces

Add the curved blade

Two skates tied together

Draw one leg raised for a classic skating pose.

1 / 22

When I woke up this morning, everything was covered in snow! I can't wait to get outside...what should I do first?

Snowflake

About 60°

Draw an X

Horizontal line

Decorate with V's

Most snowflakes have six sides.

Other Snowflake Designs

Add a pattern to the middle for a more intricate snowflake

Use blue pen for realistic snowflakes.

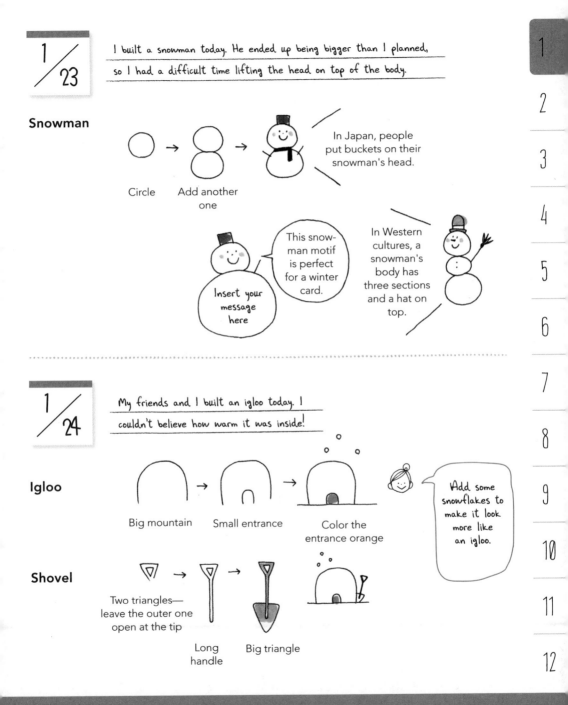

1/23

I built a snowman today. He ended up being bigger than I planned, so I had a difficult time lifting the head on top of the body.

Snowman

Circle

Add another one

In Japan, people put buckets on their snowman's head.

This snow-man motif is perfect for a winter card.

Insert your message here

In Western cultures, a snowman's body has three sections and a hat on top.

1/24

My friends and I built an igloo today. I couldn't believe how warm it was inside!

Igloo

Big mountain

Small entrance

Color the entrance orange

Add some snowflakes to make it look more like an igloo.

Shovel

Two triangles— leave the outer one open at the tip

Long handle

Big triangle

My laundry has really piled up with all of this messy weather. I hope it clears up soon!

Washer

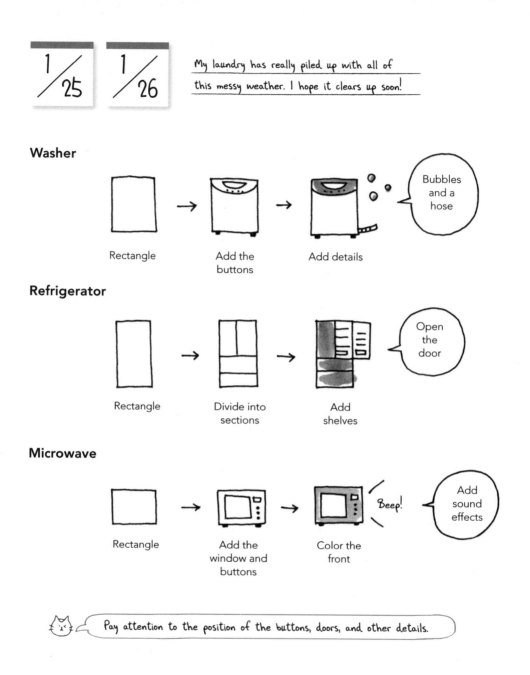

Rectangle

Add the buttons

Add details

Bubbles and a hose

Refrigerator

Rectangle

Divide into sections

Add shelves

Open the door

Microwave

Rectangle

Add the window and buttons

Color the front

Beep!

Add sound effects

Pay attention to the position of the buttons, doors, and other details.

Now that the snow has stopped, I can
finally hang my laundry out to dry.

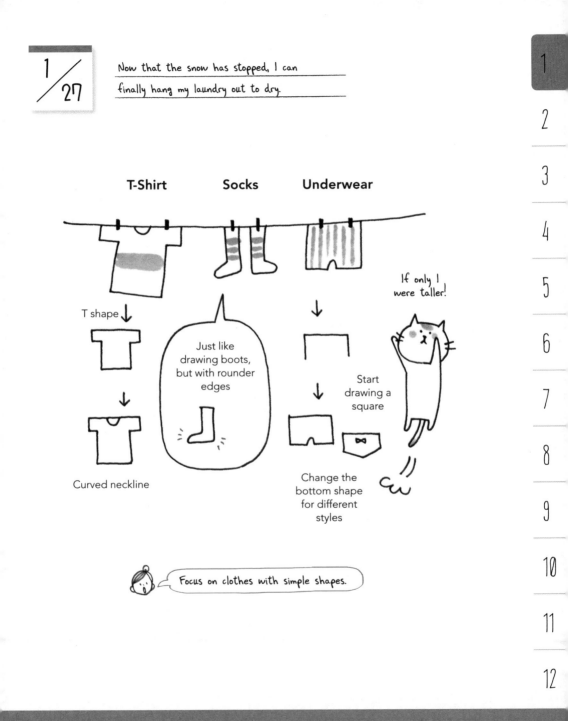

T-Shirt **Socks** **Underwear**

T shape ↓

Just like drawing boots, but with rounder edges

Curved neckline

↓

Start drawing a square

If only I were taller!

Change the bottom shape for different styles

Focus on clothes with simple shapes.

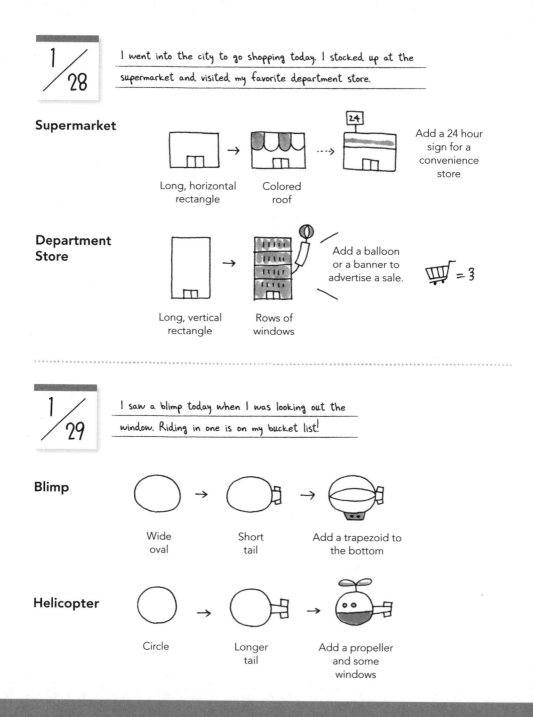

1/28

I went into the city to go shopping today. I stocked up at the supermarket and visited my favorite department store.

Supermarket

Long, horizontal rectangle

Colored roof

Add a 24 hour sign for a convenience store

Department Store

Long, vertical rectangle

Rows of windows

Add a balloon or a banner to advertise a sale.

🛒 = 3

1/29

I saw a blimp today when I was looking out the window. Riding in one is on my bucket list!

Blimp

Wide oval

Short tail

Add a trapezoid to the bottom

Helicopter

Circle

Longer tail

Add a propeller and some windows

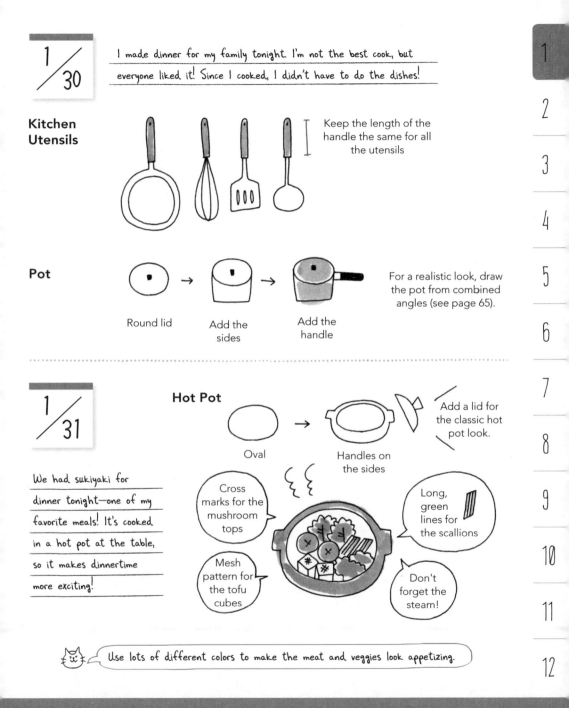

I made dinner for my family tonight. I'm not the best cook, but everyone liked it! Since I cooked, I didn't have to do the dishes!

Kitchen Utensils

Keep the length of the handle the same for all the utensils

Pot

Round lid

Add the sides

Add the handle

For a realistic look, draw the pot from combined angles (see page 65).

Hot Pot

Oval

Handles on the sides

Add a lid for the classic hot pot look.

We had sukiyaki for dinner tonight—one of my favorite meals! It's cooked in a hot pot at the table, so it makes dinnertime more exciting!

Cross marks for the mushroom tops

Mesh pattern for the tofu cubes

Long, green lines for the scallions

Don't forget the steam!

Use lots of different colors to make the meat and veggies look appetizing.

31

February

2 / 1

My father has started growing bonsai trees for a hobby.

It seems kind of boring to me, but he is obsessed.

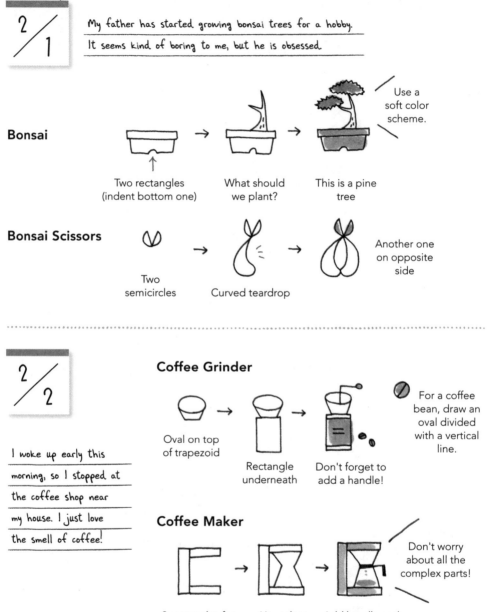

Bonsai

Two rectangles
(indent bottom one)

What should
we plant?

This is a pine
tree

Use a
soft color
scheme.

Bonsai Scissors

Two
semicircles

Curved teardrop

Another one
on opposite
side

2 / 2

I woke up early this morning, so I stopped at the coffee shop near my house. I just love the smell of coffee!

Coffee Grinder

Oval on top
of trapezoid

Rectangle
underneath

Don't forget to
add a handle!

For a coffee
bean, draw an
oval divided
with a vertical
line.

Coffee Maker

3 rectangles for
base

Hourglass

Add handle and
some coffee

Don't worry
about all the
complex parts!

2 / 3

There was a fire in my neighborhood. Luckily, the fire truck arrived quickly and the flames were easily extinguished.

Fire Truck

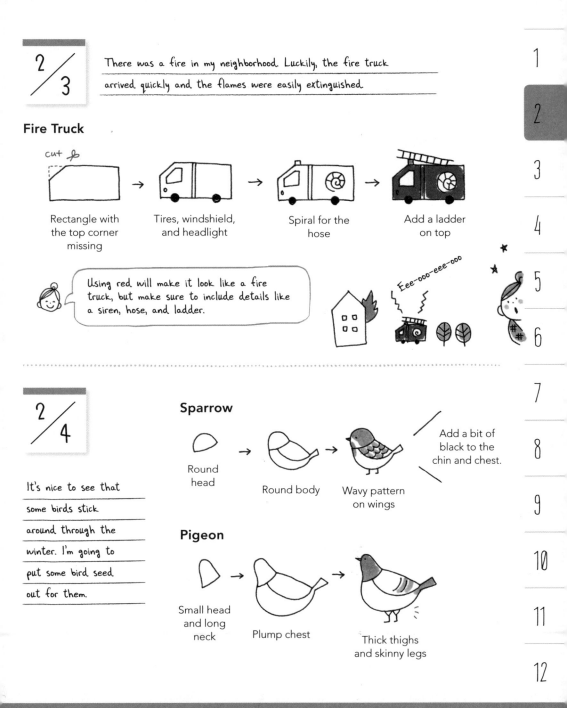

cut ✂

Rectangle with the top corner missing → Tires, windshield, and headlight → Spiral for the hose → Add a ladder on top

Using red will make it look like a fire truck, but make sure to include details like a siren, hose, and ladder.

Eee-ooo-eee-ooo

2 / 4

It's nice to see that some birds stick around through the winter. I'm going to put some bird seed out for them.

Sparrow

Round head → Round body → Wavy pattern on wings → Add a bit of black to the chin and chest.

Pigeon

Small head and long neck → Plump chest → Thick thighs and skinny legs

2/5

My mom scolded me for having such a messy room. I guess I better start cleaning.

Vacuum

 → →

Sideways egg Big wheel Dots

 →

V-shaped hose Add stripes to the hose

2/6

Couch

I spent the afternoon relaxing on the couch and reading my favorite manga comic book. I can't wait to find out what happens next!

 →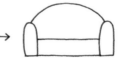

2 arches for armrests Connect with a curve and a rectangle

 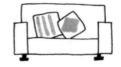

Add legs and buttons Change the shape or add pillows for a different look.

Rocket

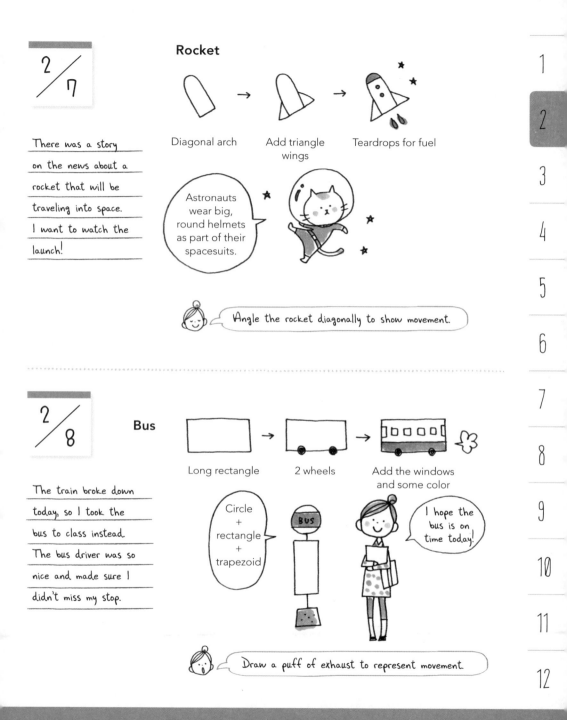

Diagonal arch

Add triangle wings

Teardrops for fuel

There was a story on the news about a rocket that will be traveling into space. I want to watch the launch!

Astronauts wear big, round helmets as part of their spacesuits.

Angle the rocket diagonally to show movement.

Bus

Long rectangle

2 wheels

Add the windows and some color

The train broke down today, so I took the bus to class instead. The bus driver was so nice and made sure I didn't miss my stop.

Circle + rectangle + trapezoid

BUS

I hope the bus is on time today!

Draw a puff of exhaust to represent movement.

1 2 3 4 5 6 7 8 9 10 11 12

2/9

The camellias are starting to bloom already!
That means spring is on the way.

Camellia

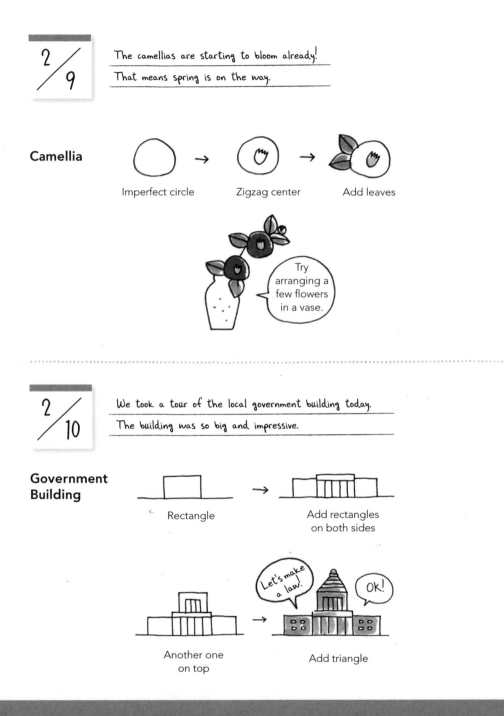

Imperfect circle → Zigzag center → Add leaves

Try arranging a few flowers in a vase.

2/10

We took a tour of the local government building today.
The building was so big and impressive.

Government Building

Rectangle → Add rectangles on both sides

Another one on top → Add triangle

Let's make a law!

OK!

2/11

I want to make my boyfriend something special for Valentine's Day, so I tested out a new muffin recipe. They were delicious!

Chocolate

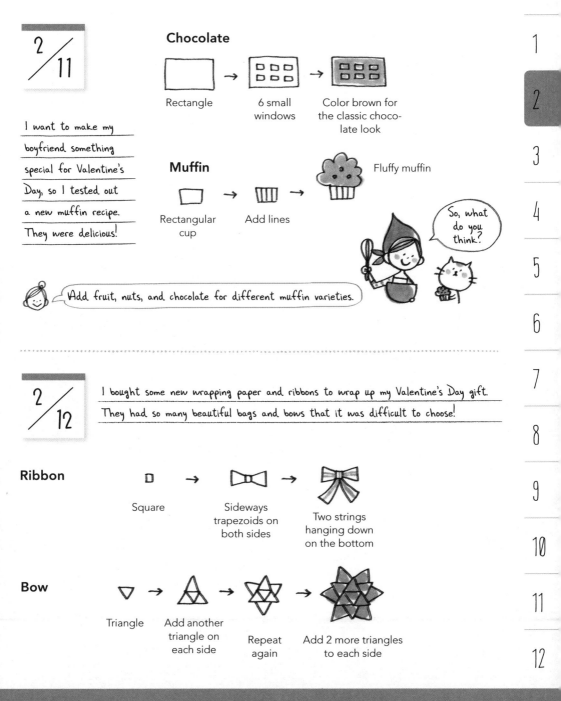

Rectangle → 6 small windows → Color brown for the classic chocolate look

Muffin

Rectangular cup → Add lines → Fluffy muffin

So, what do you think?

Add fruit, nuts, and chocolate for different muffin varieties.

2/12

I bought some new wrapping paper and ribbons to wrap up my Valentine's Day gift. They had so many beautiful bags and bows that it was difficult to choose!

Ribbon

Square → Sideways trapezoids on both sides → Two strings hanging down on the bottom

Bow

Triangle → Add another triangle on each side → Repeat again → Add 2 more triangles to each side

It's Valentine's Day!
I hope my boyfriend
likes the muffins I made
him. I also made a card
shaped like a giant
chocolate bar.

Chocolate Card

4¾" (12 cm)

3" (7 cm)

FOR YOU

4" (10 cm)

1½" (4 cm)

chocolate

3" (7 cm)

1½" (4 cm)

Front

chocolate

Back

1. Make the card.

2. Make the envelope and fold along the dotted lines.

3. Wrap the envelope around the card and tape closed on the back.

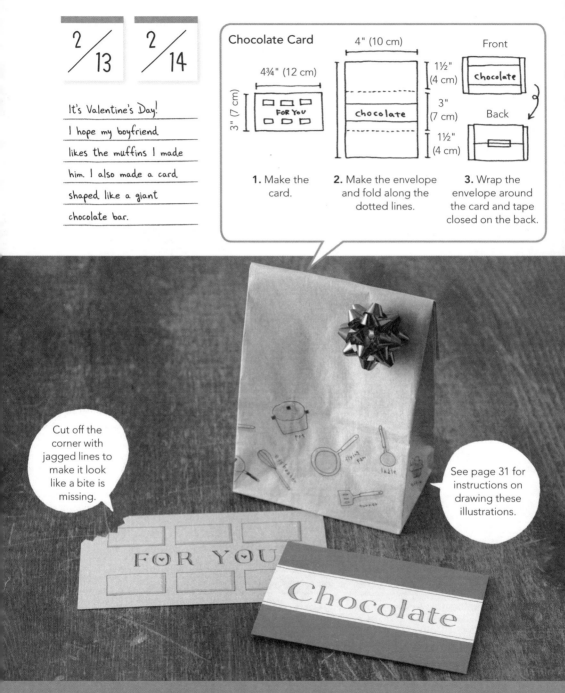

Cut off the corner with jagged lines to make it look like a bite is missing.

See page 31 for instructions on drawing these illustrations.

2 / 15

I stayed up way too late last night—my book was just so good that I couldn't put it down. I'm going to loan it to my friend

Book

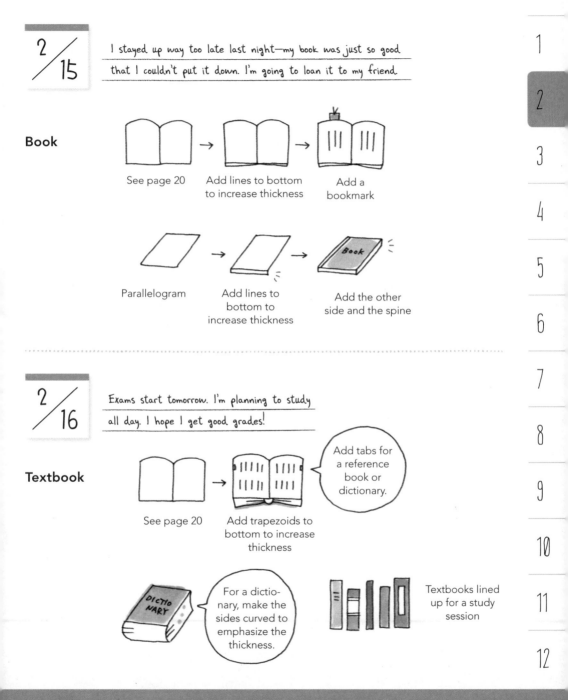

See page 20

Add lines to bottom to increase thickness

Add a bookmark

Parallelogram

Add lines to bottom to increase thickness

Add the other side and the spine

2 / 16

Exams start tomorrow. I'm planning to study all day. I hope I get good grades!

Textbook

See page 20

Add trapezoids to bottom to increase thickness

Add tabs for a reference book or dictionary.

For a dictionary, make the sides curved to emphasize the thickness.

Textbooks lined up for a study session

2 / 17 I studied at the local library today for a change of scenery. There was a group of high school students there too. I'm so glad I don't have to wear a uniform anymore!

School Uniform

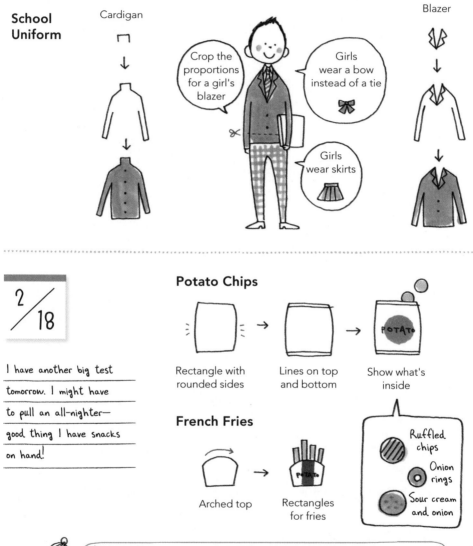

Cardigan

Crop the proportions for a girl's blazer

Girls wear a bow instead of a tie

Girls wear skirts

Blazer

2 / 18

I have another big test tomorrow. I might have to pull an all-nighter— good thing I have snacks on hand!

Potato Chips

Rectangle with rounded sides → Lines on top and bottom → Show what's inside

POTATO

French Fries

Arched top → Rectangles for fries

POTATO

Ruffled chips

Onion rings

Sour cream and onion

Draw a few chips peeking out of the bag so people know what's inside.

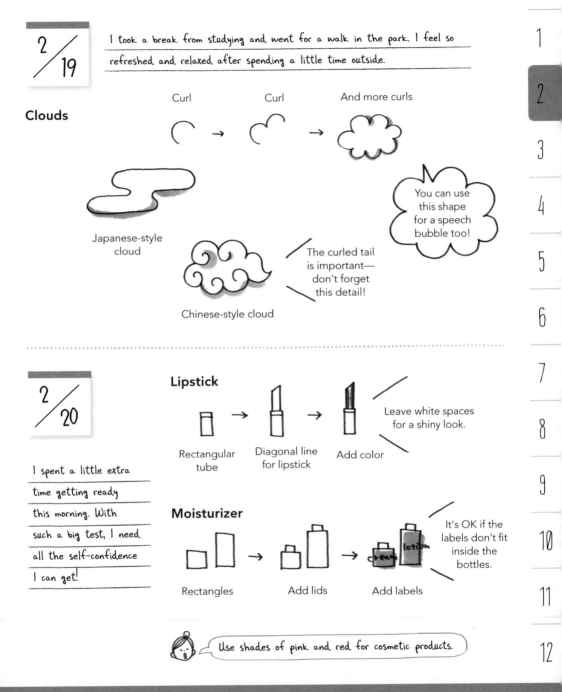

2/19

I took a break from studying and went for a walk in the park. I feel so refreshed and relaxed after spending a little time outside.

Clouds

Curl → Curl → And more curls

Japanese-style cloud

Chinese-style cloud

The curled tail is important—don't forget this detail!

You can use this shape for a speech bubble too!

2/20

I spent a little extra time getting ready this morning. With such a big test, I need all the self-confidence I can get!

Lipstick

Rectangular tube → Diagonal line for lipstick → Add color

Leave white spaces for a shiny look.

Moisturizer

Rectangles → Add lids → Add labels

lotion

cream

It's OK if the labels don't fit inside the bottles.

Use shades of pink and red for cosmetic products.

2 / 21

One more day of exams
to go! My mom made
me a big dinner to give
me energy for the test
tomorrow.

Rice Bowl

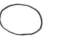

Oval

Semicircle with
a rectangular
base

Now fill the bowl
with food!

Draw the
toppings
first

Add the rice

Decorate the
bowl and add
chopsticks

2 / 22

My exams are finally
over! My friends and I
treated ourselves to ice
cream as a reward for
all our hard work.

Parfait

Long,
inverted
triangle

Circles for
ice cream
scoops

Add
toppings

Add dots
or lines for
toppings, like
candy, nuts,
and fruit.

Sundae

Semicircle with
triangular base

Circle for
ice cream
scoop

Add a cookie or
brownie

If it's a glass
dish, make
sure to add
color inside
too.

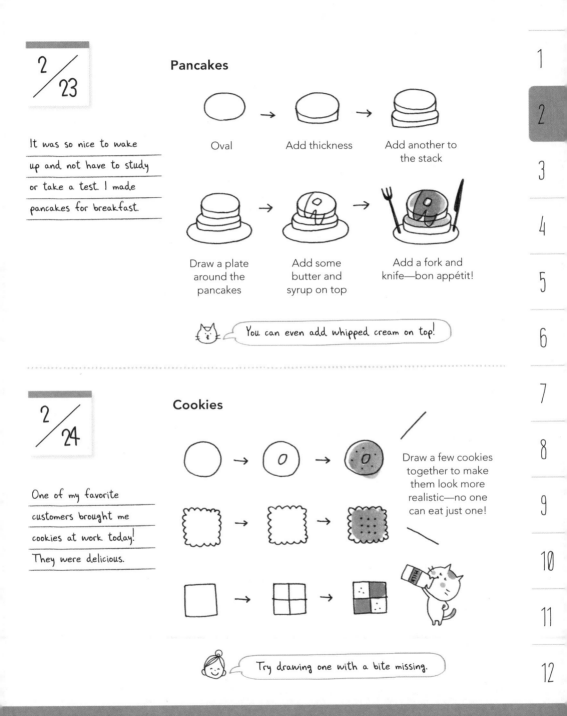

Pancakes

It was so nice to wake up and not have to study or take a test. I made pancakes for breakfast.

Oval

Add thickness

Add another to the stack

Draw a plate around the pancakes

Add some butter and syrup on top

Add a fork and knife—bon appétit!

You can even add whipped cream on top!

Cookies

One of my favorite customers brought me cookies at work today! They were delicious.

Draw a few cookies together to make them look more realistic—no one can eat just one!

Try drawing one with a bite missing.

I had a great day today! I wish I was always in such a good mood.

Happy Facial Expressions

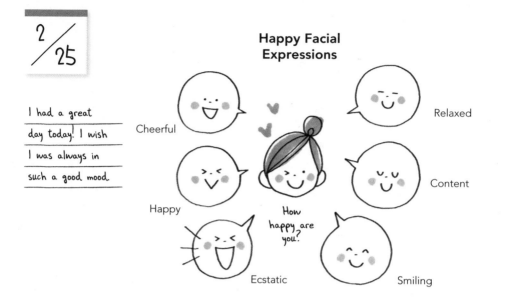

Cheerful

Relaxed

Happy

Content

How happy are you?

Ecstatic

Smiling

I didn't do the best job, but I painted my nails today. I admire women who can draw all sorts of fancy designs.

Nail Polish

Rectangle → Long handle

Line up a few different colors

Round bottle without the cap → Draw the brush and add a drop of polish

How do they look?

2 / 27

The weather is slowly starting to warm up. I need to bring my spring clothes out of storage... and maybe buy a few new things.

Cardigan

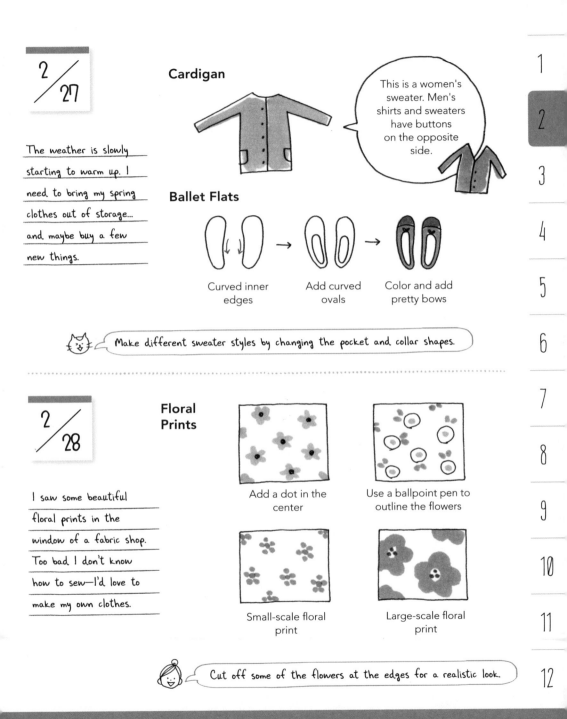

This is a women's sweater. Men's shirts and sweaters have buttons on the opposite side.

Ballet Flats

Curved inner edges → Add curved ovals → Color and add pretty bows

Make different sweater styles by changing the pocket and collar shapes.

2 / 28

I saw some beautiful floral prints in the window of a fabric shop. Too bad I don't know how to sew—I'd love to make my own clothes.

Floral Prints

Add a dot in the center

Use a ballpoint pen to outline the flowers

Small-scale floral print

Large-scale floral print

Cut off some of the flowers at the edges for a realistic look.

Today is
Leap Day!
It occurs
once every
4 years!

I found some of my childhood
toys when I was reorganizing
my closet. They brought back
so many wonderful memories!

Add a key to
the back of an
animal (see
page 12) or car
(see page 62) to
transform it into
a wind-up toy.

Kendama

A kendama is
a traditional
Japanese
toy

Rectangle
with curved
middle

Triangular
stick

Add the string
and ball

Tambourine

Circle

Add the base

3 semicircles

Add ribbons

Bugle

Big triangle

Extend the line
and add a smaller
triangle

Connect the two
triangles with a
curved line

Add 3
T-shapes

3 / 1

The weather was pretty nice today. I went on the swings at the park, which made me feel like a kid again.

Swing

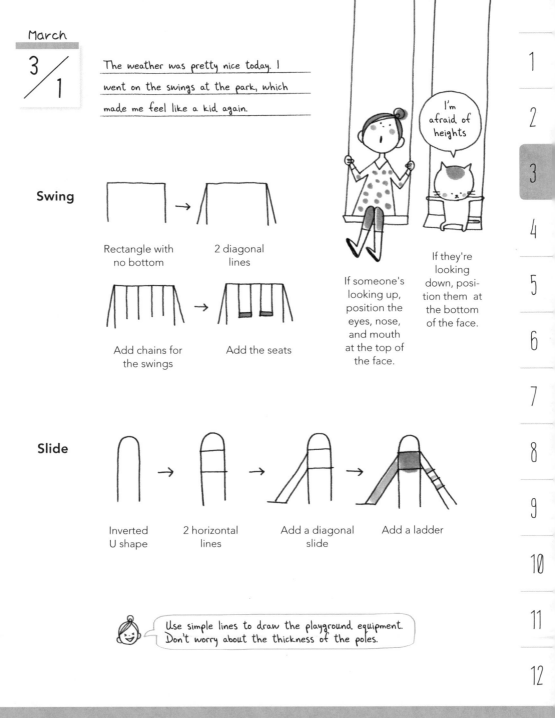

Rectangle with no bottom → 2 diagonal lines

Add chains for the swings → Add the seats

I'm afraid of heights

If someone's looking up, position the eyes, nose, and mouth at the top of the face.

If they're looking down, position them at the bottom of the face.

Slide

Inverted U shape → 2 horizontal lines → Add a diagonal slide → Add a ladder

Use simple lines to draw the playground equipment. Don't worry about the thickness of the poles.

I'm really looking forward to spring. I can't wait until all the flowers bloom. The cherry blossoms are my favorite!

Cherry Blossom

Pointed petal

5 petals total

Add more flowers and buds, then connect with a branch

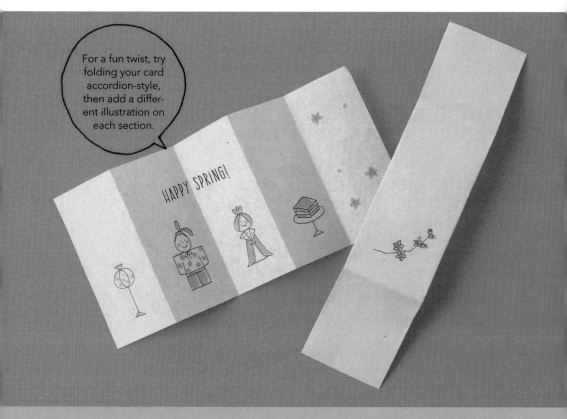

For a fun twist, try folding your card accordion-style, then add a different illustration on each section.

HAPPY SPRING!

3 / 3

My friends and I were talking about our favorite childhood activities.
I used to take piano lessons. I wonder if I can still play.

Piano

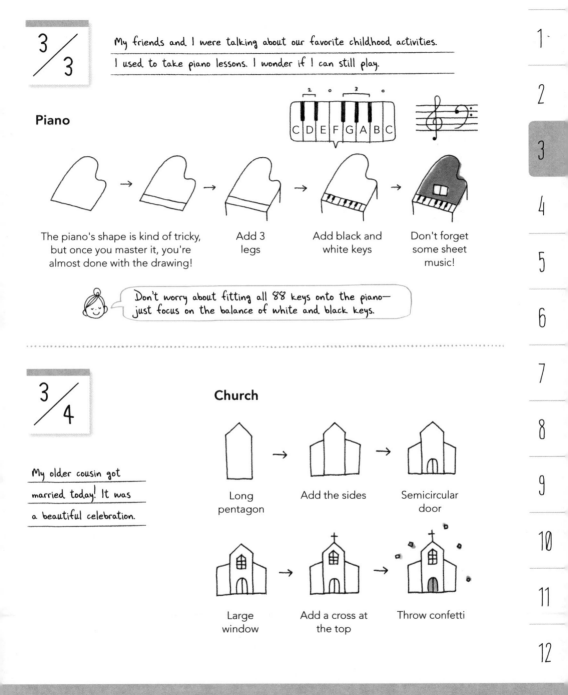

C D E F G A B C

The piano's shape is kind of tricky, but once you master it, you're almost done with the drawing!

Add 3 legs

Add black and white keys

Don't forget some sheet music!

Don't worry about fitting all 88 keys onto the piano—just focus on the balance of white and black keys.

3 / 4

My older cousin got married today! It was a beautiful celebration.

Church

Long pentagon

Add the sides

Semicircular door

Large window

Add a cross at the top

Throw confetti

1
2
3
4
5
6
7
8
9
10
11
12

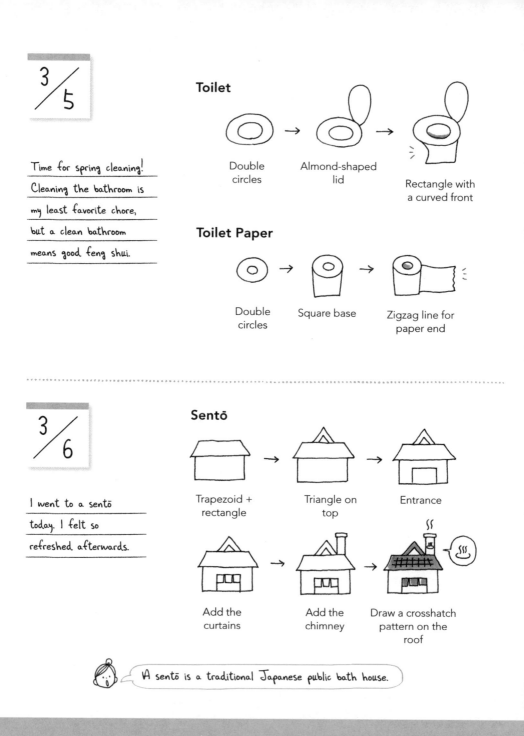

3 / 5

Time for spring cleaning! Cleaning the bathroom is my least favorite chore, but a clean bathroom means good feng shui.

Toilet

Double circles → Almond-shaped lid → Rectangle with a curved front

Toilet Paper

Double circles → Square base → Zigzag line for paper end

3 / 6

I went to a sentō today. I felt so refreshed afterwards.

Sentō

Trapezoid + rectangle → Triangle on top → Entrance

Add the curtains → Add the chimney → Draw a crosshatch pattern on the roof

A sentō is a traditional Japanese public bath house.

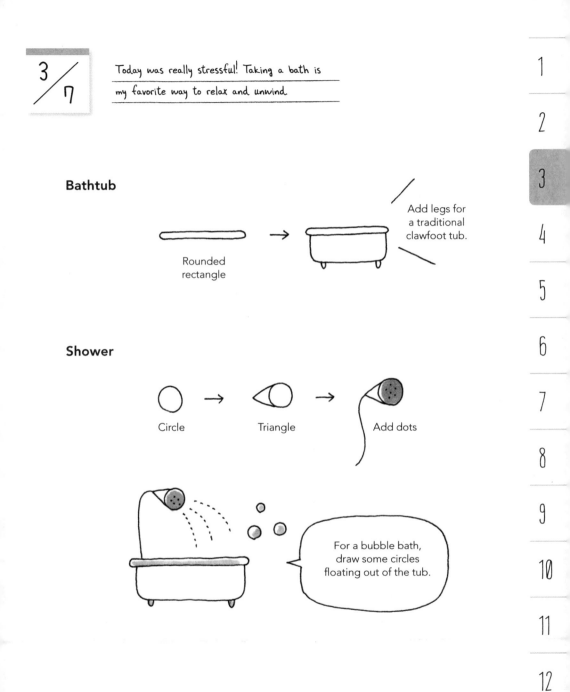

Today was really stressful! Taking a bath is my favorite way to relax and unwind.

Bathtub

Rounded rectangle

Add legs for a traditional clawfoot tub.

Shower

Circle

Triangle

Add dots

For a bubble bath, draw some circles floating out of the tub.

Vase

I went to a pottery class
with my friend. We made
vases for our first project.
I can't wait to make
another one!

Different Vase
Designs

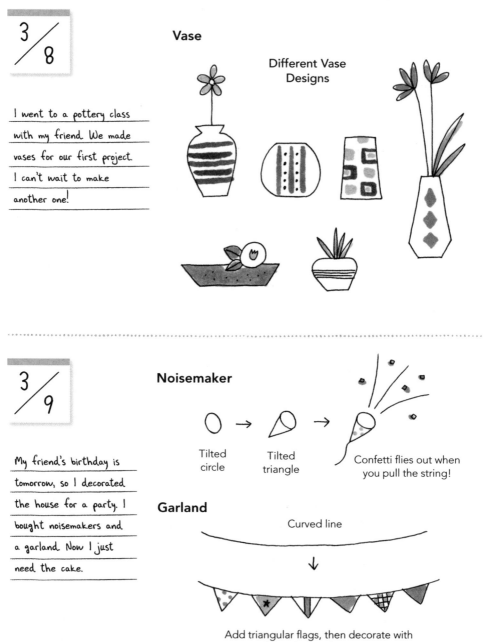

3 / 9

Noisemaker

My friend's birthday is
tomorrow, so I decorated
the house for a party. I
bought noisemakers and
a garland. Now I just
need the cake.

Tilted
circle
→
Tilted
triangle
→
Confetti flies out when
you pull the string!

Garland

Curved line

↓

Add triangular flags, then decorate with
fun colors and patterns

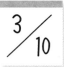

3/10

Birthday Cake

The party was a huge success! Everyone had a great time and the cake was delicious.

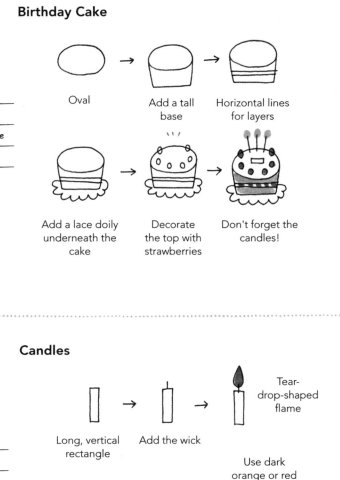

Oval

Add a tall base

Horizontal lines for layers

Add a lace doily underneath the cake

Decorate the top with strawberries

Don't forget the candles!

3/11

Candles

I love to light candles when it's time to relax. I especially love the scented ones.

Long, vertical rectangle

Add the wick

Tear-drop-shaped flame

Use dark orange or red for the flame.

In a candle holder

Painted candles

Melting candle

I'm really getting into this pottery thing! I made a cup and saucer in class today.

Cup

Oval → Add the base → Add a handle

Saucer

Circle → Add a pattern ⇢ Or try a wavy edge

I ordered some takeout from a new restaurant and the food was so bland! I had to use a lot of condiments just to give the food some flavor. Remind me not to order from there again!

Condiments

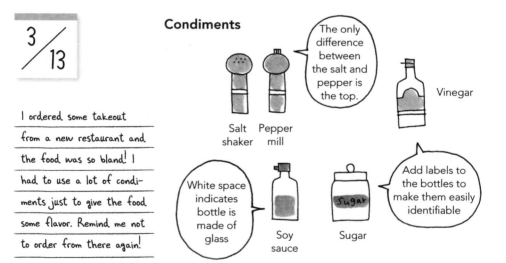

The only difference between the salt and pepper is the top.

Salt shaker Pepper mill

Vinegar

White space indicates bottle is made of glass

Soy sauce

Sugar

Add labels to the bottles to make them easily identifiable

3/14

My boyfriend gave me a box of macarons today! They are almost too pretty to eat!

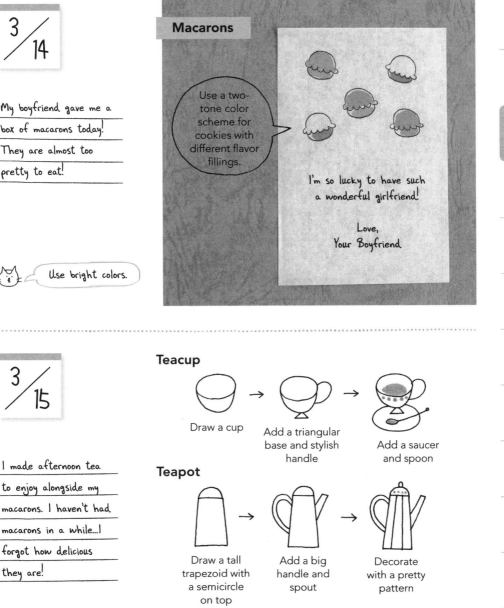

Macarons

Use a two-tone color scheme for cookies with different flavor fillings.

I'm so lucky to have such a wonderful girlfriend!

Love,
Your Boyfriend

Use bright colors.

3/15

I made afternoon tea to enjoy alongside my macarons. I haven't had macarons in a while...I forgot how delicious they are!

Teacup

Draw a cup → Add a triangular base and stylish handle → Add a saucer and spoon

Teapot

Draw a tall trapezoid with a semicircle on top → Add a big handle and spout → Decorate with a pretty pattern

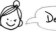 Decorate the china with a blue pattern for a classic look.

3/16

We had our first spring storm today. My hair was a tangled mess from the wind, but I didn't mind since it means that spring is just around the corner.

Spring Storm

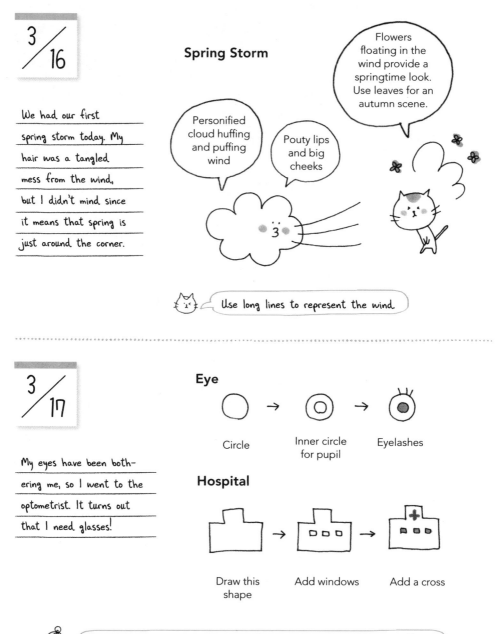

Flowers floating in the wind provide a springtime look. Use leaves for an autumn scene.

Personified cloud huffing and puffing wind

Pouty lips and big cheeks

Use long lines to represent the wind

3/17

My eyes have been bothering me, so I went to the optometrist. It turns out that I need glasses!

Eye

Circle → Inner circle for pupil → Eyelashes

Hospital

Draw this shape → Add windows → Add a cross

A red cross makes a building identifiable as a hospital or medical office.

I was nervous about wearing my new glasses to class. My teacher told me they make me look smarter!

Glasses

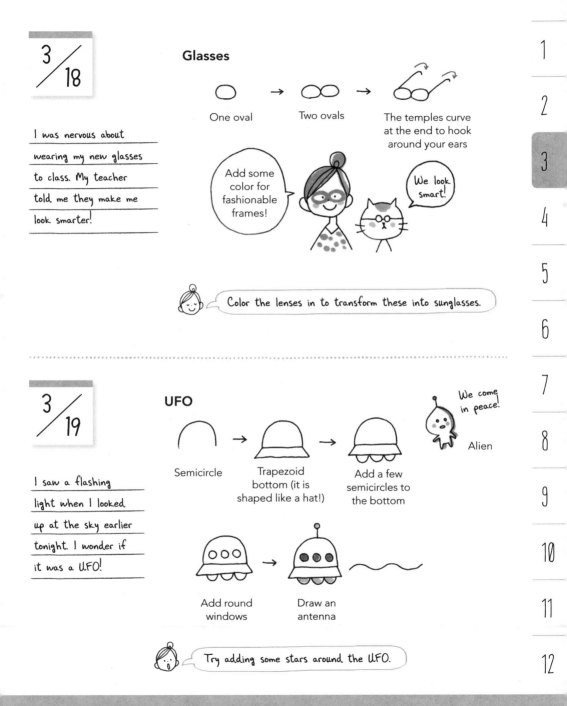

One oval

Two ovals

The temples curve at the end to hook around your ears

Add some color for fashionable frames!

We look smart!

Color the lenses in to transform these into sunglasses.

I saw a flashing light when I looked up at the sky earlier tonight. I wonder if it was a UFO!

UFO

We come in peace!

Alien

Semicircle

Trapezoid bottom (it is shaped like a hat!)

Add a few semicircles to the bottom

Add round windows

Draw an antenna

Try adding some stars around the UFO.

Herbs

I planted a small garden in honor of the first day of spring. I hope my plants grow!

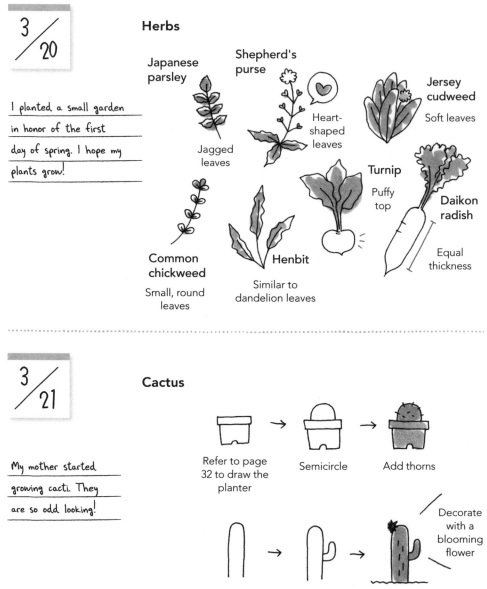

Japanese parsley

Jagged leaves

Shepherd's purse

Heart-shaped leaves

Jersey cudweed

Soft leaves

Turnip

Puffy top

Daikon radish

Equal thickness

Common chickweed

Small, round leaves

Henbit

Similar to dandelion leaves

Cactus

My mother started growing cacti. They are so odd looking!

Refer to page 32 to draw the planter

Semicircle

Add thorns

Skinny cylinder

Add an arm

Decorate with a blooming flower

I spent the day strolling around with my camera. I took lots of pictures of all the flowers starting to bloom.

Camera

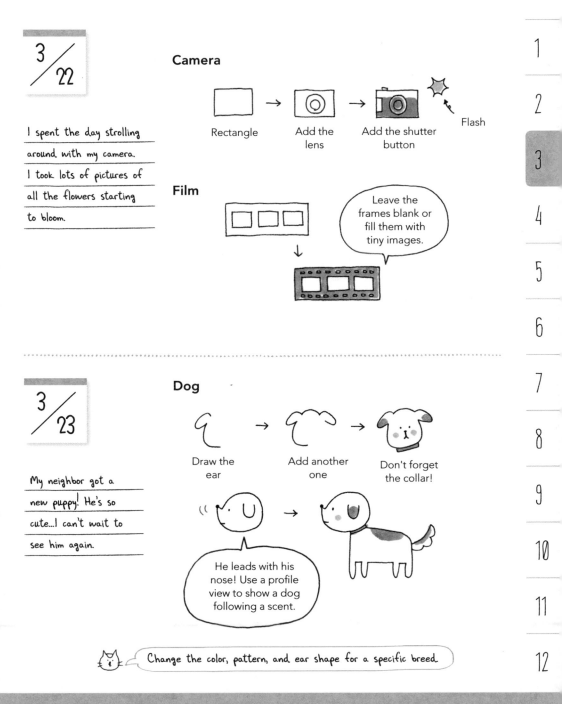

Rectangle

Add the lens

Add the shutter button

Flash

Film

Leave the frames blank or fill them with tiny images.

My neighbor got a new puppy! He's so cute...I can't wait to see him again.

Dog

Draw the ear

Add another one

Don't forget the collar!

He leads with his nose! Use a profile view to show a dog following a scent.

Change the color, pattern, and ear shape for a specific breed.

1
2
3
4
5
6
7
8
9
10
11
12

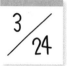

3 / 24

I treated myself to a ramen noodle bowl for lunch. The restaurant was so busy! Luckily, I was able to find the last open seat at the counter.

Ramen Noodles

Bowl
(see page 42)

→

Add your favorite toppings, such as fish, meat, and veggies.

Add noodles

→

Decorate the bowl with a pretty pattern

Don't forget the soup spoon!

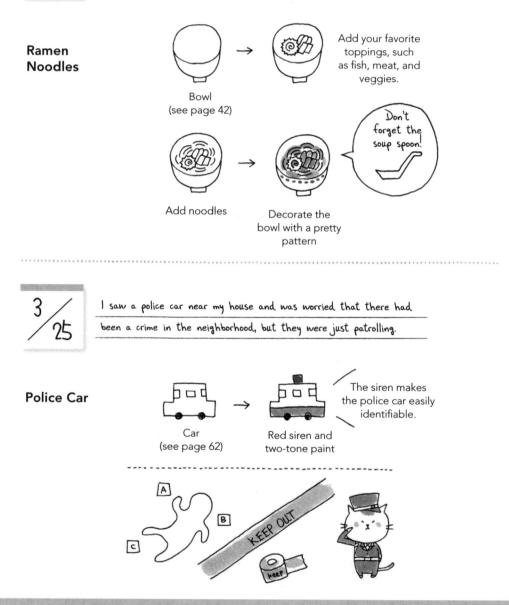

3 / 25

I saw a police car near my house and was worried that there had been a crime in the neighborhood, but they were just patrolling.

Police Car

Car
(see page 62)

→

Red siren and two-tone paint

The siren makes the police car easily identifiable.

A

B

C

KEEP OUT

keep

3 / 26

They tore down one of the old school buildings and are constructing a new one. I can't wait to have class in the new building.

School

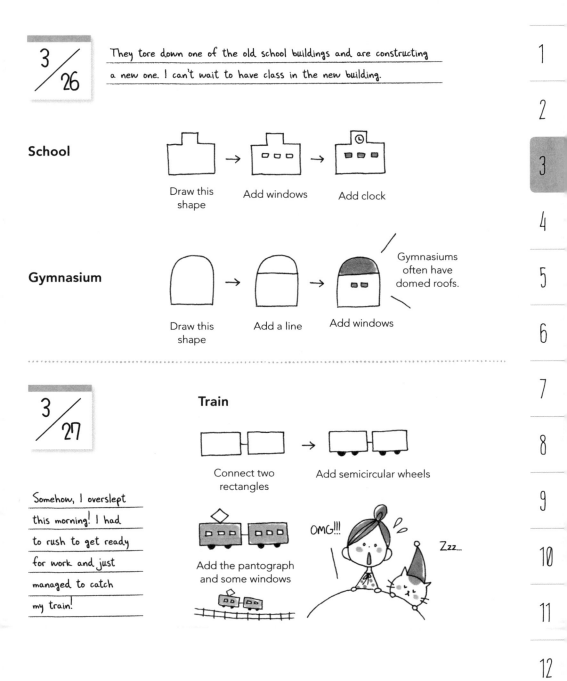

Draw this shape → Add windows → Add clock

Gymnasium

Draw this shape → Add a line → Add windows

Gymnasiums often have domed roofs.

3 / 27

Somehow, I overslept this morning! I had to rush to get ready for work and just managed to catch my train!

Train

Connect two rectangles → Add semicircular wheels

Add the pantograph and some windows

OMG!!!

Zzz...

My dad took me out to practice driving this weekend. Am I ever going to get my license?

Car

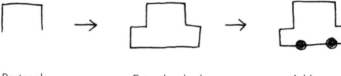

Rectangle
with no
bottom line

Extend on both
sides

Add two
wheels

 →

Add the
windows

Add exhaust to
show that the car is
on the move!

3 / 30

You know spring is really here once the tulips start blooming. I love seeing all the different colors!

Tulips

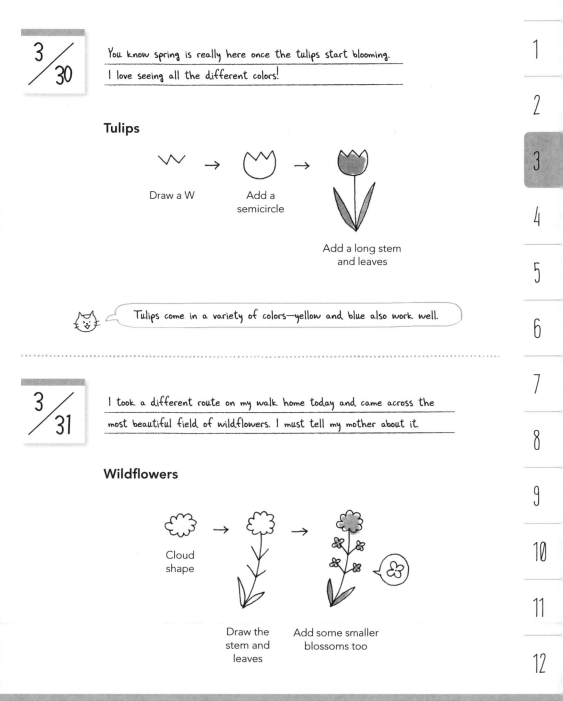

W → M → (tulip)

Draw a W Add a semicircle Add a long stem and leaves

Tulips come in a variety of colors—yellow and blue also work well.

3 / 31

I took a different route on my walk home today and came across the most beautiful field of wildflowers. I must tell my mother about it.

Wildflowers

Cloud shape → →

Draw the stem and leaves Add some smaller blossoms too

1

2

3

4

5

6

7

8

9

10

11

12

GETTING STARTED

The Basics

Are you intimidated by the prospect of drawing? Well, there's no need to be! Just relax and follow these simple steps:

Apple

1 Decide what you want to draw

Be the apple

2 Stare at the paper and visualize the object

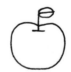

Looking good

3 Start sketching

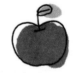

Almost there!

4 Refine the drawing and add details

5 Now for the fun part...coloring!

One of the secrets to creating realistic drawings is selecting the proper perspective. Some objects are easily identifiable from one angle, while others benefit from combining two angles to create a more complex drawing.

Single Angle

| Scissors | Key | Umbrella | House |

Combined Angles

Bird's-eye View Side View Combined Angle

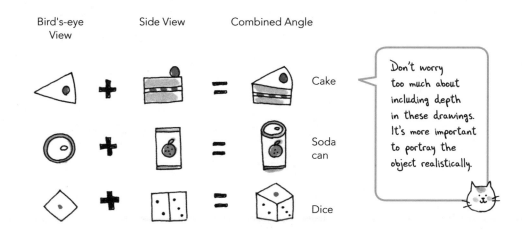

Cake

Soda can

Dice

Don't worry too much about including depth in these drawings. It's more important to portray the object realistically.

SPRING

April
May
June

April

4 / 1

I read a story on the internet that said the world is going to end today! I hope it's just an April Fool's joke.

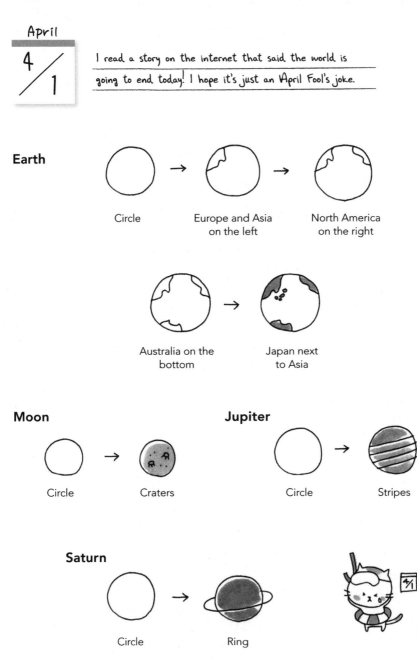

Earth

Circle → Europe and Asia on the left → North America on the right

Australia on the bottom → Japan next to Asia

Moon

Circle → Craters

Jupiter

Circle → Stripes

Saturn

Circle → Ring

Oh no, I've been tricked!

I think I might try a new hairstyle when I visit the salon tomorrow. I flipped through my magazines to get a few ideas.

Hairstyles

Long bob with straight bangs

Short bob

I chickened out and just ended up getting a trim. But I'm definitely going to try a new hairstyle next time.

Scissors

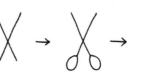

X with a longer upper half

Circles for the finger rings

Curves for the blades and an extra hook for the finger rest

Barber's Pole

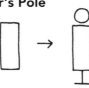

Color the stripes red, white, and blue.

Rectangle

Circle top and upside down T bottom

Diagonal stripes

4/4

Bicycle

The weather was nice today, so I rode my bike into town.

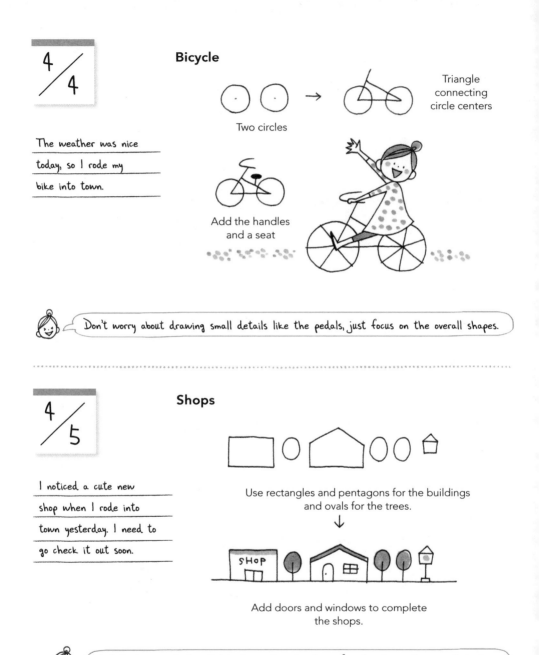

Two circles

Triangle connecting circle centers

Add the handles and a seat

Don't worry about drawing small details like the pedals, just focus on the overall shapes.

4/5

Shops

I noticed a cute new shop when I rode into town yesterday. I need to go check it out soon.

Use rectangles and pentagons for the buildings and ovals for the trees.

↓

SHOP

Add doors and windows to complete the shops.

Include trees and streetlights to capture the look of a downtown shopping district.

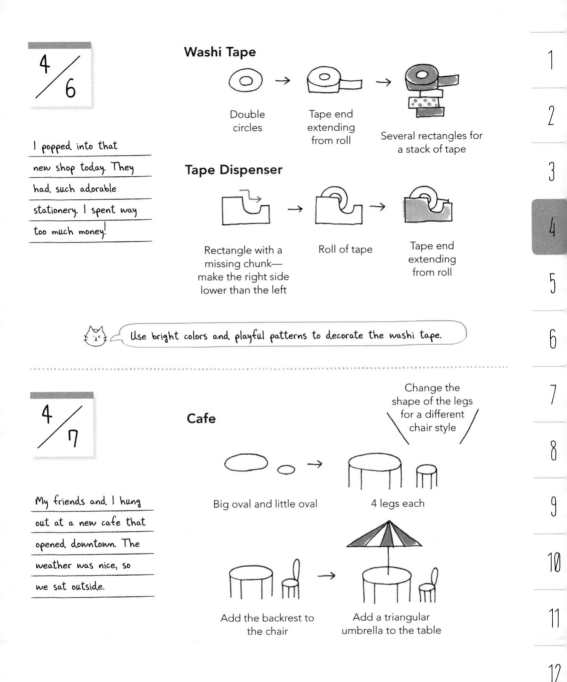

4/6

I popped into that
new shop today. They
had such adorable
stationery. I spent way
too much money!

Washi Tape

Double
circles

Tape end
extending
from roll

Several rectangles for
a stack of tape

Tape Dispenser

Rectangle with a
missing chunk—
make the right side
lower than the left

Roll of tape

Tape end
extending
from roll

Use bright colors and playful patterns to decorate the washi tape.

4/7

My friends and I hung
out at a new cafe that
opened downtown. The
weather was nice, so
we sat outside.

Cafe

Change the
shape of the legs
for a different
chair style

Big oval and little oval

4 legs each

Add the backrest to
the chair

Add a triangular
umbrella to the table

I babysat the little girl who lives next door.

She wears the cutest yellow hat.

Kid

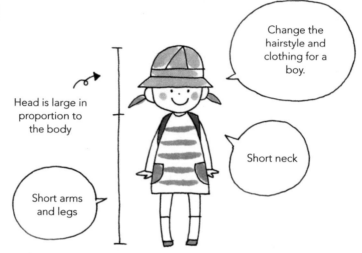

Head is large in proportion to the body

Change the hairstyle and clothing for a boy.

Short neck

Short arms and legs

Hat

Semicircle → Trapezoid brim → Color yellow

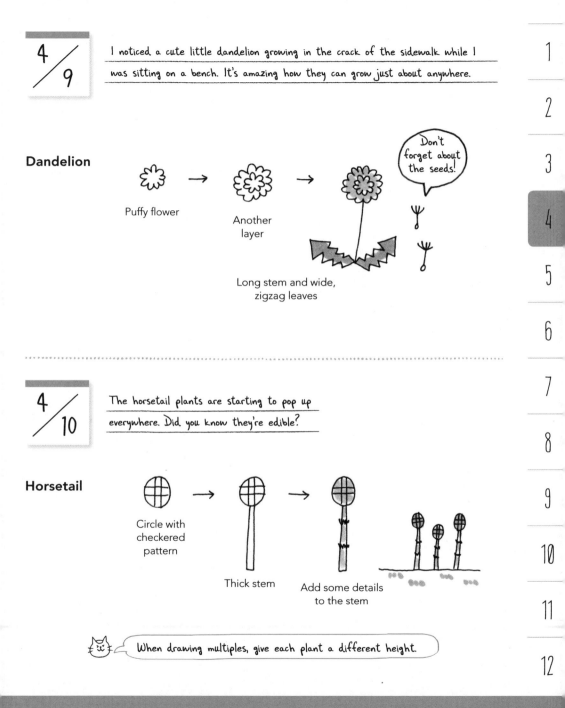

4 / 9

I noticed a cute little dandelion growing in the crack of the sidewalk while I was sitting on a bench. It's amazing how they can grow just about anywhere.

Dandelion

Puffy flower

Another layer

Don't forget about the seeds!

Long stem and wide, zigzag leaves

4 / 10

The horsetail plants are starting to pop up everywhere. Did you know they're edible?

Horsetail

Circle with checkered pattern

Thick stem

Add some details to the stem

When drawing multiples, give each plant a different height.

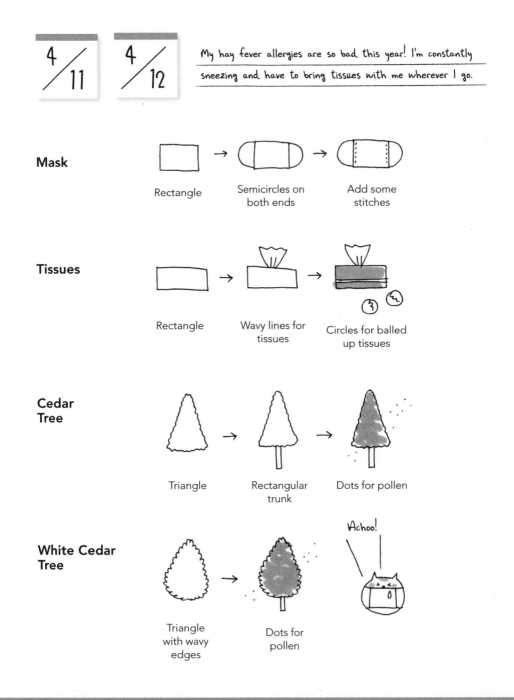

4 / 11 4 / 12

My hay fever allergies are so bad this year! I'm constantly sneezing and have to bring tissues with me wherever I go.

Mask

Rectangle → Semicircles on both ends → Add some stitches

Tissues

Rectangle → Wavy lines for tissues → Circles for balled up tissues

Cedar Tree

Triangle → Rectangular trunk → Dots for pollen

White Cedar Tree

Triangle with wavy edges → Dots for pollen

Achoo!

I'm planning a party for the new Art Club members.
I hope a lot of people show up!

Party Invitation

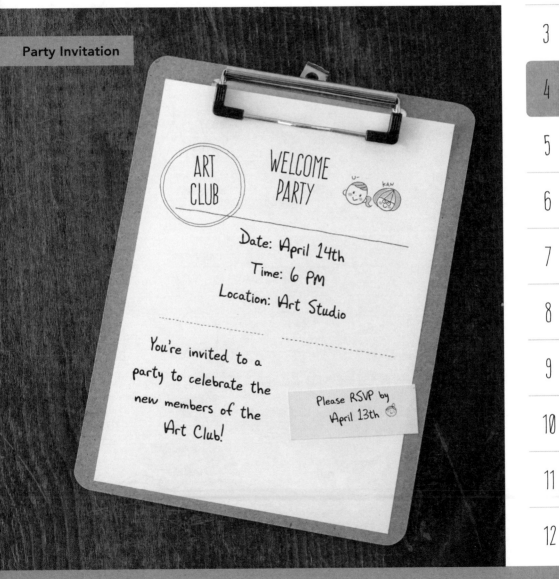

The weather has been
so nice lately! I'm trying
to spend as much time
outdoors as possible.

Butterfly

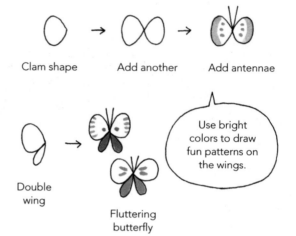

Clam shape → Add another → Add antennae

Double wing → Fluttering butterfly

Use bright colors to draw fun patterns on the wings.

Turtle

I stopped at the pet
store to buy some cat
food. They have so
many unique animals.

Hello!

Big mountain → Add head, tail, and legs → Decorate the shell with a geometric pattern

Snake

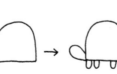

Round head → Long, curvy body

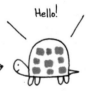

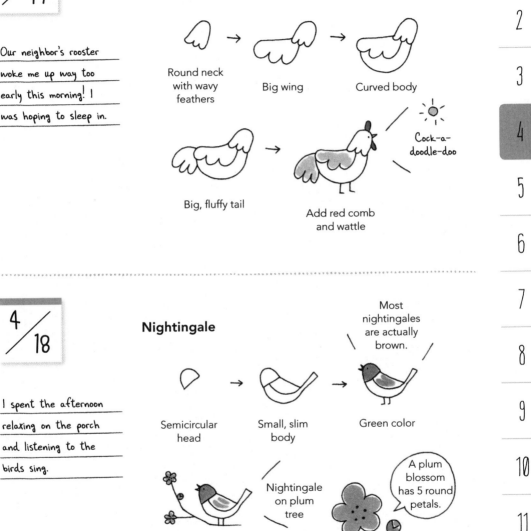

4/17

Our neighbor's rooster woke me up way too early this morning! I was hoping to sleep in.

Rooster

Round neck with wavy feathers

Big wing

Curved body

Big, fluffy tail

Add red comb and wattle

Cock-a-doodle-doo

4/18

I spent the afternoon relaxing on the porch and listening to the birds sing.

Nightingale

Semicircular head

Small, slim body

Green color

Most nightingales are actually brown.

Plum branch

Nightingale on plum tree

A plum blossom has 5 round petals.

1

2

3

4

5

6

7

8

9

10

11

12

77

It's cherry blossom season! My friends and I had a viewing party to celebrate.

How to Make a Paper Cherry Blossom

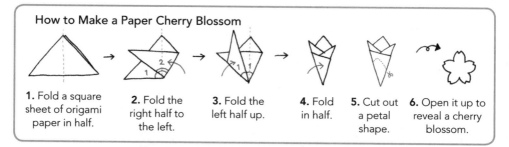

1. Fold a square sheet of origami paper in half.

2. Fold the right half to the left.

3. Fold the left half up.

4. Fold in half.

5. Cut out a petal shape.

6. Open it up to reveal a cherry blossom.

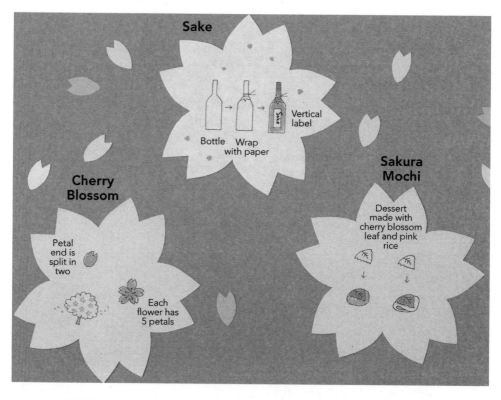

Sake

Bottle → Wrap with paper → Vertical label

Cherry Blossom

Petal end is split in two

Each flower has 5 petals

Sakura Mochi

Dessert made with cherry blossom leaf and pink rice

These paper cherry blossoms can be used as pretty decorations or for cute cards.

4 / 21

I visited my grandfather today and he sent me home with lots of bamboo shoots from his garden. My mom is going to cook some for dinner tonight.

Bamboo Shoot

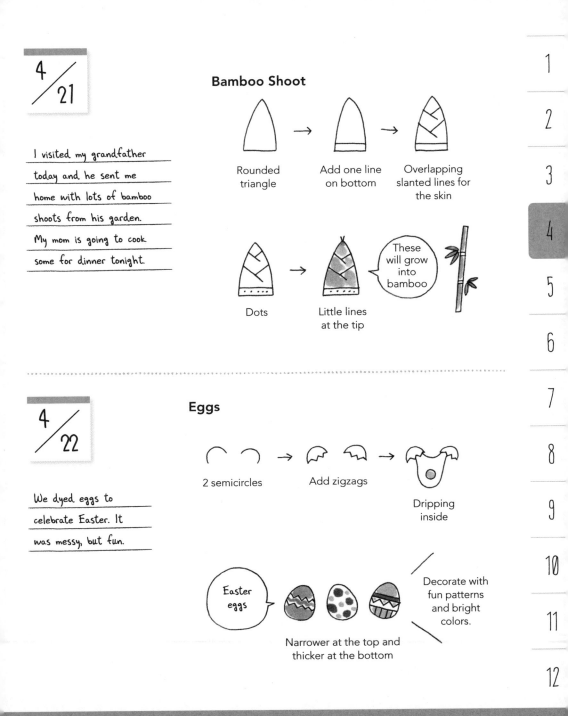

Rounded triangle

Add one line on bottom

Overlapping slanted lines for the skin

Dots

Little lines at the tip

These will grow into bamboo

4 / 22

We dyed eggs to celebrate Easter. It was messy, but fun.

Eggs

2 semicircles

Add zigzags

Dripping inside

Easter eggs

Narrower at the top and thicker at the bottom

Decorate with fun patterns and bright colors.

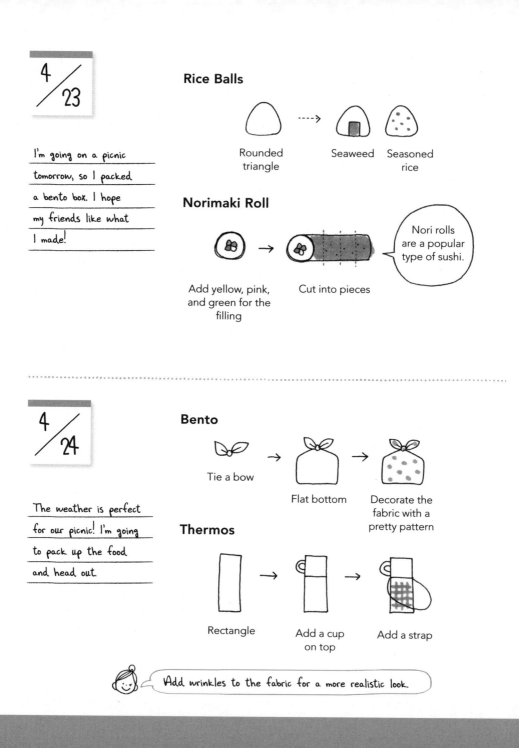

4 / 23

I'm going on a picnic tomorrow, so I packed a bento box. I hope my friends like what I made!

Rice Balls

Rounded triangle ----> Seaweed Seasoned rice

Norimaki Roll

Add yellow, pink, and green for the filling → Cut into pieces

Nori rolls are a popular type of sushi.

4 / 24

The weather is perfect for our picnic! I'm going to pack up the food and head out.

Bento

Tie a bow → Flat bottom → Decorate the fabric with a pretty pattern

Thermos

Rectangle → Add a cup on top → Add a strap

Add wrinkles to the fabric for a more realistic look.

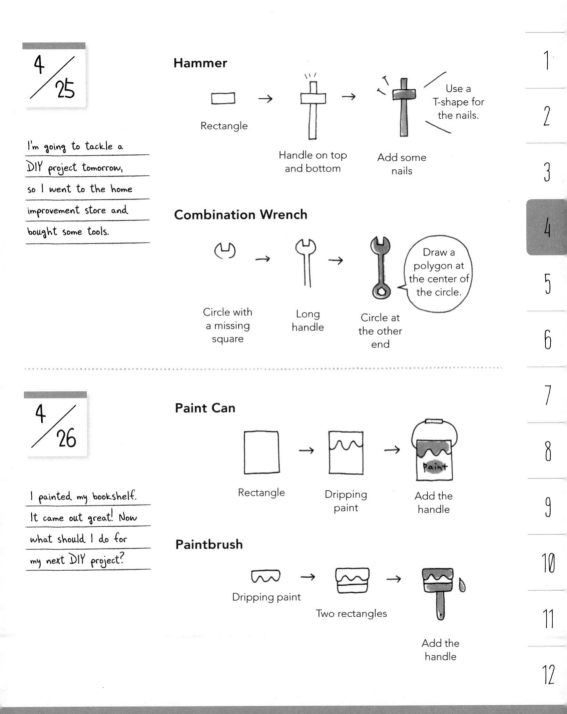

4 / 25

I'm going to tackle a DIY project tomorrow, so I went to the home improvement store and bought some tools.

Hammer

Rectangle

Handle on top and bottom

Add some nails

Use a T-shape for the nails.

Combination Wrench

Circle with a missing square

Long handle

Circle at the other end

Draw a polygon at the center of the circle.

4 / 26

I painted my bookshelf. It came out great! Now what should I do for my next DIY project?

Paint Can

Rectangle

Dripping paint

Add the handle

Paint

Paintbrush

Dripping paint

Two rectangles

Add the handle

1
2
3
4
5
6
7
8
9
10
11
12

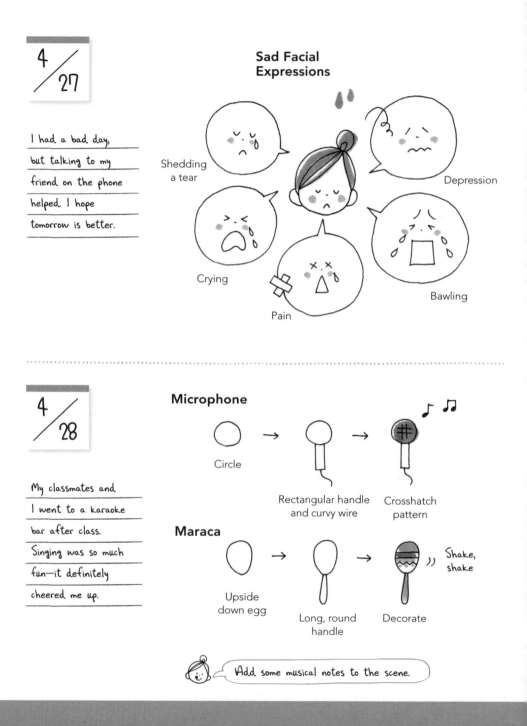

4 / 27

I had a bad day, but talking to my friend on the phone helped. I hope tomorrow is better.

Sad Facial Expressions

Shedding a tear

Depression

Crying

Pain

Bawling

4 / 28

My classmates and I went to a karaoke bar after class. Singing was so much fun—it definitely cheered me up.

Microphone

Circle

Rectangular handle and curvy wire

Crosshatch pattern

Maraca

Upside down egg

Long, round handle

Decorate

Shake, shake

Add some musical notes to the scene.

4 / 29

I spent the day in Tokyo and visited both Tokyo Tower and the Tokyo Skytree. The Skytree is so tall that you can't see the top when you're standing on the ground!

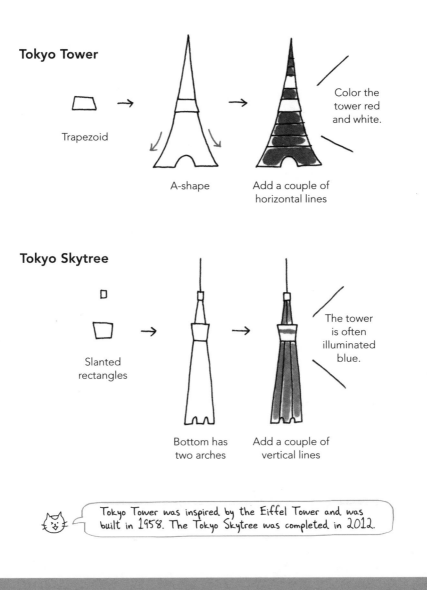

Tokyo Tower

Trapezoid

A-shape

Add a couple of horizontal lines

Color the tower red and white.

Tokyo Skytree

Slanted rectangles

Bottom has two arches

Add a couple of vertical lines

The tower is often illuminated blue.

Tokyo Tower was inspired by the Eiffel Tower and was built in 1958. The Tokyo Skytree was completed in 2012.

My grandmother got a cell phone! I helped her get it set up. We had an interesting conversation about how much has changed since she was a little girl.

Rotary Telephone

Trapezoid → Circular dial → Add receiver and a winding cord

Smartphone

Rectangle → Double rectangle → Add a couple of apps

20th century

21st century

May

5/1

5/2

I went to the amusement park today. No matter how old I am, I'll never get sick of the Ferris wheel and merry-go-round. I added some drawings to my scrapbook to commemorate all the fun I had today.

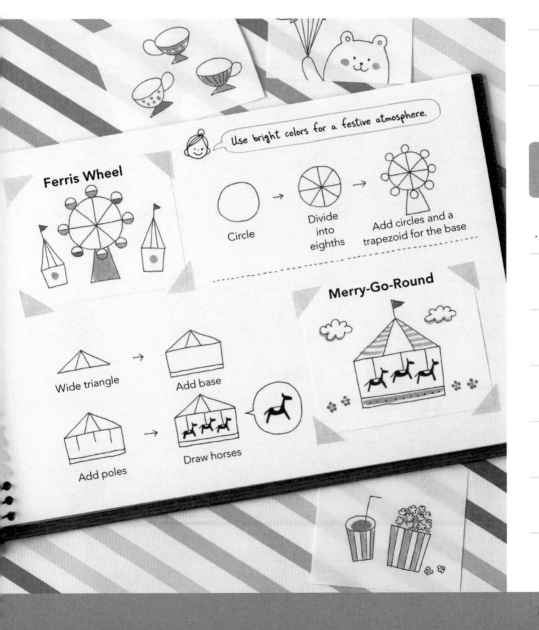

Use bright colors for a festive atmosphere.

Ferris Wheel

Circle

Divide into eighths

Add circles and a trapezoid for the base

Merry-Go-Round

Wide triangle

Add base

Add poles

Draw horses

5 / 3

My parents left for their trip to Kyushu today. It's green tea picking season, so it's a great time to visit. I'm jealous—I'd love to go on a trip myself.

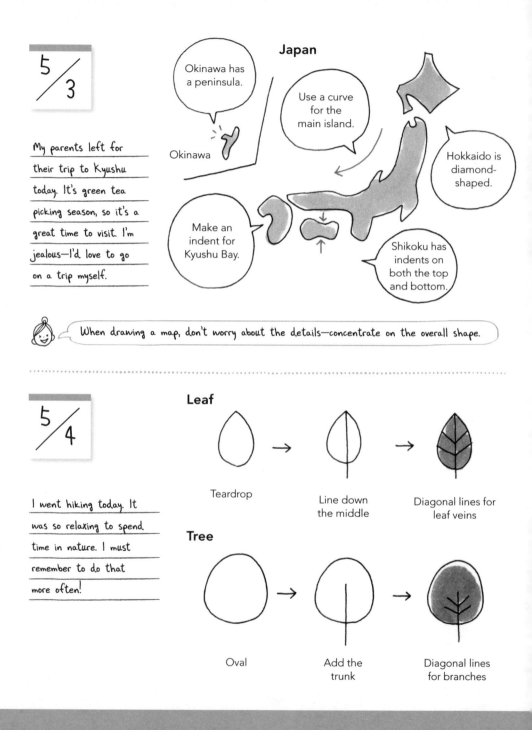

Japan

Okinawa has a peninsula.

Okinawa

Use a curve for the main island.

Hokkaido is diamond-shaped.

Make an indent for Kyushu Bay.

Shikoku has indents on both the top and bottom.

When drawing a map, don't worry about the details—concentrate on the overall shape.

5 / 4

I went hiking today. It was so relaxing to spend time in nature. I must remember to do that more often!

Leaf

Teardrop

Line down the middle

Diagonal lines for leaf veins

Tree

Oval

Add the trunk

Diagonal lines for branches

5 / 5

Today is Children's Day, a Japanese holiday celebrating the health and happiness of kids. Families with children fly fish flags called koinobori.

Koinobori Flags

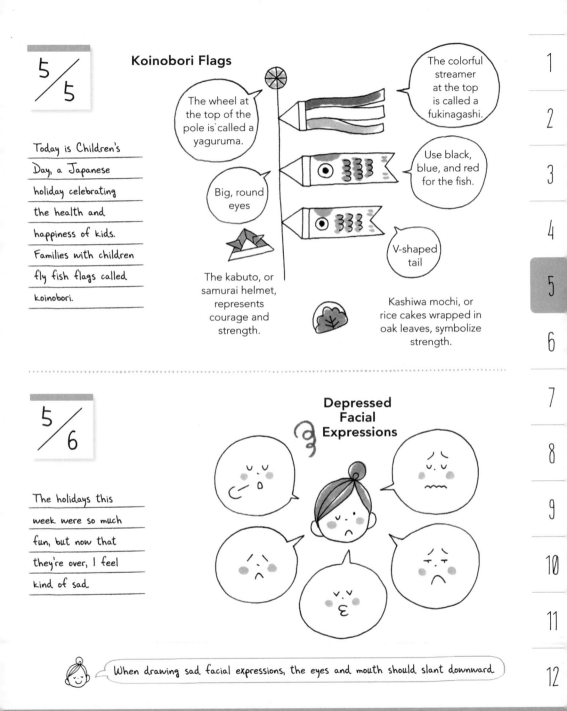

The wheel at the top of the pole is called a yaguruma.

The colorful streamer at the top is called a fukinagashi.

Big, round eyes

Use black, blue, and red for the fish.

V-shaped tail

The kabuto, or samurai helmet, represents courage and strength.

Kashiwa mochi, or rice cakes wrapped in oak leaves, symbolize strength.

5 / 6

The holidays this week were so much fun, but now that they're over, I feel kind of sad.

Depressed Facial Expressions

When drawing sad facial expressions, the eyes and mouth should slant downward

I found my old radio and brought it outside so I could listen to some music while enjoying the nice weather.

Radio

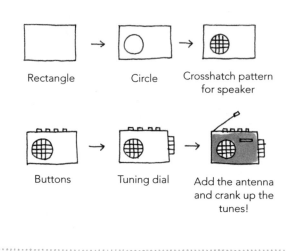

Rectangle

Circle

Crosshatch pattern for speaker

Buttons

Tuning dial

Add the antenna and crank up the tunes!

My dad was running late for work, so I ironed his shirt for him. He was so grateful.

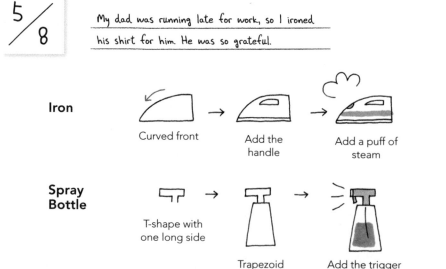

Iron

Curved front

Add the handle

Add a puff of steam

Spray Bottle

T-shape with one long side

Trapezoid for bottle

Add the trigger and the straw

5/9

The weather was crazy today—it was so sunny this morning, but poured this afternoon. My mom picked me up from the train station so I wouldn't have to walk home in the rain. I wonder what tomorrow will be like?

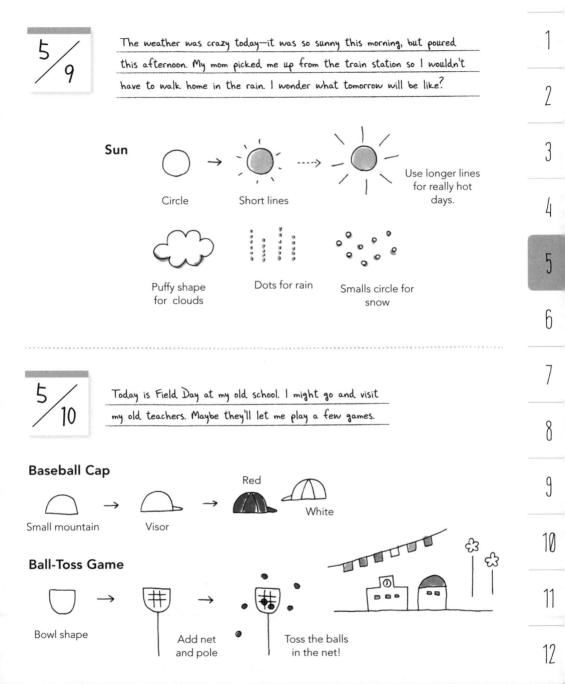

Sun

Circle → Short lines ----> Use longer lines for really hot days.

Puffy shape for clouds

Dots for rain

Smalls circle for snow

5/10

Today is Field Day at my old school. I might go and visit my old teachers. Maybe they'll let me play a few games.

Baseball Cap

Small mountain → Visor → Red / White

Ball-Toss Game

Bowl shape → Add net and pole → Toss the balls in the net!

1
2
3
4
5
6
7
8
9
10
11
12

89

5 / 11 A ladybug flew into my room through the open window. Spring has arrived!

Ladybug

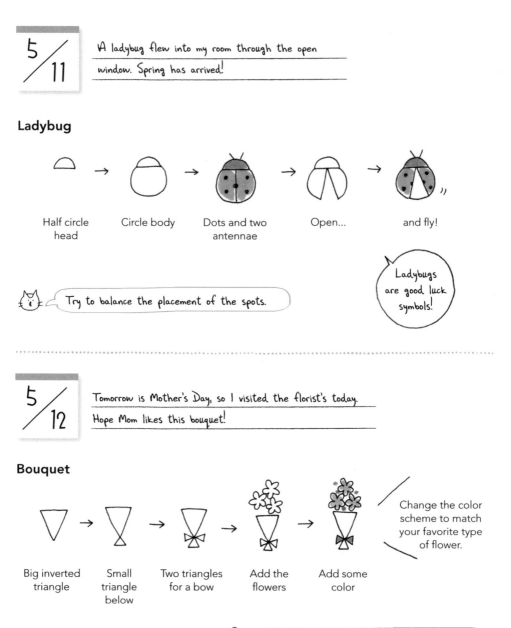

Half circle head

Circle body

Dots and two antennae

Open...

and fly!

Try to balance the placement of the spots.

Ladybugs are good luck symbols!

5 / 12 Tomorrow is Mother's Day, so I visited the florist's today. Hope Mom likes this bouquet!

Bouquet

Big inverted triangle

Small triangle below

Two triangles for a bow

Add the flowers

Add some color

Change the color scheme to match your favorite type of flower.

Don't worry about drawing the flower stems.

Mom loved the flowers so much she nearly cried! I made these little gift tags to go along with the bouquet.

THANKS MOM

mother's day

Gift tag

Carnation

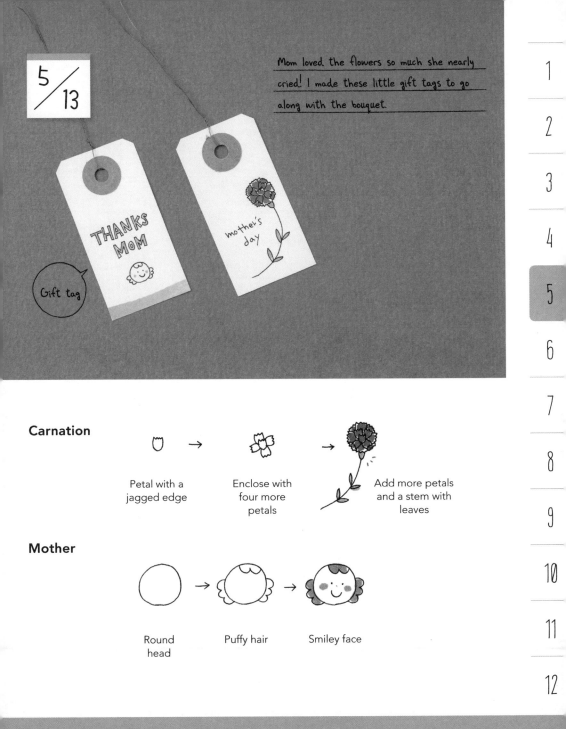

Petal with a jagged edge

Enclose with four more petals

Add more petals and a stem with leaves

Mother

Round head

Puffy hair

Smiley face

5/14

I found a four-leaf clover in the grass today! I hope it brings me luck!

Four-Leaf Clover

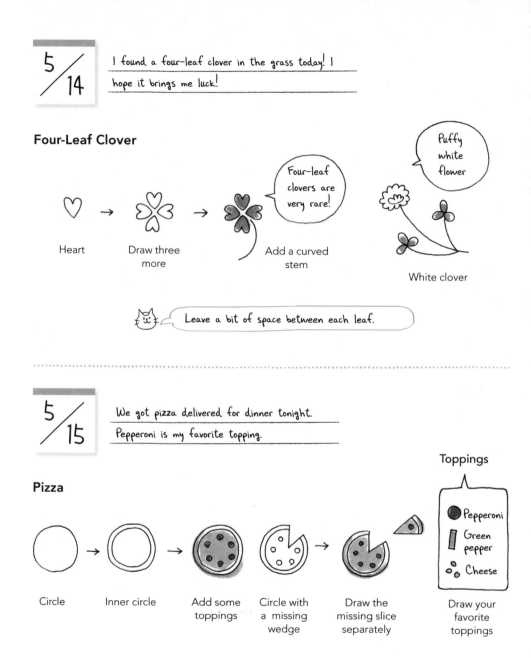

Heart → Draw three more → Add a curved stem

Four-leaf clovers are very rare!

Puffy white flower

White clover

Leave a bit of space between each leaf.

5/15

We got pizza delivered for dinner tonight. Pepperoni is my favorite topping.

Pizza

Toppings

Circle → Inner circle → Add some toppings → Circle with a missing wedge → Draw the missing slice separately

Draw your favorite toppings

Pepperoni
Green pepper
Cheese

5/16

I stopped by the bakery right before closing and everything was half price! I know what I'm having for breakfast tomorrow!

Croissant

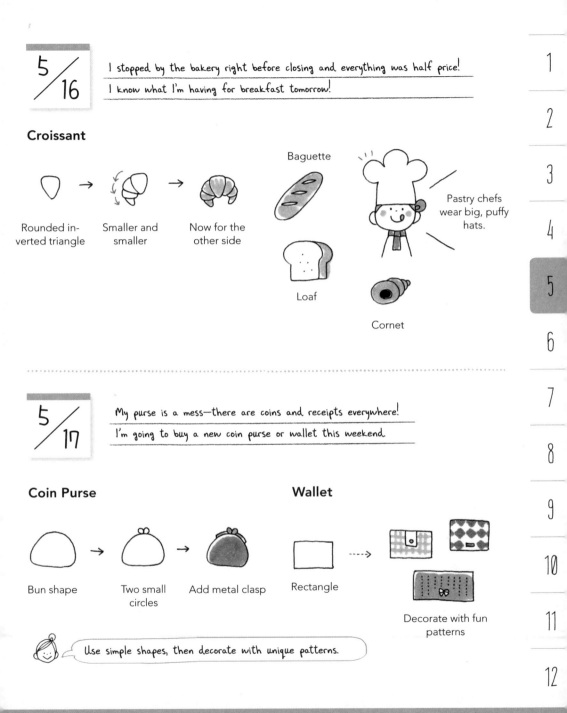

Rounded in-verted triangle

Smaller and smaller

Now for the other side

Baguette

Loaf

Cornet

Pastry chefs wear big, puffy hats.

5/17

My purse is a mess—there are coins and receipts everywhere! I'm going to buy a new coin purse or wallet this weekend.

Coin Purse

Wallet

Bun shape

Two small circles

Add metal clasp

Rectangle

Decorate with fun patterns

Use simple shapes, then decorate with unique patterns.

5/18	5/19	The whole family went clam digging this weekend. We found so many clams! Dinner is going to be delicious.

Rake

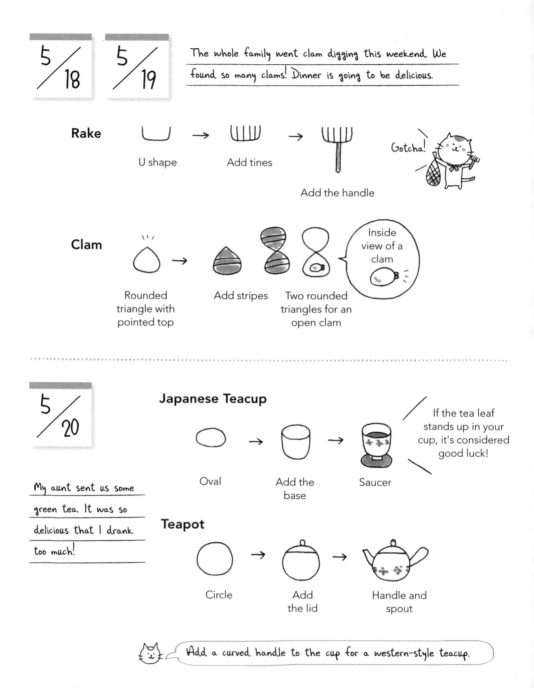

U shape → Add tines → Add the handle

Gotcha!

Clam

Rounded triangle with pointed top → Add stripes → Two rounded triangles for an open clam

Inside view of a clam

5/20

My aunt sent us some green tea. It was so delicious that I drank too much!

Japanese Teacup

Oval → Add the base → Saucer

If the tea leaf stands up in your cup, it's considered good luck!

Teapot

Circle → Add the lid → Handle and spout

Add a curved handle to the cup for a western-style teacup.

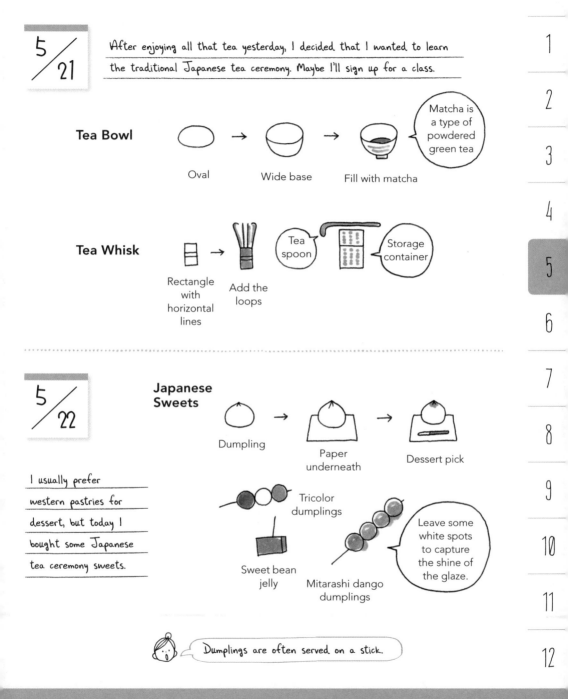

5 / 21

After enjoying all that tea yesterday, I decided that I wanted to learn the traditional Japanese tea ceremony. Maybe I'll sign up for a class.

Tea Bowl

Oval → Wide base → Fill with matcha

Matcha is a type of powdered green tea

Tea Whisk

Rectangle with horizontal lines → Add the loops

Tea spoon

Storage container

5 / 22

Japanese Sweets

Dumpling → Paper underneath → Dessert pick

I usually prefer western pastries for dessert, but today I bought some Japanese tea ceremony sweets.

Tricolor dumplings

Sweet bean jelly

Mitarashi dango dumplings

Leave some white spots to capture the shine of the glaze.

Dumplings are often served on a stick.

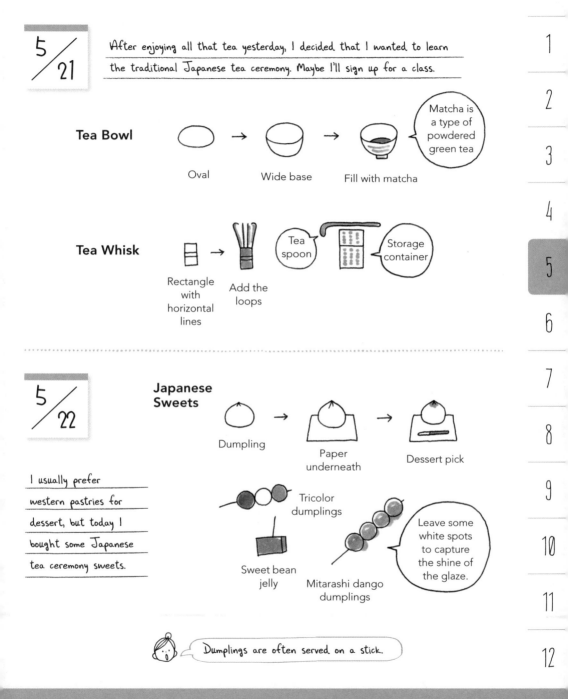

5 / 23

My graduation ceremony was today! I am very happy, but I'm also feeling sentimental...I'm going to miss school!

Diploma

Rectangle Add some text Add a gold frame

Graduation Cap

Diamond shape Add the base and a tassel

 It's OK if you don't have a gold marker, use a yellow one instead

5/24 5/25

The senior class party was this weekend. I made the invitations. The design was inspired by a ticket.

Party Invitation

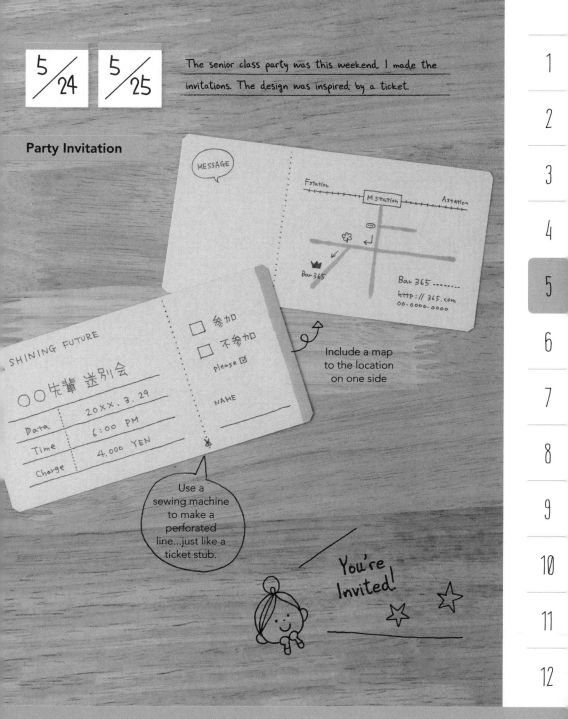

MESSAGE

Fstation —— M Station —— Astation

Bar 365

Bar 365 ·········
http://365.com
00-0000-0000

SHINING FUTURE

〇〇先輩 送別会

20XX. 3. 29

Data		20XX. 3. 29
Time		6:00 PM
Charge		4,000 YEN

☐ 参加
☐ 不参加
Please ☑

NAME

Include a map to the location on one side

Use a sewing machine to make a perforated line...just like a ticket stub.

You're Invited!

5/26 I went to the pool and swam laps for exercise. It's been a while, but my time for the 25 meter wasn't terrible.

Swimming

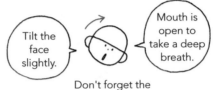

Tilt the face slightly.

Mouth is open to take a deep breath.

Don't forget the swim cap!

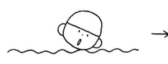

Wavy line for water Arm extends over the head

Kickboard

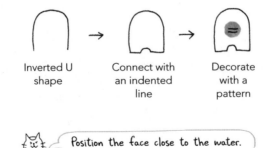

Inverted U shape

Connect with an indented line

Decorate with a pattern

Position the face close to the water.

5 / 27

It felt so good to exercise yesterday that I decided to go for a run today. I slept really well after working out two days in a row.

Running

Point her nose in the directions she's running

Pay attention to the center of gravity

Arms bent at the elbows

Extend the right arm and left leg forward

On the next stride, she'll extend her left arm and right leg forward.

Most people run with their hands closed in a fist.

1

2

3

4

5

6

7

8

9

10

11

12

5 / 28

We're going camping this weekend! I dug the tent and some other equipment out of the storage room. What else do I need to pack?

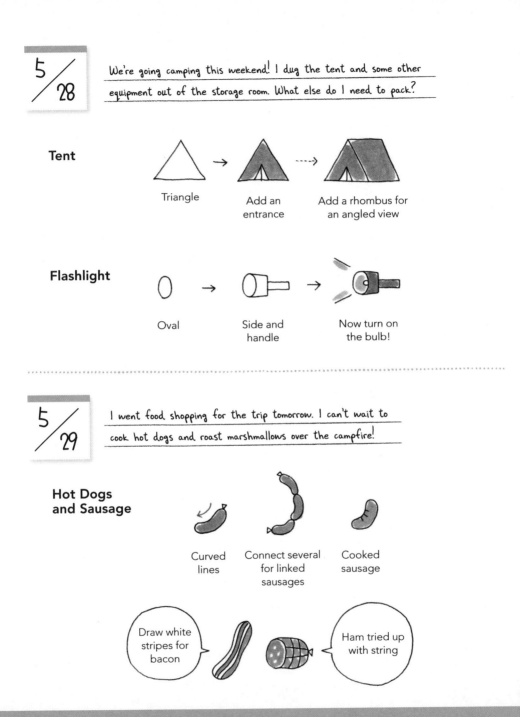

Tent

Triangle

Add an entrance

Add a rhombus for an angled view

Flashlight

Oval

Side and handle

Now turn on the bulb!

5 / 29

I went food shopping for the trip tomorrow. I can't wait to cook hot dogs and roast marshmallows over the campfire!

Hot Dogs and Sausage

Curved lines

Connect several for linked sausages

Cooked sausage

Draw white stripes for bacon

Ham tried up with string

5/30 **5/31** I had so much fun camping! It was a lot of work to cook food over the fire, but everything tasted delicious!

Compass

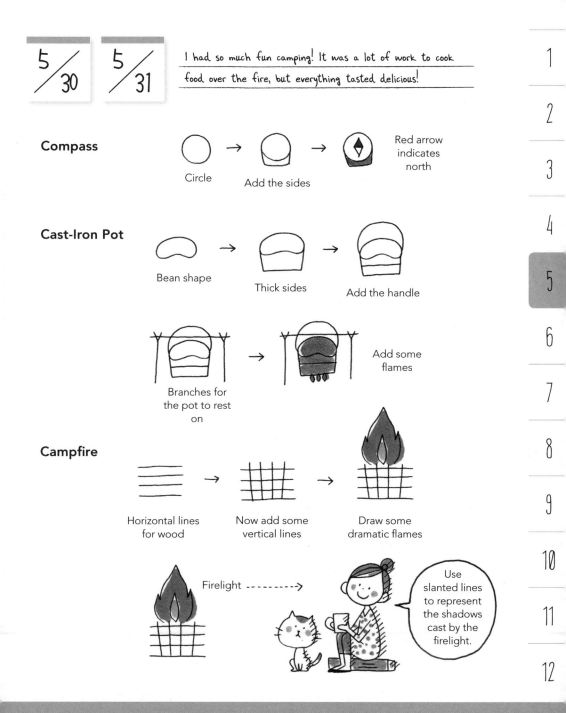

Circle → Add the sides → Red arrow indicates north

Cast-Iron Pot

Bean shape → Thick sides → Add the handle

Branches for the pot to rest on → Add some flames

Campfire

Horizontal lines for wood → Now add some vertical lines → Draw some dramatic flames

Firelight ------->

Use slanted lines to represent the shadows cast by the firelight.

June

6 / 1

I went shopping today for some new summer clothes.

The stores had so many pretty sundresses.

Summer Clothes

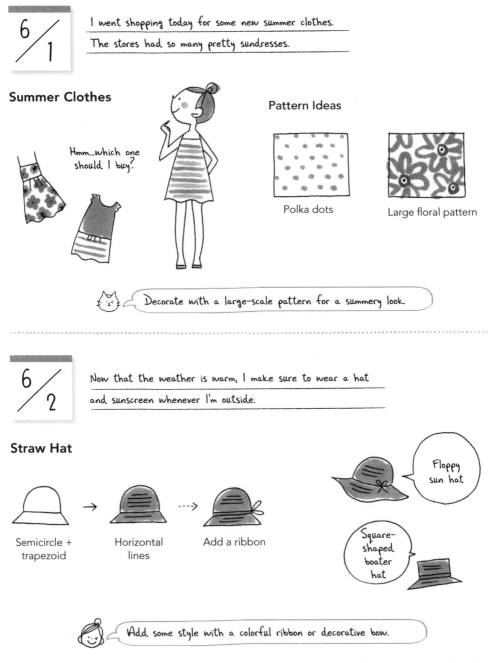

Hmm...which one should I buy?

Pattern Ideas

Polka dots

Large floral pattern

Decorate with a large-scale pattern for a summery look.

6 / 2

Now that the weather is warm, I make sure to wear a hat

and sunscreen whenever I'm outside.

Straw Hat

Semicircle + trapezoid

Horizontal lines

Add a ribbon

Floppy sun hat

Square-shaped boater hat

Add some style with a colorful ribbon or decorative bow.

6/3

I purchased another straw purse. Why do I keep buying the same style year after year?

Straw Purse

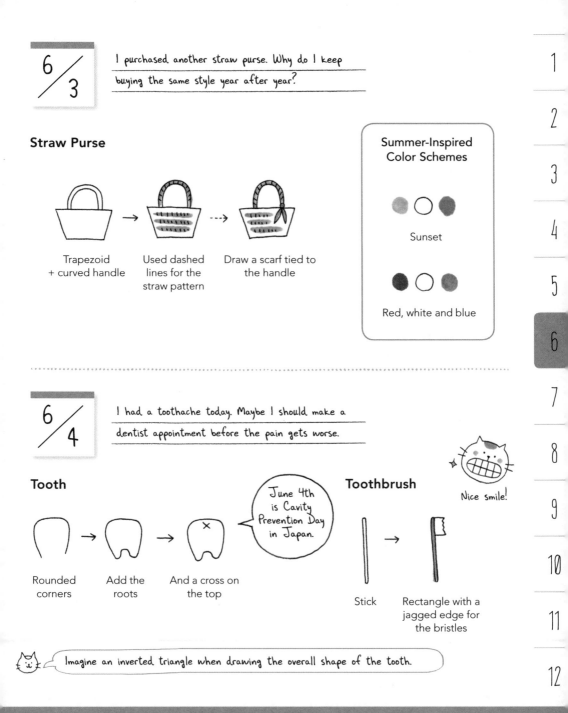

Trapezoid + curved handle

Used dashed lines for the straw pattern

Draw a scarf tied to the handle

Summer-Inspired Color Schemes

Sunset

Red, white and blue

6/4

I had a toothache today. Maybe I should make a dentist appointment before the pain gets worse.

Tooth

Rounded corners

Add the roots

And a cross on the top

June 4th is Cavity Prevention Day in Japan.

Toothbrush

Nice smile!

Stick

Rectangle with a jagged edge for the bristles

Imagine an inverted triangle when drawing the overall shape of the tooth.

6/5 Motorbike

My friend just got her motorbike license. I can't wait to go for a ride!

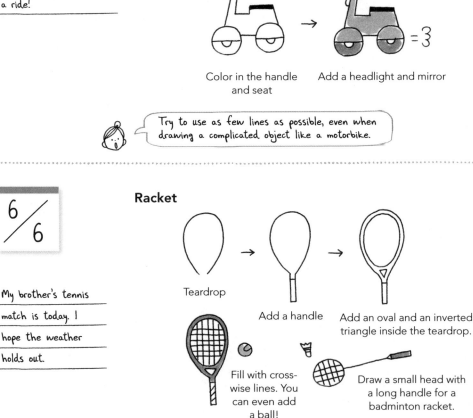

Two tires

Use straight lines

Color in the handle and seat

Add a headlight and mirror

Try to use as few lines as possible, even when drawing a complicated object like a motorbike.

6/6 Racket

My brother's tennis match is today. I hope the weather holds out.

Teardrop

Add a handle

Add an oval and an inverted triangle inside the teardrop.

Fill with cross-wise lines. You can even add a ball!

Draw a small head with a long handle for a badminton racket.

Keep it simple—don't use too many lines when drawing the strings.

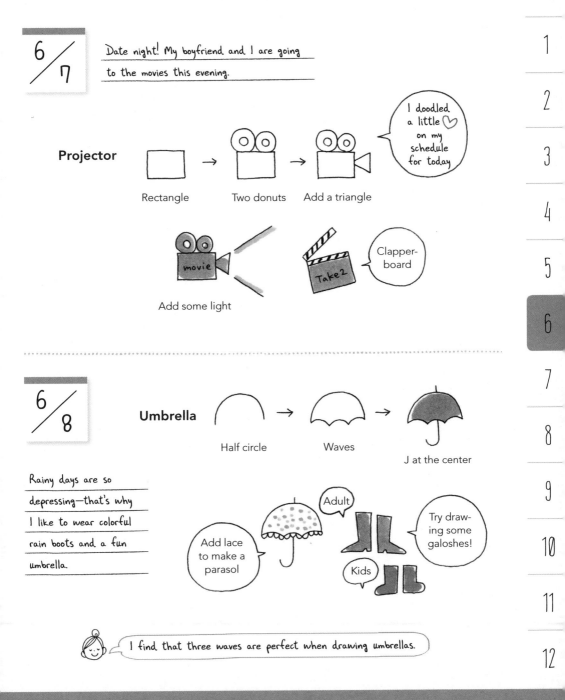

6 / 7 Date night! My boyfriend and I are going to the movies this evening.

Projector

Rectangle → Two donuts → Add a triangle

I doodled a little ♡ on my schedule for today

Add some light

Clapper-board

movie

Take 2

6 / 8 **Umbrella**

Half circle → Waves → J at the center

Rainy days are so depressing—that's why I like to wear colorful rain boots and a fun umbrella.

Add lace to make a parasol

Adult

Try drawing some galoshes!

Kids

I find that three waves are perfect when drawing umbrellas.

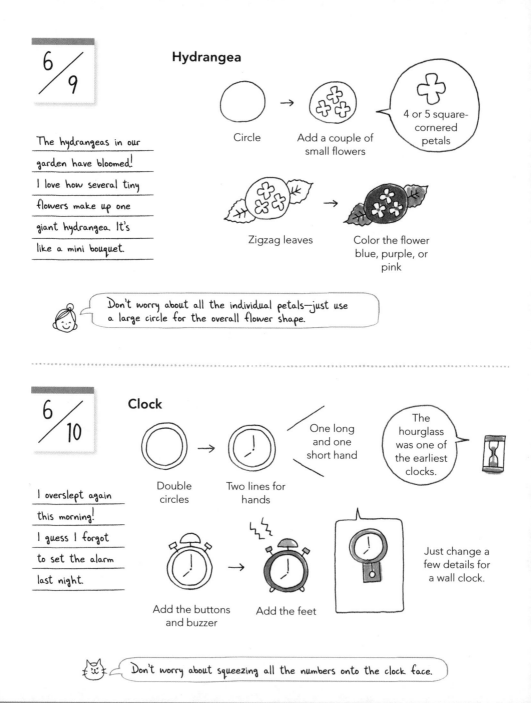

6 / 9

Hydrangea

The hydrangeas in our garden have bloomed! I love how several tiny flowers make up one giant hydrangea. It's like a mini bouquet.

Circle

Add a couple of small flowers

4 or 5 square-cornered petals

Zigzag leaves

Color the flower blue, purple, or pink

Don't worry about all the individual petals—just use a large circle for the overall flower shape.

6 / 10

Clock

I overslept again this morning! I guess I forgot to set the alarm last night.

Double circles

Two lines for hands

One long and one short hand

The hourglass was one of the earliest clocks.

Add the buttons and buzzer

Add the feet

Just change a few details for a wall clock.

Don't worry about squeezing all the numbers onto the clock face.

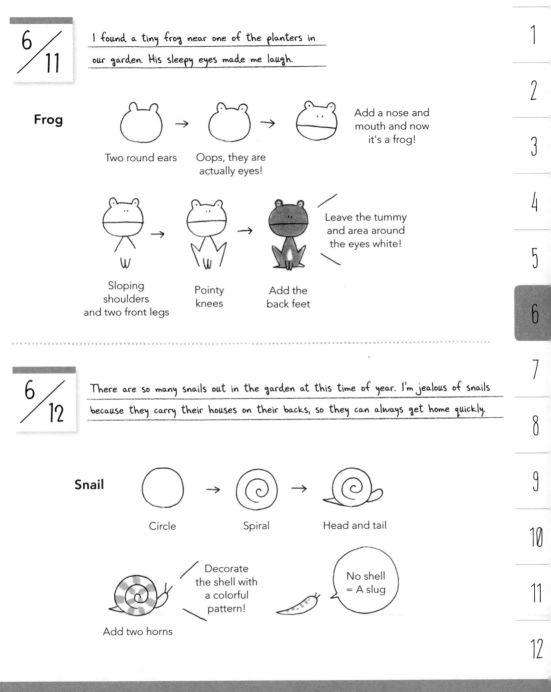

Frog

6/11

I found a tiny frog near one of the planters in our garden. His sleepy eyes made me laugh.

Two round ears

Oops, they are actually eyes!

Add a nose and mouth and now it's a frog!

Sloping shoulders and two front legs

Pointy knees

Add the back feet

Leave the tummy and area around the eyes white!

6/12

There are so many snails out in the garden at this time of year. I'm jealous of snails because they carry their houses on their backs, so they can always get home quickly.

Snail

Circle

Spiral

Head and tail

Add two horns

Decorate the shell with a colorful pattern!

No shell = A slug

It rained all weekend, so I spent a lot of time drawing. I made some envelopes out of origami paper and put my favorite illustrations inside. I'll give these little cards to my friends.

Flower

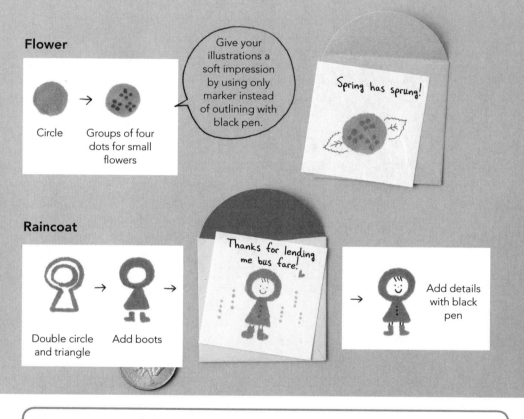

Circle

Groups of four dots for small flowers

Give your illustrations a soft impression by using only marker instead of outlining with black pen.

Spring has sprung!

Raincoat

Double circle and triangle

Add boots

Thanks for lending me bus fare!

Add details with black pen

How to Make an Envelope

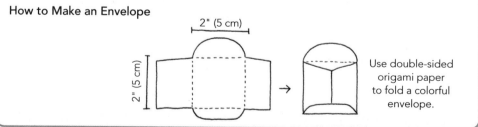

2" (5 cm)

2" (5 cm)

Use double-sided origami paper to fold a colorful envelope.

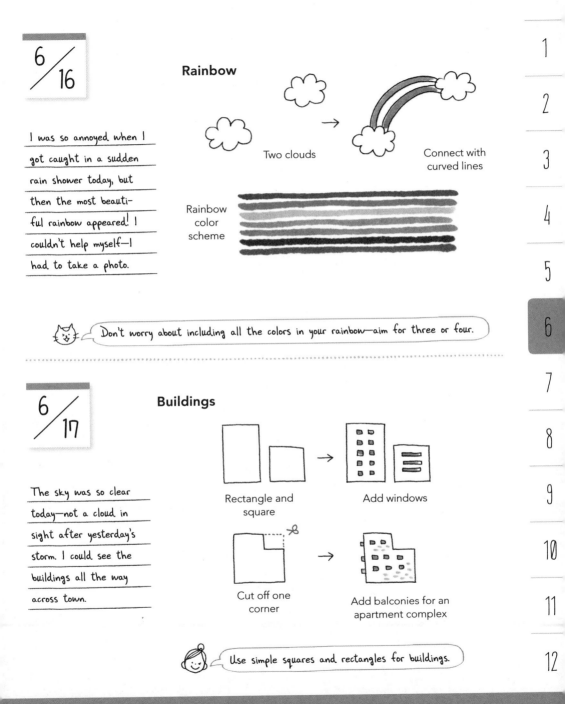

6/16 Rainbow

I was so annoyed when I got caught in a sudden rain shower today, but then the most beauti- ful rainbow appeared! I couldn't help myself—I had to take a photo.

Two clouds

Connect with curved lines

Rainbow color scheme

Don't worry about including all the colors in your rainbow—aim for three or four.

6/17 Buildings

The sky was so clear today—not a cloud in sight after yesterday's storm. I could see the buildings all the way across town.

Rectangle and square

Add windows

Cut off one corner

Add balconies for an apartment complex

Use simple squares and rectangles for buildings.

Today is Father's Day!
I got my dad a tie.
Hope he likes it!

Tie

 → →

Position the stripes at different angles on the top and bottom.

Inverted triangle

Long diamond shape

Add a pattern

Father

 →

Square-ish head

Short hair

Smiling face

Make your dad a tie-shaped card!

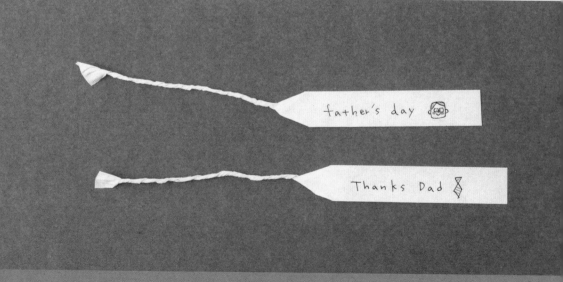

There are so many pretty birds around at this time of year.

I saw a group of swallows when I looked out the window earlier.

Swallow

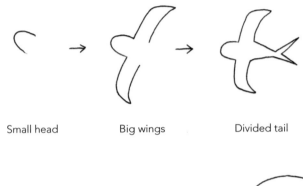

Small head Big wings Divided tail

 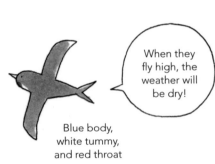

Beak and eyes

Blue body, white tummy, and red throat

When they fly high, the weather will be dry!

Taxi

I went out with
friends last night
and had so much fun
that I missed the last
train home. I ended
up having to pay for
a taxi.

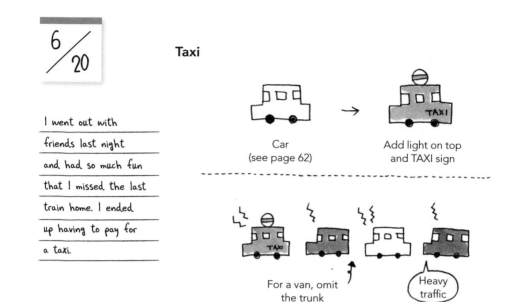

Car
(see page 62)

Add light on top
and TAXI sign

For a van, omit
the trunk

Heavy
traffic

Gecko

There was a gecko
outside my window
today. I was kind of
scared at first, but
when I looked closer,
I realized it was kind
of cute.

5 fingers

Excellent
climber

Tongue
sticking out
of mouth

Long tail

Brown
color

Gecko

Newt

Newts have a
red tummy.

Today is the summer solstice, which means it's the longest day of the year. I didn't need to turn the lights on until 8 o'clock at night!

Light Bulb

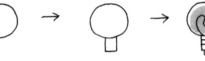

Circle Rectangle Spiral wire

You can also draw a
light bulb hanging
from the ceiling.

Use a light bulb to indicate when
someone has a good idea.

6/23

I need to find something to wear to my friend's wedding this weekend. I want to look stylish.

Party Dresses

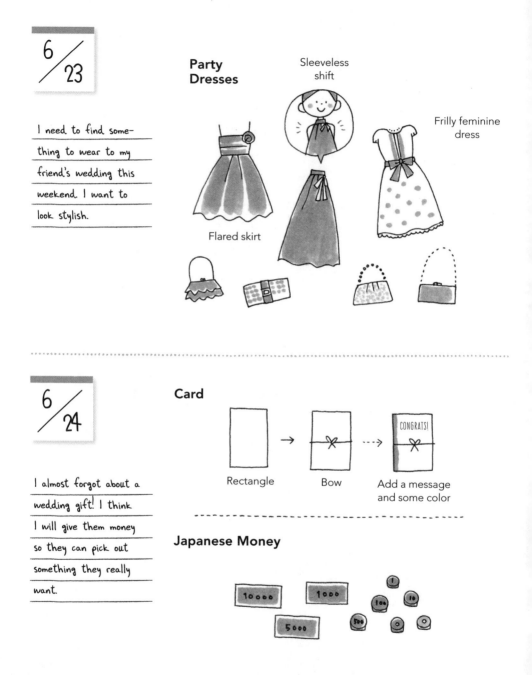

Sleeveless shift

Frilly feminine dress

Flared skirt

6/24

I almost forgot about a wedding gift! I think I will give them money so they can pick out something they really want.

Card

Rectangle → Bow --→ Add a message and some color

CONGRATS!

Japanese Money

10 000 1 000 1

5 000 100 10 500 50 5

Wedding Ceremony

The wedding was so beautiful! All the women loved my friend's dress. I wonder what my own wedding dress will be like?

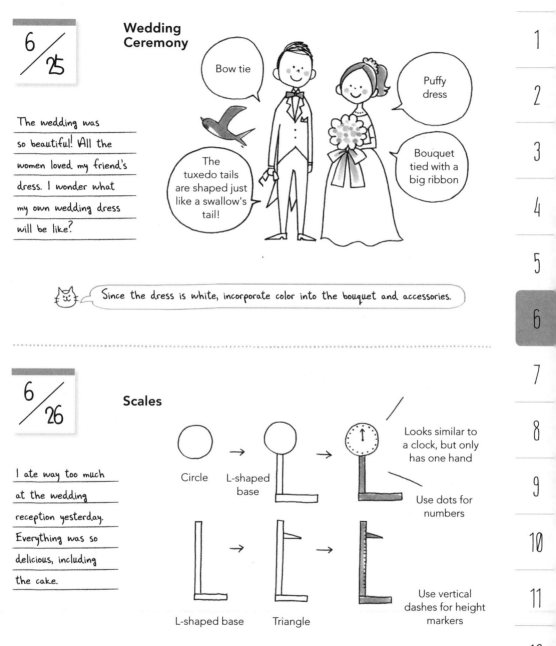

Bow tie

Puffy dress

The tuxedo tails are shaped just like a swallow's tail!

Bouquet tied with a big ribbon

Since the dress is white, incorporate color into the bouquet and accessories.

6 / 26

Scales

I ate way too much at the wedding reception yesterday. Everything was so delicious, including the cake.

Circle

L-shaped base

Looks similar to a clock, but only has one hand

Use dots for numbers

L-shaped base

Triangle

Use vertical dashes for height markers

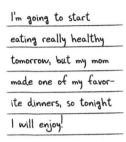

6 / 27

I'm going to start
eating really healthy
tomorrow, but my mom
made one of my favor-
ite dinners, so tonight
I will enjoy!

Salisbury Steak

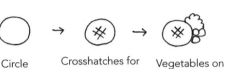

Circle

Crosshatches for
grill marks

Vegetables on
the side

Large circle for plate

Fork, knife, and
napkin

Decorate the plate to add a special detail to your drawing.

6 / 28

I ate a big fruit
salad for breakfast
this morning! It was
so delicious...maybe
this diet won't be so
hard after all.

Pineapple

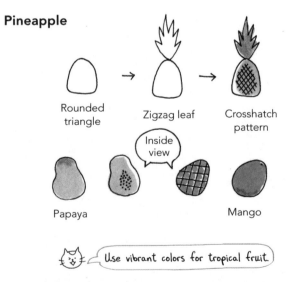

Rounded
triangle

Zigzag leaf

Crosshatch
pattern

Papaya

Inside
view

Mango

Use vibrant colors for tropical fruit.

6 / 29

I saw my favorite band in concert last night. They were so good live!

Drums

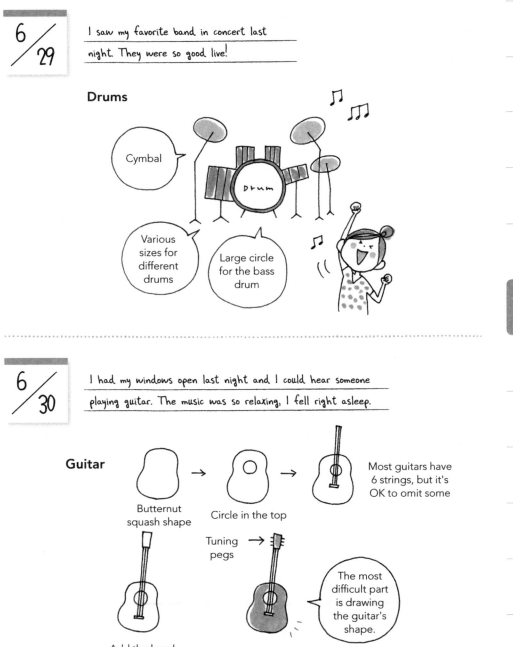

Cymbal

Various sizes for different drums

Large circle for the bass drum

Drum

6 / 30

I had my windows open last night and I could hear someone playing guitar. The music was so relaxing, I fell right asleep.

Guitar

Butternut squash shape

Circle in the top

Most guitars have 6 strings, but it's OK to omit some

Add the head

Tuning pegs

The most difficult part is drawing the guitar's shape.

COLORING TECHNIQUES

Neat & Tidy For smart looking drawings, stay inside the lines when coloring. Don't worry if you miss a spot—you can always go back and fill it in later.

 → 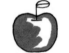 → →

Outline with
black pen

Add color just
inside the outline

Fill the inside before
the outline dries

You're
finished!

Artistic For an artistic look, don't worry about coloring inside the lines so much. Personally, I prefer this method, as you can see throughout this book.

 → → →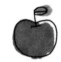

A little here...

but not here

Outline with
black pen

Imagine where
you want to add
color

Add color,
making your
strokes in the
same direction

Leave white
spots for shiny
accents

This technique may look easy, but it's important to make a plan before you start coloring. Otherwise, your drawing will look sloppy.

Let's start coloring without drawing an outline first. This technique will provide your illustrations with a soft impression. You can use a black pen to go back and add details later.

Circle Stem

Small circles Stem and vine

Circle and Face and
triangles whiskers

Just make
sure the marker
is dry before you
add details with
a pen.

SUMMER

July
August
September

Ahh!

July

7 / 1

Summer is finally here in full swing! I can't wait to go hiking and spend some time out on the water.

Lake

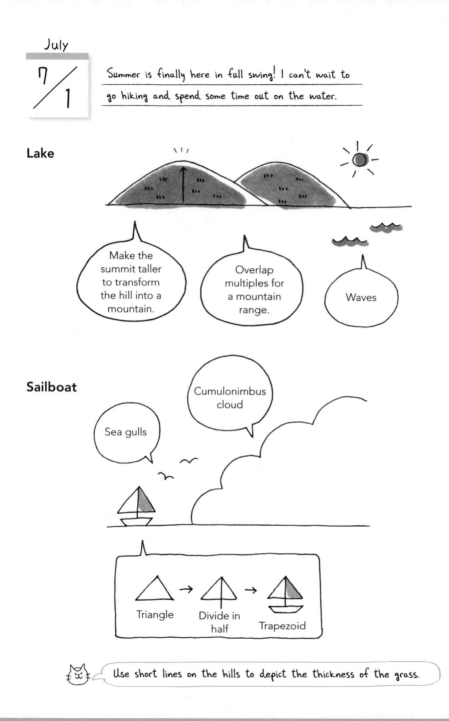

Make the summit taller to transform the hill into a mountain.

Overlap multiples for a mountain range.

Waves

Sailboat

Cumulonimbus cloud

Sea gulls

Triangle → Divide in half → Trapezoid

Use short lines on the hills to depict the thickness of the grass.

7 / 2

I'd love to climb up to the top of Mt. Fuji one day and watch the sunrise.

Mt. Fuji

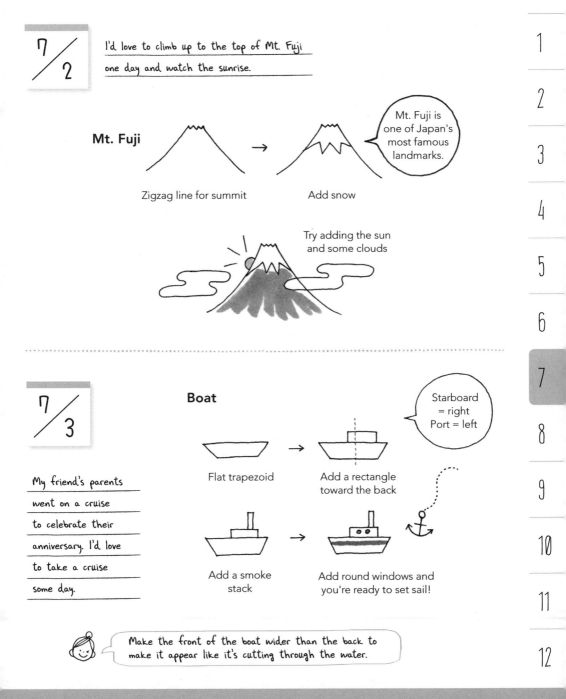

Zigzag line for summit

Add snow

Mt. Fuji is one of Japan's most famous landmarks.

Try adding the sun and some clouds

7 / 3

My friend's parents went on a cruise to celebrate their anniversary. I'd love to take a cruise some day.

Boat

Starboard = right
Port = left

Flat trapezoid

Add a rectangle toward the back

Add a smoke stack

Add round windows and you're ready to set sail!

Make the front of the boat wider than the back to make it appear like it's cutting through the water.

7 / 4

I couldn't handle the heat anymore, so I pulled the fan out of the closet. Much better!

Fan

Double circles

Radial spokes

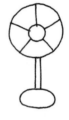

Add a long neck and base

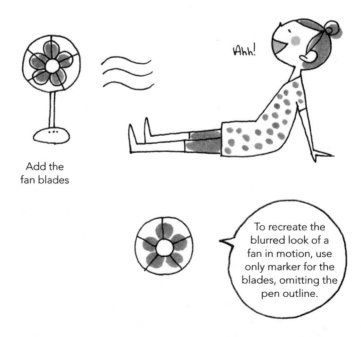

Add the fan blades

Ahh!

To recreate the blurred look of a fan in motion, use only marker for the blades, omitting the pen outline.

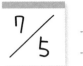

This heat wave is crazy! The fan wasn't cutting it anymore, so I turned on the air conditioner.

Air Conditioner

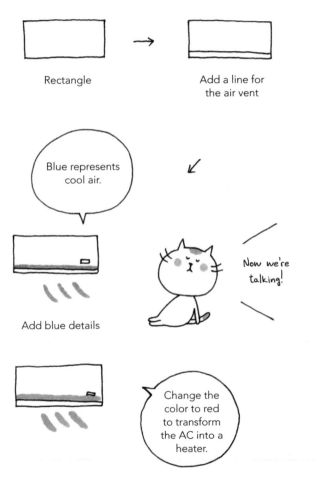

Rectangle

Add a line for the air vent

Blue represents cool air.

Add blue details

Now we're talking!

Change the color to red to transform the AC into a heater.

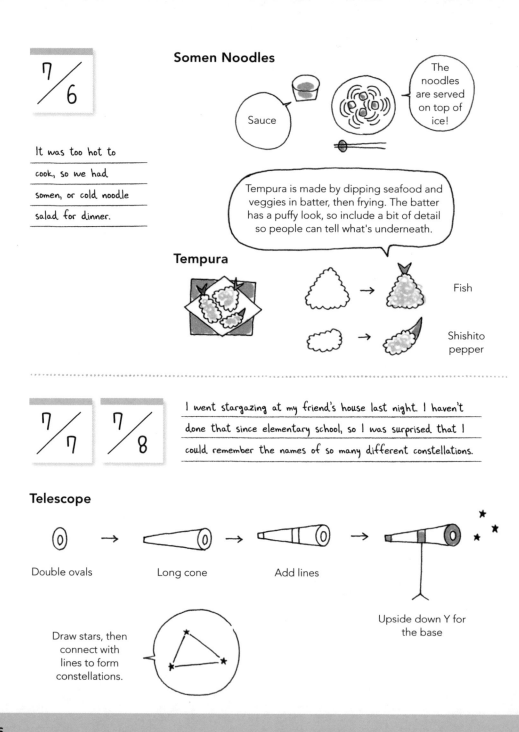

Somen Noodles

Sauce

The noodles are served on top of ice!

It was too hot to cook, so we had somen, or cold noodle salad for dinner.

Tempura is made by dipping seafood and veggies in batter, then frying. The batter has a puffy look, so include a bit of detail so people can tell what's underneath.

Tempura

Fish

Shishito pepper

I went stargazing at my friend's house last night. I haven't done that since elementary school, so I was surprised that I could remember the names of so many different constellations.

Telescope

Double ovals

Long cone

Add lines

Upside down Y for the base

Draw stars, then connect with lines to form constellations.

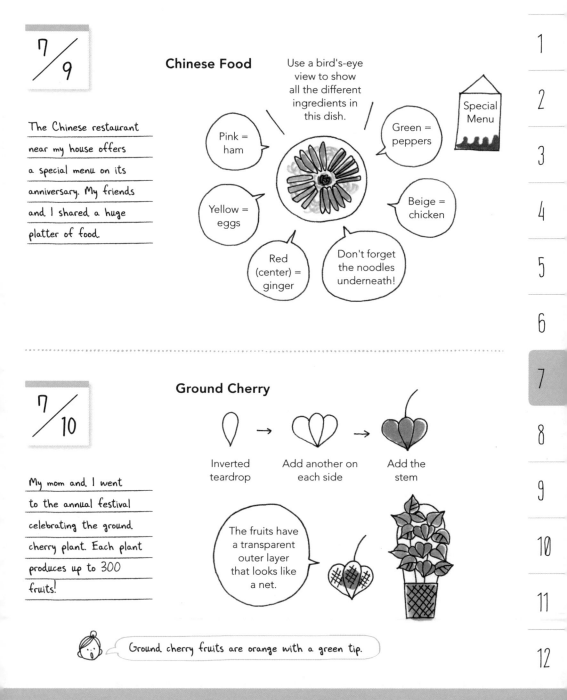

Chinese Food

7/9

The Chinese restaurant near my house offers a special menu on its anniversary. My friends and I shared a huge platter of food.

Use a bird's-eye view to show all the different ingredients in this dish.

Pink = ham

Green = peppers

Special Menu

Yellow = eggs

Beige = chicken

Red (center) = ginger

Don't forget the noodles underneath!

Ground Cherry

7/10

My mom and I went to the annual festival celebrating the ground cherry plant. Each plant produces up to 300 fruits!

Inverted teardrop

Add another on each side

Add the stem

The fruits have a transparent outer layer that looks like a net.

Ground cherry fruits are orange with a green tip.

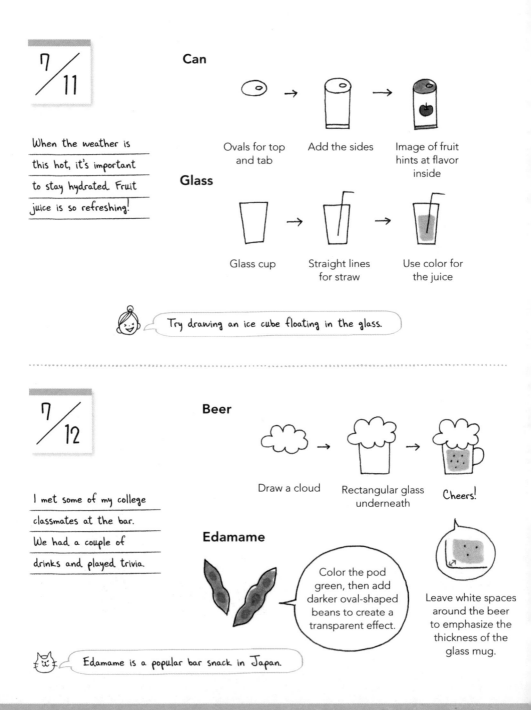

7 / 11

When the weather is this hot, it's important to stay hydrated. Fruit juice is so refreshing!

Can

Ovals for top and tab

Add the sides

Image of fruit hints at flavor inside

Glass

Glass cup

Straight lines for straw

Use color for the juice

Try drawing an ice cube floating in the glass.

7 / 12

I met some of my college classmates at the bar. We had a couple of drinks and played trivia.

Beer

Draw a cloud

Rectangular glass underneath

Cheers!

Edamame

Color the pod green, then add darker oval-shaped beans to create a transparent effect.

Leave white spaces around the beer to emphasize the thickness of the glass mug.

Edamame is a popular bar snack in Japan.

7/13

My father, little brother, and I went to the baseball game tonight. Our team ended up winning with a walk-off home run!

Baseball Bat

Thick / Thin

Tapered cylinder → Round end → Play ball!

Baseball Glove

Draw a big thumb → Add 4 fingers → Use dotted lines for the seams

7/14 **7/15**

I finally wrote thank you notes to everyone who gave me graduation presents. I decorated the notes with summer-themed illustrations.

THANK YOU!

THANK YOU!

I hope you've had a great summer so far! Thanks so much for coming to my party!

Love,
Kamo

Thank You Notes

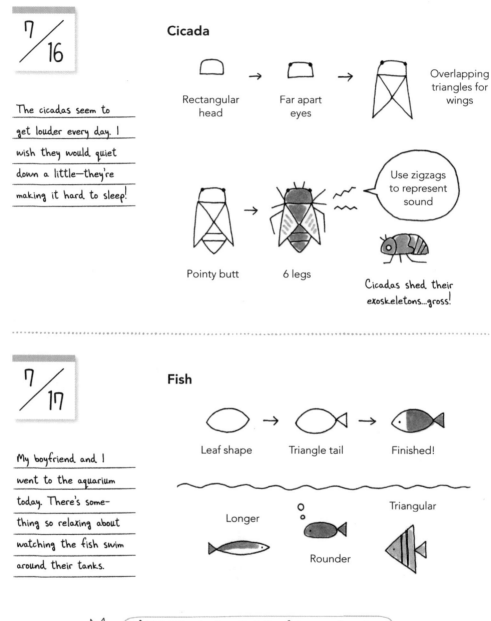

7/16

The cicadas seem to get louder every day. I wish they would quiet down a little—they're making it hard to sleep!

Cicada

Rectangular head

Far apart eyes

Overlapping triangles for wings

Pointy butt

6 legs

Use zigzags to represent sound

Cicadas shed their exoskeletons...gross!

7/17

My boyfriend and I went to the aquarium today. There's something so relaxing about watching the fish swim around their tanks.

Fish

Leaf shape

Triangle tail

Finished!

Longer

Rounder

Triangular

Add bubbles to show that the fish are underwater.

School Uniform

My little cousin
got her new school
uniform for the fall.
She looks so cute!

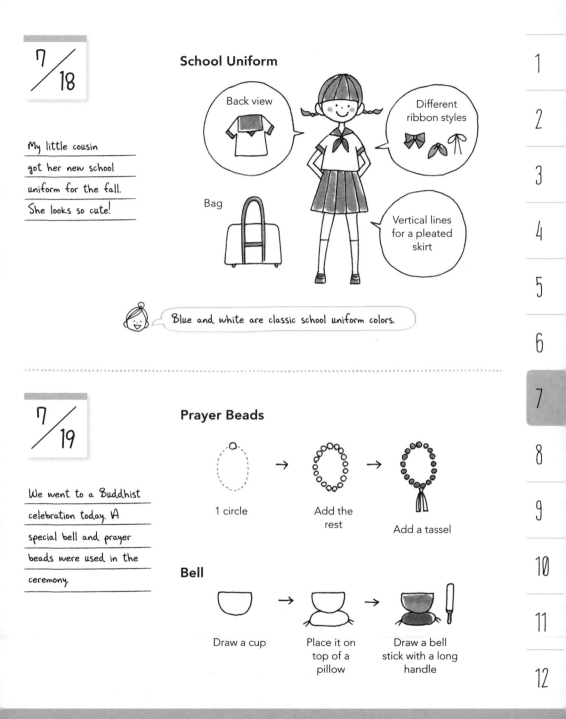

Back view

Different
ribbon styles

Bag

Vertical lines
for a pleated
skirt

Blue and white are classic school uniform colors.

7 / 19

Prayer Beads

We went to a Buddhist
celebration today. A
special bell and prayer
beads were used in the
ceremony.

1 circle

Add the
rest

Add a tassel

Bell

Draw a cup

Place it on
top of a
pillow

Draw a bell
stick with a long
handle

1

2

3

4

5

6

7

8

9

10

11

12

7 / 20

Since visiting the aquarium last week, I've become interested in marine biology. I watched a great documentary about the ocean.

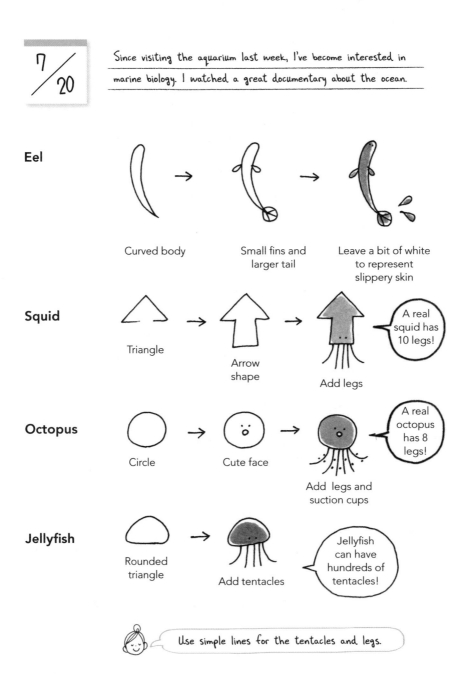

Eel

Curved body → Small fins and larger tail → Leave a bit of white to represent slippery skin

Squid

Triangle → Arrow shape → Add legs

A real squid has 10 legs!

Octopus

Circle → Cute face → Add legs and suction cups

A real octopus has 8 legs!

Jellyfish

Rounded triangle → Add tentacles

Jellyfish can have hundreds of tentacles!

Use simple lines for the tentacles and legs.

7 / 21

My friend and I went out to lunch today. I tried this new hamburger that they've been advertising on TV. It was delicious!

Hamburger

 →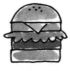

Burger patty
Cheese
Lettuce
Tomato

Semicircle +
rectangle

Add the fillings

7 / 22

After going out to lunch yesterday, I was inspired to invent my own sandwich. It was pretty good if I do say so myself!

Sandwich

△] →

Lettuce
Mustard
Ham

Triangle +
bracket

Add the fillings

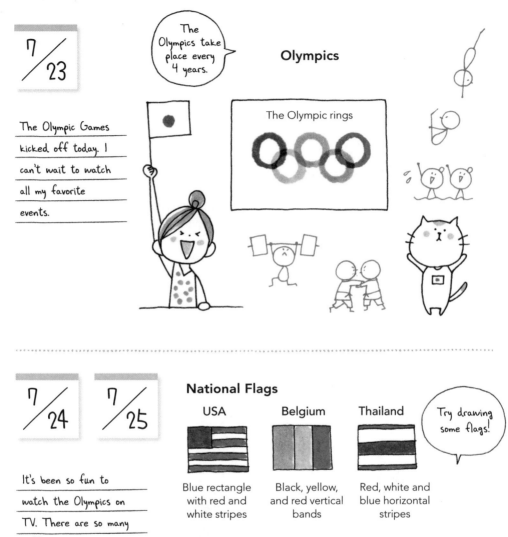

7/23

> The Olympics take place every 4 years.

Olympics

The Olympic Games kicked off today. I can't wait to watch all my favorite events.

The Olympic rings

7/24 7/25

It's been so fun to watch the Olympics on TV. There are so many different countries represented.

National Flags

> Try drawing some flags!

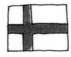

USA

Blue rectangle with red and white stripes

Belgium

Black, yellow, and red vertical bands

Thailand

Red, white and blue horizontal stripes

Finland

Blue cross on a white background

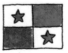

Panama

Four rectangles with red and blue stars

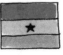

Ghana

Red, yellow, and green stripes with a black star

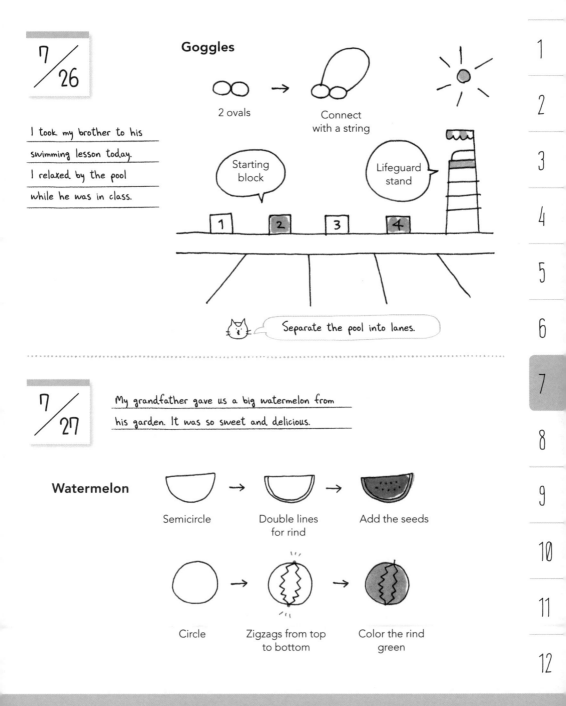

7/26

I took my brother to his
swimming lesson today.
I relaxed by the pool
while he was in class.

Goggles

2 ovals

Connect
with a string

Starting
block

Lifeguard
stand

1 2 3 4

Separate the pool into lanes.

7/27

My grandfather gave us a big watermelon from
his garden. It was so sweet and delicious.

Watermelon

Semicircle

Double lines
for rind

Add the seeds

Circle

Zigzags from top
to bottom

Color the rind
green

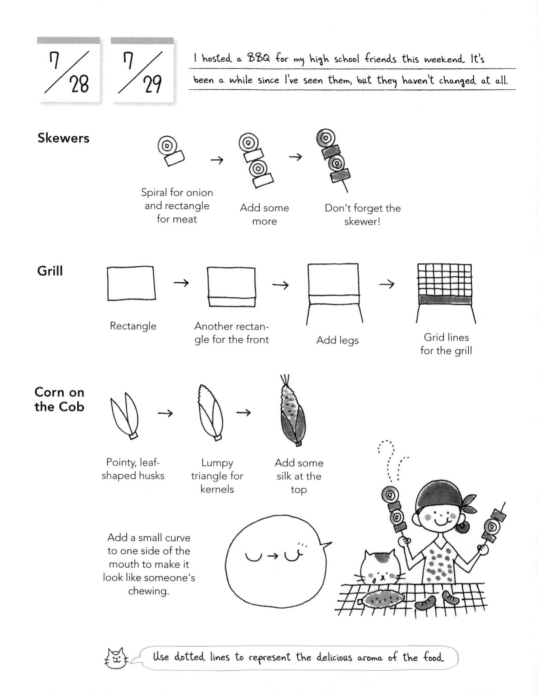

| 7/28 | 7/29 | I hosted a BBQ for my high school friends this weekend. It's been a while since I've seen them, but they haven't changed at all. |

Skewers

Spiral for onion and rectangle for meat → Add some more → Don't forget the skewer!

Grill

Rectangle → Another rectangle for the front → Add legs → Grid lines for the grill

Corn on the Cob

Pointy, leaf-shaped husks → Lumpy triangle for kernels → Add some silk at the top

Add a small curve to one side of the mouth to make it look like someone's chewing.

∪ → ◡

Use dotted lines to represent the delicious aroma of the food.

7 / 30

I got so many mosquito bites at the BBQ. They're so itchy! I need to go buy some calamine lotion.

Mosquito

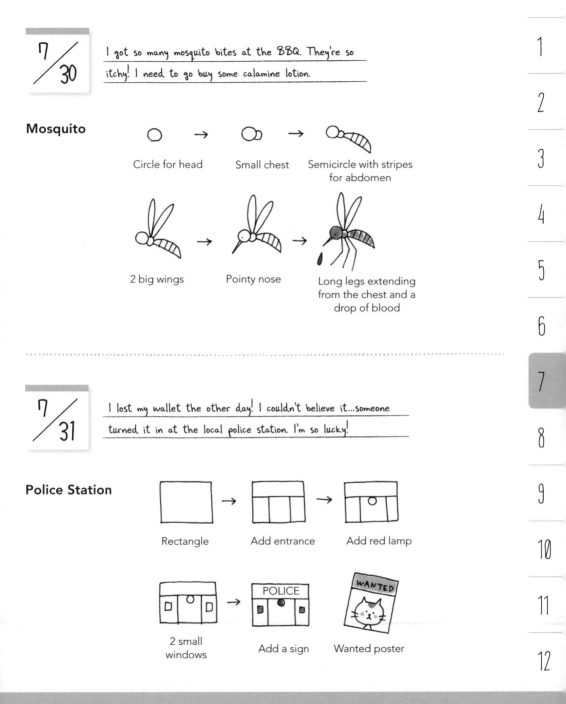

Circle for head

Small chest

Semicircle with stripes for abdomen

2 big wings

Pointy nose

Long legs extending from the chest and a drop of blood

7 / 31

I lost my wallet the other day! I couldn't believe it...someone turned it in at the local police station. I'm so lucky!

Police Station

Rectangle

Add entrance

Add red lamp

2 small windows

Add a sign

Wanted poster

August

8 / 1

I walked by an old house that we used to say was haunted. Now I can't stop thinking about ghosts!

Ghost

| Inverted teardrop shape | Add the face | Add hands and a hat |

8 / 2

Lotus

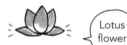

| Teardrop | Add one on each side | Add a horizontal petal on each side |

Lotus flower

The pond at the local park is full of beautiful lotus flowers in bloom. I sat on the bench and practiced drawing them. It was so relaxing!

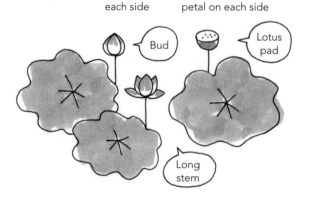

Bud

Lotus pad

Long stem

8 / 3

I love the noise that crickets make at night. It's kind of relaxing when I'm trying to fall asleep.

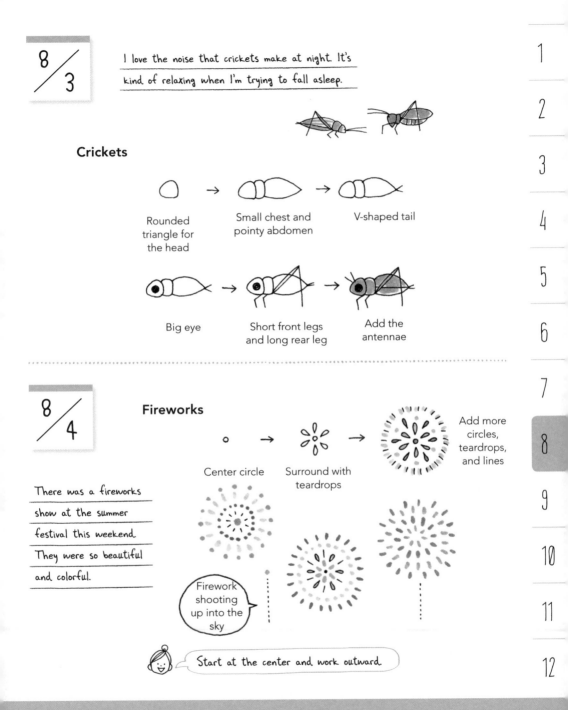

Crickets

Rounded triangle for the head

Small chest and pointy abdomen

V-shaped tail

Big eye

Short front legs and long rear leg

Add the antennae

8 / 4

Fireworks

Center circle

Surround with teardrops

Add more circles, teardrops, and lines

There was a fireworks show at the summer festival this weekend. They were so beautiful and colorful.

Firework shooting up into the sky

Start at the center and work outward

8 / 5

I love to look out the window at breakfast and see the morning glories in full bloom.

Morning Glory

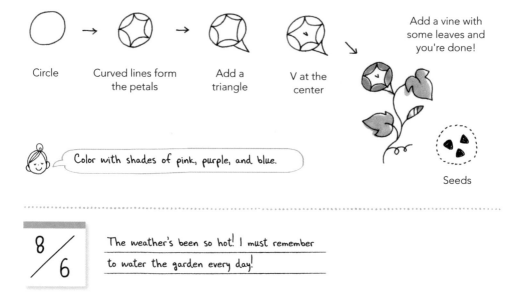

Circle

Curved lines form the petals

Add a triangle

V at the center

Add a vine with some leaves and you're done!

 Color with shades of pink, purple, and blue.

Seeds

8 / 6

The weather's been so hot! I must remember to water the garden every day!

Watering Can

Trapezoid

Add handles on the top and side

Add a long triangle

Draw a circle at the tip and fill with dots

 Don't forget the water!

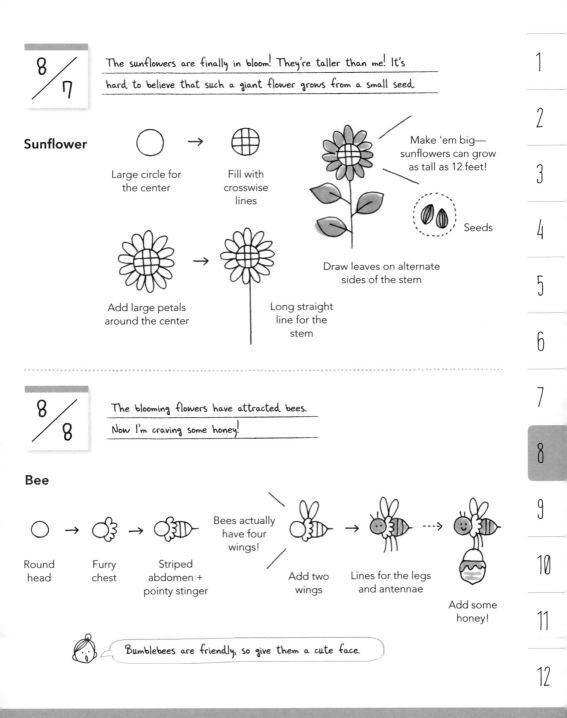

The sunflowers are finally in bloom! They're taller than me! It's hard to believe that such a giant flower grows from a small seed.

Sunflower

Large circle for the center

Fill with crosswise lines

Make 'em big— sunflowers can grow as tall as 12 feet!

Seeds

Add large petals around the center

Long straight line for the stem

Draw leaves on alternate sides of the stem

The blooming flowers have attracted bees.
Now I'm craving some honey!

Bee

Round head

Furry chest

Striped abdomen + pointy stinger

Bees actually have four wings!

Add two wings

Lines for the legs and antennae

Add some honey!

Bumblebees are friendly, so give them a cute face.

8 / 9

Shaved Ice

It was so hot today that I treated myself to a shaved ice. It gave me brain freeze, but it was worth it. Mmm...so good.

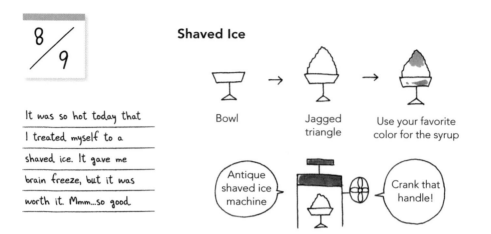

Bowl

Jagged triangle

Use your favorite color for the syrup

Antique shaved ice machine

Crank that handle!

8 / 10

Flip-Flops

We're going to the beach tomorrow. I'm so excited! I just hope I don't get a sunburn!

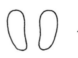

Two feet

Add the straps

Decorate with bright colors!

Inner Tube

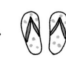

Double circle

Add a colorful pattern

Use bright colors for the beach gear.

142

8/11 8/12 I had such a wonderful time at the beach this weekend! I went
swimming, played in the sand, and relaxed under the umbrella.

Beach Umbrella

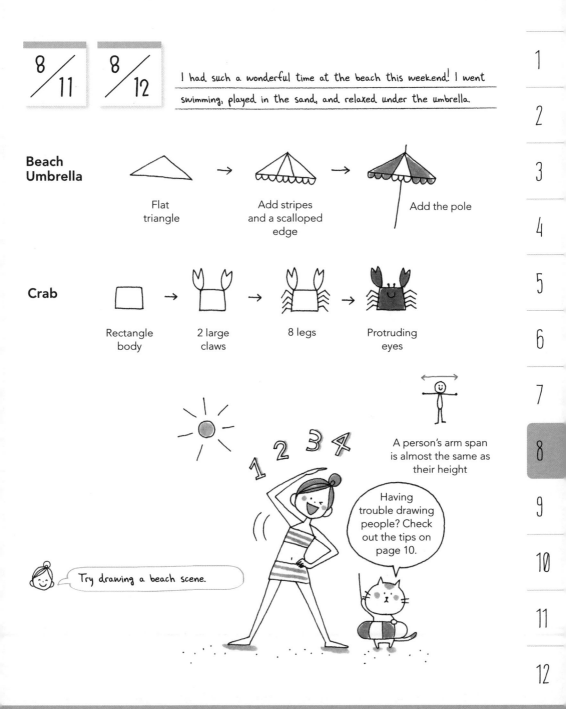

Flat triangle → Add stripes and a scalloped edge → Add the pole

Crab

Rectangle body → 2 large claws → 8 legs → Protruding eyes

A person's arm span is almost the same as their height

Having trouble drawing people? Check out the tips on page 10.

Try drawing a beach scene.

We went to visit my grandparents who live in Hiroshima. We took the train—it was so fast!

Bullet Train

00.8.13

Pointed nose → Add windows

HIROSHIMA CAT CAFE

00.8.14

Best place ever!

00.8.13

Leave Tokyo at 9:00

We visited the local museum

00.8.15

ADMIT ONE

Leave Hiroshima at 12:00

Train Ticket

3" (7.5 cm)

1" (2.5 cm)

Cut a rectangle of paper into the shape of a ticket (you can even include a perforated stub). Decorate with drawings to commemorate your travels. Don't forget to punch a hole!

Fan

Our AC broke, so I had to use an old-fashioned fan to keep cool. How did they survive the summer in the olden days?

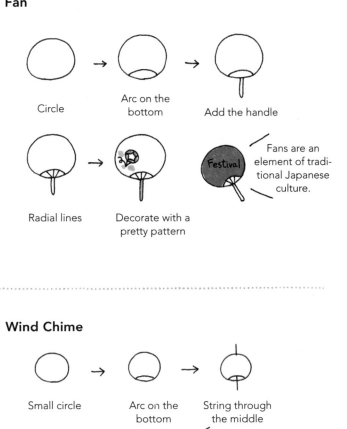

Circle

Arc on the bottom

Add the handle

Radial lines

Decorate with a pretty pattern

Fans are an element of traditional Japanese culture.

Festival

Wind Chime

I bought a Japanese-style wind chime to hang out on the porch. The sound is so pretty!

Small circle

Arc on the bottom

String through the middle

Add strip of paper

Decorate

Curve the paper, so it looks as if it's blowing in the wind.

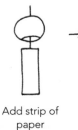 Wind chimes are associated with cool summer breezes, so decorate with blue accents.

1
2
3
4
5
6
7
8
9
10
11
12

I've been eating ice cream nearly every day this summer. I know it's not very healthy, but an ice cream cone is so delicious when the weather is hot.

Ice Cream Cone

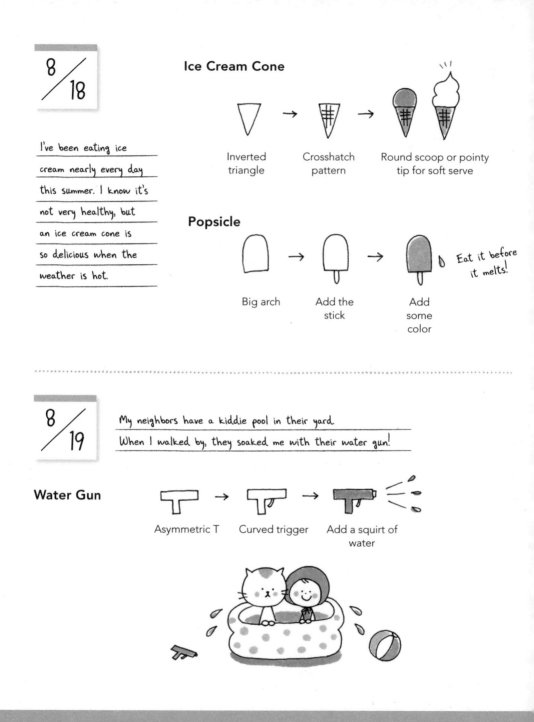

Inverted triangle → Crosshatch pattern → Round scoop or pointy tip for soft serve

Popsicle

Big arch → Add the stick → Add some color

Eat it before it melts!

8 / 19

My neighbors have a kiddie pool in their yard When I walked by, they soaked me with their water gun!

Water Gun

Asymmetric T → Curved trigger → Add a squirt of water

My best friend just got back from a trip to Hawaii. Her pictures were beautiful! I'm going to start saving money for a vacation.

Hibiscus

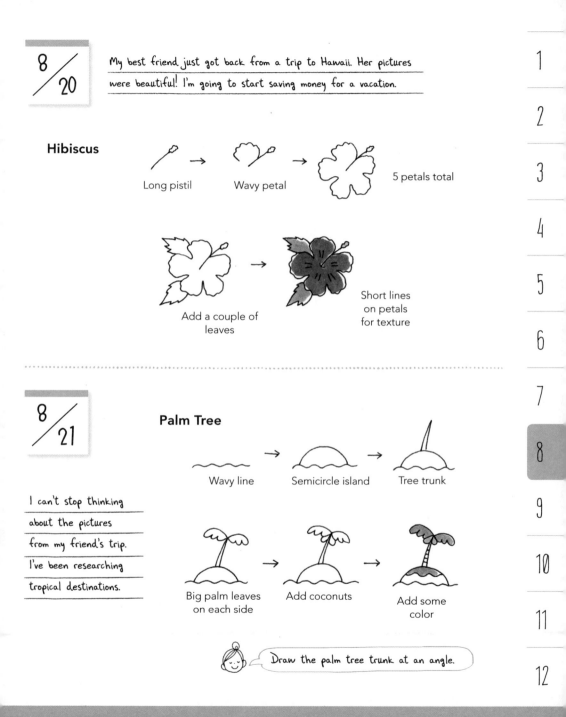

Long pistil → Wavy petal → 5 petals total

Add a couple of leaves → Short lines on petals for texture

Palm Tree

Wavy line → Semicircle island → Tree trunk

I can't stop thinking about the pictures from my friend's trip. I've been researching tropical destinations.

Big palm leaves on each side → Add coconuts → Add some color

Draw the palm tree trunk at an angle.

1
2
3
4
5
6
7
8
9
10
11
12

Summer Kimono

There is a summer festival tomorrow. I'm going to wear my new summer kimono.

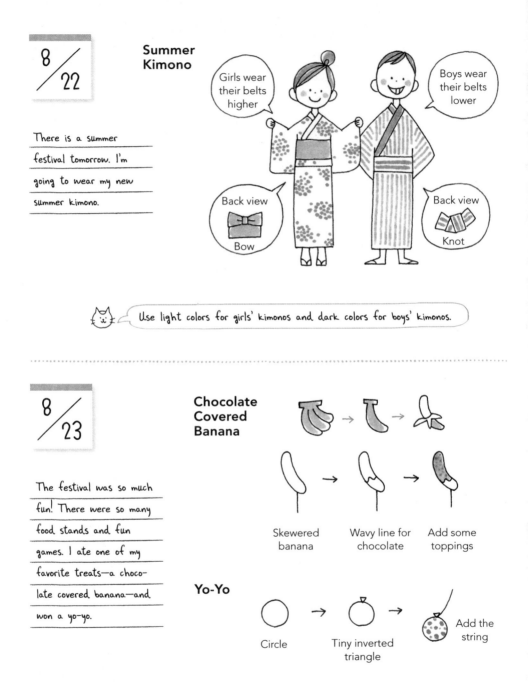

Girls wear their belts higher

Boys wear their belts lower

Back view
Bow

Back view
Knot

Use light colors for girls' kimonos and dark colors for boys' kimonos.

8 / 23

Chocolate Covered Banana

The festival was so much fun! There were so many food stands and fun games. I ate one of my favorite treats—a chocolate covered banana—and won a yo-yo.

Skewered banana

Wavy line for chocolate

Add some toppings

Yo-Yo

Circle

Tiny inverted triangle

Add the string

I also won a pet
goldfish at the festival
yesterday. I hope my
cat doesn't bother him!

Goldfish

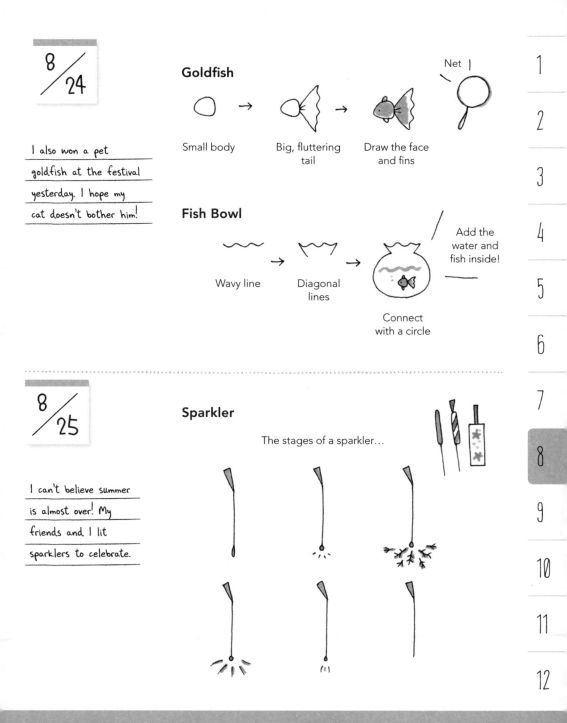

Small body → Big, fluttering tail → Draw the face and fins

Net

Fish Bowl

Wavy line → Diagonal lines → Connect with a circle

Add the water and fish inside!

I can't believe summer
is almost over! My
friends and I lit
sparklers to celebrate.

Sparkler

The stages of a sparkler...

1
2
3
4
5
6
7
8
9
10
11
12

149

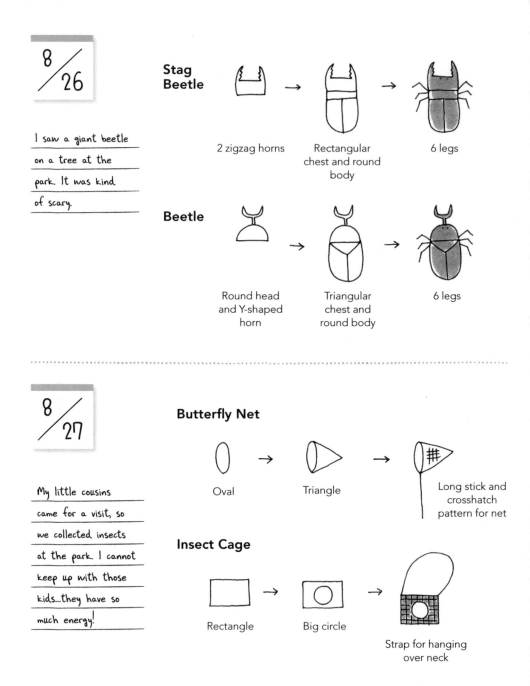

I saw a giant beetle on a tree at the park. It was kind of scary.

Stag Beetle

2 zigzag horns

Rectangular chest and round body

6 legs

Beetle

Round head and Y-shaped horn

Triangular chest and round body

6 legs

My little cousins came for a visit, so we collected insects at the park. I cannot keep up with those kids...they have so much energy!

Butterfly Net

Oval

Triangle

Long stick and crosshatch pattern for net

Insect Cage

Rectangle

Big circle

Strap for hanging over neck

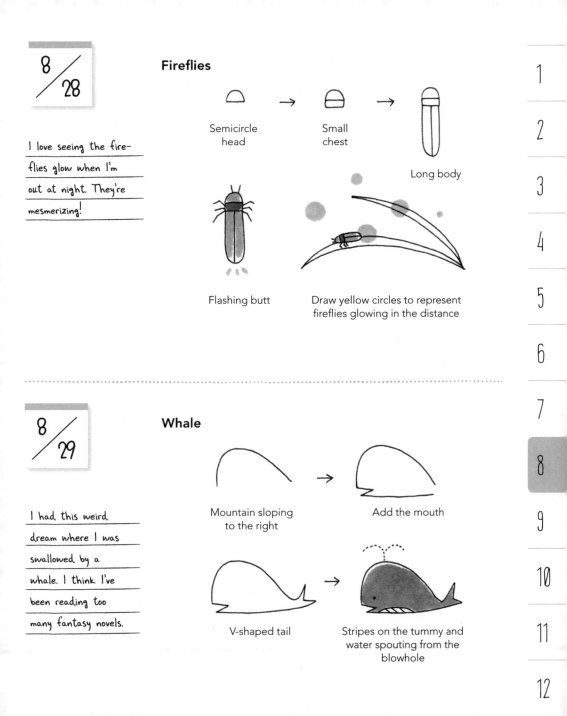

8 / 28

I love seeing the fire-
flies glow when I'm
out at night. They're
mesmerizing!

Fireflies

Semicircle head

Small chest

Long body

Flashing butt

Draw yellow circles to represent fireflies glowing in the distance

8 / 29

I had this weird
dream where I was
swallowed by a
whale. I think I've
been reading too
many fantasy novels.

Whale

Mountain sloping to the right

Add the mouth

V-shaped tail

Stripes on the tummy and water spouting from the blowhole

8 / 30

I stayed up way too late last night playing cards with my family. Good thing we don't play with real money, or I would have lost a lot!

Club

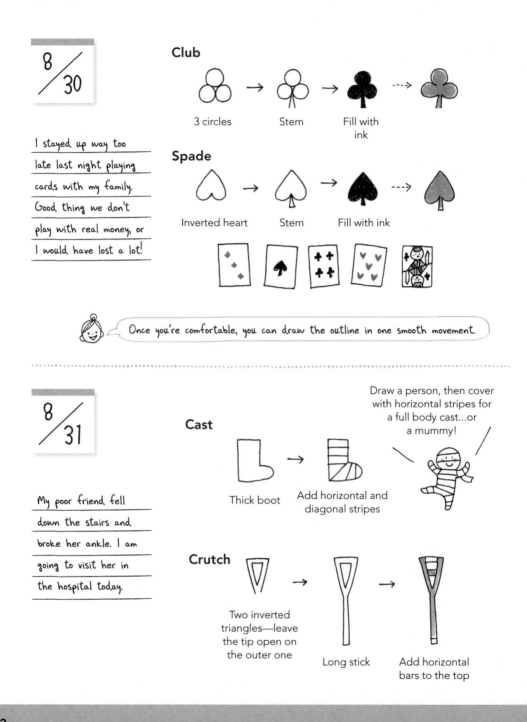

3 circles → Stem → Fill with ink --->

Spade

Inverted heart → Stem → Fill with ink --->

Once you're comfortable, you can draw the outline in one smooth movement.

8 / 31

My poor friend fell down the stairs and broke her ankle. I am going to visit her in the hospital today.

Cast

Draw a person, then cover with horizontal stripes for a full body cast...or a mummy!

Thick boot → Add horizontal and diagonal stripes

Crutch

Two inverted triangles—leave the tip open on the outer one → Long stick → Add horizontal bars to the top

September

9 / 1

I was so impressed by
the EMTs at the hospital
that I signed up for a
first aid course.

Ambulance

 →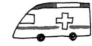

Rectangle with curved top left corner Add 2 wheels

Lights on the roof Add the windshield and a cross symbol

9 / 2

We learned how to
pack an emergency
kit in my first aid
class tonight. It's
important to have
water and medical
supplies on hand in
case of emergency.

Water Bottle

 → →

Cap Indented sides Add a label

Gloves Whistle
 Bandage
 Gauze
 Backpack

They're forecasting a hurricane this weekend. There's going to be lots of wind and rain, so I plan to stay inside where it's warm and dry.

Hurricane

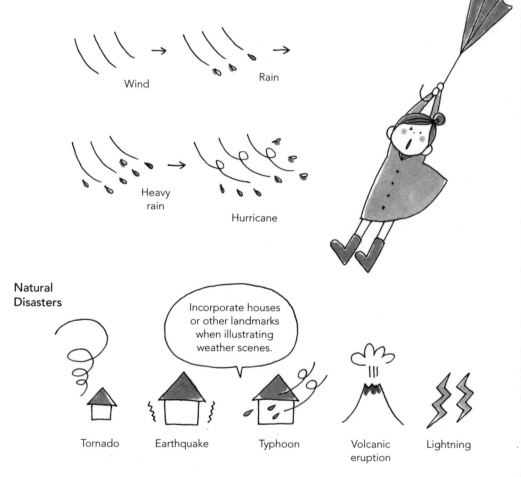

Wind

Rain

Heavy rain

Hurricane

Natural Disasters

Incorporate houses or other landmarks when illustrating weather scenes.

Tornado

Earthquake

Typhoon

Volcanic eruption

Lightning

I went to the cutest furniture shop today. It made me wish I had my own apartment so I could decorate it.

Furniture

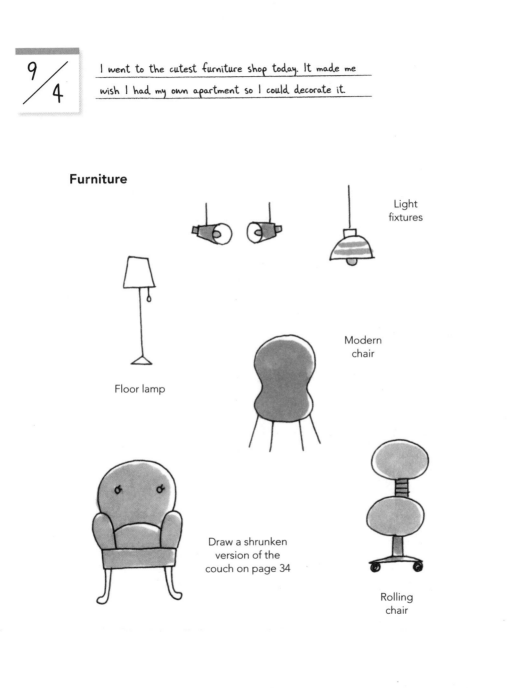

Light fixtures

Floor lamp

Modern chair

Draw a shrunken version of the couch on page 34

Rolling chair

My visit to the furniture shop has me thinking about getting my own apartment. What type of floor plan would be best for me?

Floor Plan

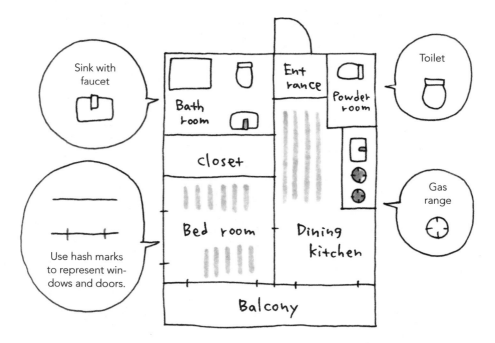

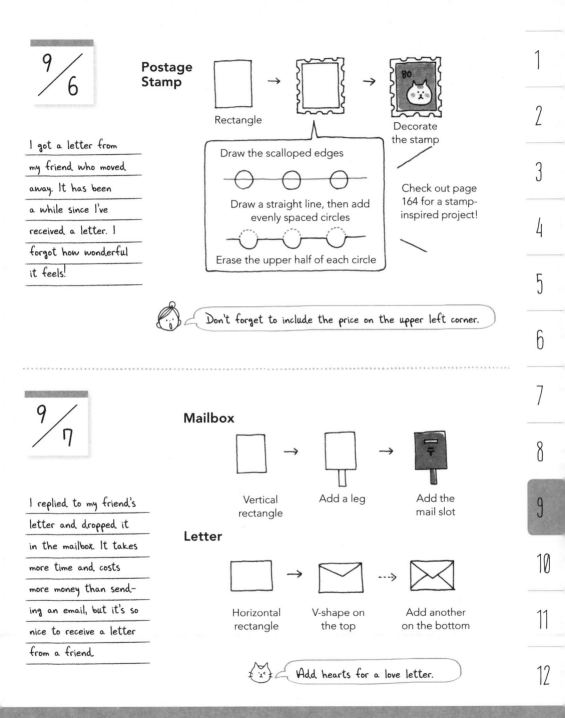

9/6

Postage Stamp

Rectangle → Draw the scalloped edges → Decorate the stamp

Draw a straight line, then add evenly spaced circles

Erase the upper half of each circle

Check out page 164 for a stamp-inspired project!

I got a letter from my friend who moved away. It has been a while since I've received a letter. I forgot how wonderful it feels!

Don't forget to include the price on the upper left corner.

9/7

Mailbox

Vertical rectangle → Add a leg → Add the mail slot

Letter

Horizontal rectangle → V-shape on the top --→ Add another on the bottom

I replied to my friend's letter and dropped it in the mailbox. It takes more time and costs more money than sending an email, but it's so nice to receive a letter from a friend.

Add hearts for a love letter.

I went for a walk through my neighborhood today.

I never noticed all the different styles of houses.

Houses

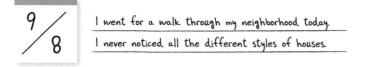

Triangle roof → Square base → Add doors and windows

Tall triangular roof

Cut off the top half of the triangle for a flat roof.

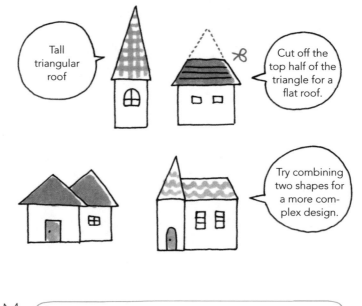

Try combining two shapes for a more complex design.

Draw uniquely-shaped roofs and windows to add character.

My girlfriends are coming over tomorrow. I drew them a map so they'd be able to find their way from the train station.

Map

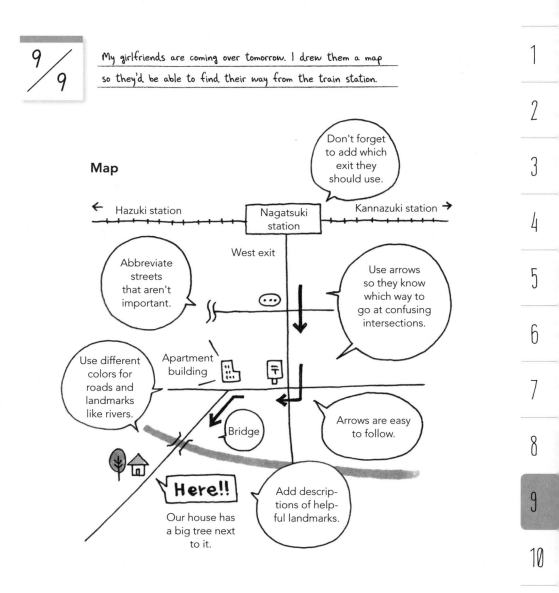

We had a girls' day today! I made my friends donuts as a special treat.

Donut

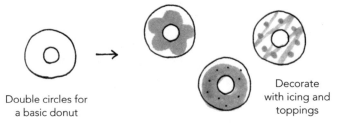

Double circles for a basic donut

Decorate with icing and toppings

I got all the way to the train station, then realized I forgot my keys at home. I had to walk all the way back to the house and just managed to catch my train.

Key

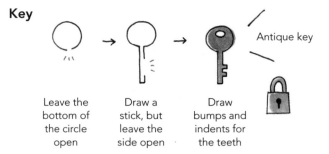

Leave the bottom of the circle open

Draw a stick, but leave the side open

Draw bumps and indents for the teeth

Antique key

9/12

Now that the weather is cooling off, my appetite has increased. We went out to dinner at an all-you-can-eat meat buffet. I ate way too much!

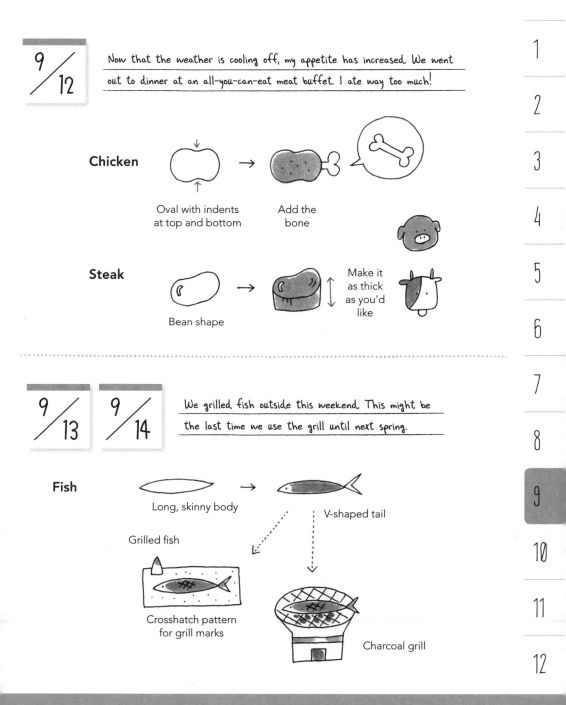

Chicken

Oval with indents at top and bottom

Add the bone

Steak

Bean shape

Make it as thick as you'd like

9/13 **9/14**

We grilled fish outside this weekend. This might be the last time we use the grill until next spring.

Fish

Long, skinny body

V-shaped tail

Grilled fish

Crosshatch pattern for grill marks

Charcoal grill

9 / 15

I made spaghetti
and meat sauce from
scratch. My cook-
ing skills are really
improving.

Spaghetti

Start with the
sauce

Add the noodles
underneath

Big plate

Add a fork

9 / 16

It's almost time for
the rice harvest.
Freshly harvested rice
is so delicious!

**Rice
Plant**

Curved line

Add another

Long, thin leaves

Dots for rice

Add color

Grandparents

Today is Respect for the Aged Day! I sent my grandparents some goodies to let them know I care.

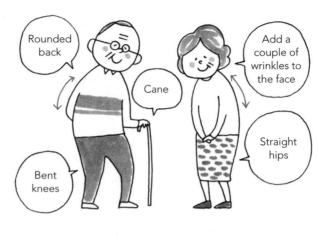

Rounded back

Add a couple of wrinkles to the face

Cane

Straight hips

Bent knees

 Grandparents are nice—draw kind facial expressions.

Rolling Suitcase

I'm traveling abroad tomorrow! I'm almost done packing. I just hope I didn't forget anything!

Rectangle with 2 wheels

→ Add a handle

--→ Extend the handle to roll the bag

Old-Fashioned Suitcase

 Rectangle

→ Add belted straps

→ 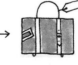 Add stickers and an ID tag

1
2
3
4
5
6
7
8
9
10
11
12

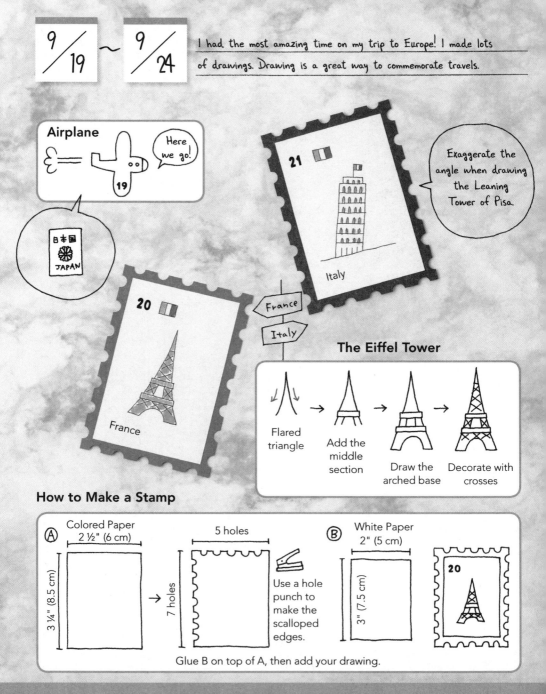

9/19 ~ 9/24

I had the most amazing time on my trip to Europe! I made lots of drawings. Drawing is a great way to commemorate travels.

Airplane

Here we go!

19

日本国 JAPAN

21

Italy

Exaggerate the angle when drawing the Leaning Tower of Pisa.

20

France

France

Italy

The Eiffel Tower

Flared triangle → Add the middle section → Draw the arched base → Decorate with crosses

How to Make a Stamp

Ⓐ Colored Paper 2 ½" (6 cm)

3 ¼" (8.5 cm)

7 holes

5 holes

Use a hole punch to make the scalloped edges.

Ⓑ White Paper 2" (5 cm)

3" (7.5 cm)

20

Glue B on top of A, then add your drawing.

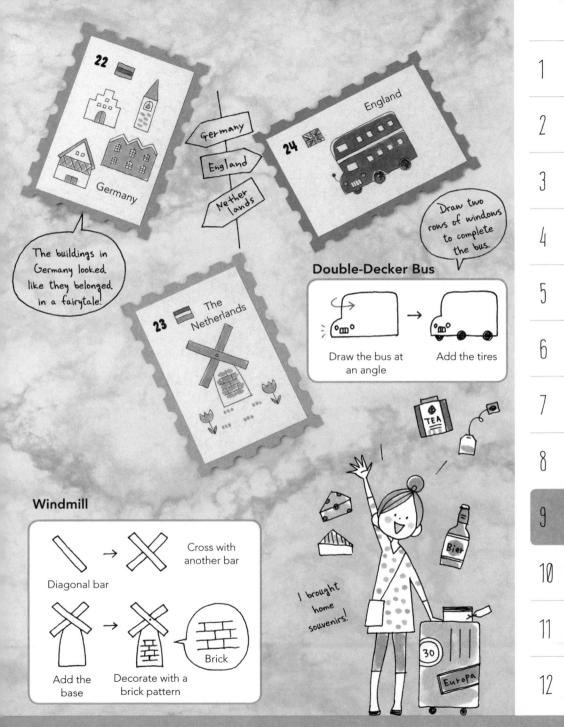

22 🏳️

Germany

The buildings in Germany looked like they belonged in a fairytale!

Germany
England
Netherlands

England

24 🇬🇧

Draw two rows of windows to complete the bus.

23 🏳️ The Netherlands

Double-Decker Bus

Draw the bus at an angle → Add the tires

Windmill

Diagonal bar → Cross with another bar

Add the base → Decorate with a brick pattern

Brick

TEA

Bier

I brought home souvenirs!

30
Europa

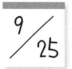

9 / 25

I'm still recovering from jet lag, but I went for a nice walk outside. The weather was beautiful.

Japanese Bush Clover

Peony

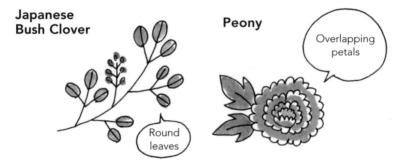

Round leaves

Overlapping petals

9 / 26

The cosmos flowers are in bloom. They look so pretty growing on the side of the road.

Cosmos

Small circle → Rectangular petal → 8 petals total

Seeds

Long, thin leaves

Round bud

I went to the new art exhibit that just opened at the museum.

It was a really relaxing way to spend the afternoon.

Paintings

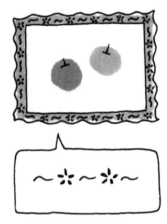

~ ✳ ~ ✳ ~

Repeat this pattern for a decorative frame

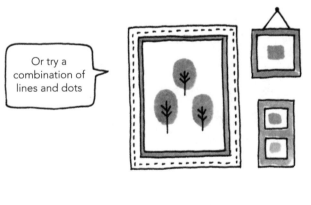

Or try a combination of lines and dots

Repeat simple patterns to create interesting frames.

I was so inspired by yesterday's tip to the museum that I pulled out my art supplies and started painting.

Paintbrush

C'est magnifique!

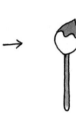 →

Plump teardrop shape

Long, skinny handle

Add a drop of paint

Paint

 →

Tall trapezoid Add the cap

Add colorful labels

9 / 29

My brother had
a big math report
due, so I helped
him out. I hope he
gets a good grade!

Report

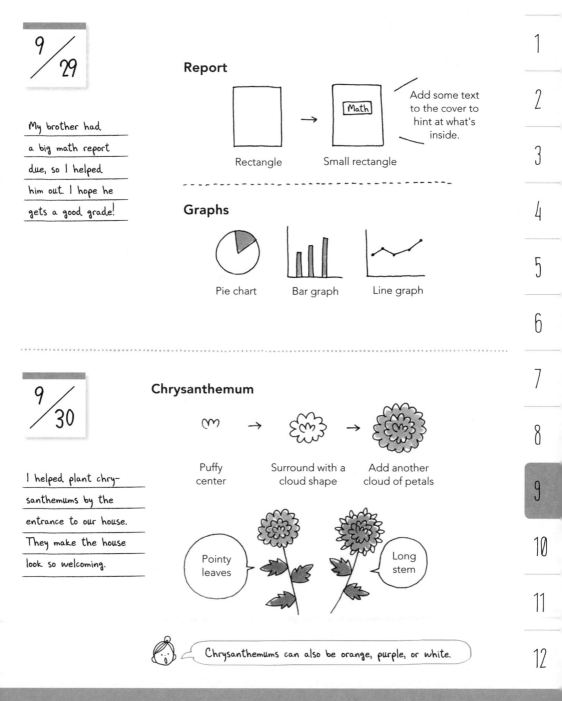

Rectangle → Small rectangle

Add some text to the cover to hint at what's inside.

Graphs

Pie chart Bar graph Line graph

9 / 30

I helped plant chry-
santhemums by the
entrance to our house.
They make the house
look so welcoming.

Chrysanthemum

Puffy center → Surround with a cloud shape → Add another cloud of petals

Pointy leaves

Long stem

Chrysanthemums can also be orange, purple, or white.

SELECTING YOUR COLOR SCHEME

It's easy to go overboard when adding color to your illustrations, so keep it simple!
I recommend using a neutral color for the outline and one or two colors to fill the illustration.
If you're using light colors to fill the illustration, then it's important to use a dark color for the outline.

The Basics

1 Choose your outline color

black brown navy

and so on...

2 Next, select two colors to fill the illustration

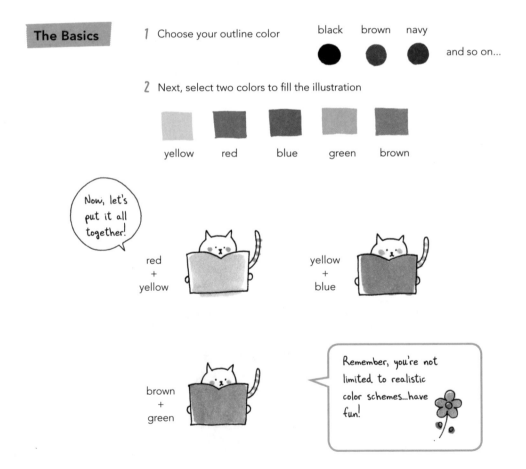

yellow red blue green brown

Now, let's put it all together!

red
+
yellow

yellow
+
blue

brown
+
green

Remember, you're not limited to realistic color schemes...have fun!

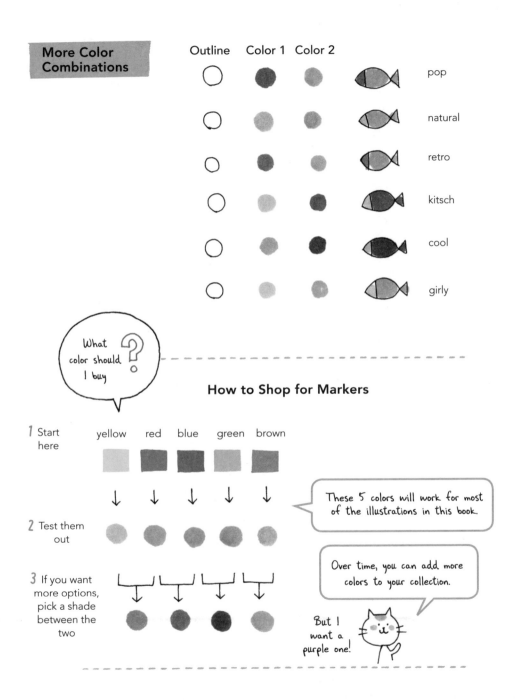

More Color Combinations

Outline	Color 1	Color 2		
○	●	●	🐟	pop
○	●	●	🐟	natural
○	●	●	🐟	retro
○	●	●	🐟	kitsch
○	●	●	🐟	cool
○	●	●	🐟	girly

What color should I buy

How to Shop for Markers

1 Start here

yellow red blue green brown

↓ ↓ ↓ ↓ ↓

These 5 colors will work for most of the illustrations in this book.

2 Test them out

3 If you want more options, pick a shade between the two

Over time, you can add more colors to your collection.

But I want a purple one!

FALL

October
November
December

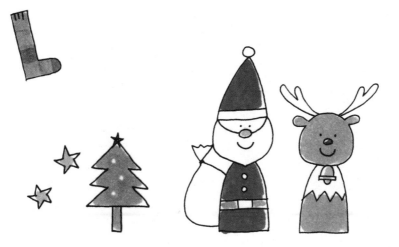

October

10 / 1

It's time to update my fall wardrobe. Checks and plaids are so popular this season.

Checks and Plaids

Small checks

Thick and thin lines

Mix marker and black pen

Argyle (use marker for diamonds + black pen for thin diagonal lines)

10 / 2

Sweaters are a major element of fall fash- ion. It took me so long to decide which one to wear that I was almost late today!

Sweaters

V-neck

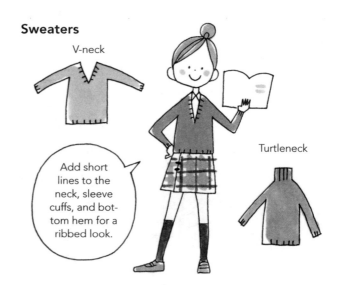

Add short lines to the neck, sleeve cuffs, and bot- tom hem for a ribbed look.

Turtleneck

Wool Clothes

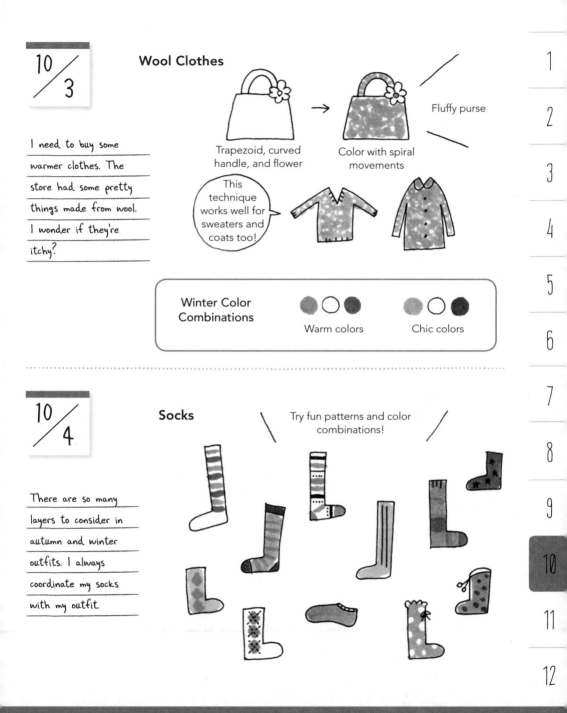

I need to buy some warmer clothes. The store had some pretty things made from wool. I wonder if they're itchy?

Trapezoid, curved handle, and flower

Color with spiral movements

Fluffy purse

This technique works well for sweaters and coats too!

Winter Color Combinations

Warm colors

Chic colors

Socks

Try fun patterns and color combinations!

There are so many layers to consider in autumn and winter outfits. I always coordinate my socks with my outfit.

1
2
3
4
5
6
7
8
9
10
11
12

Dragonfly

Lately, swarms of dragonflies have been appearing in the evening. They are such interesting creatures.

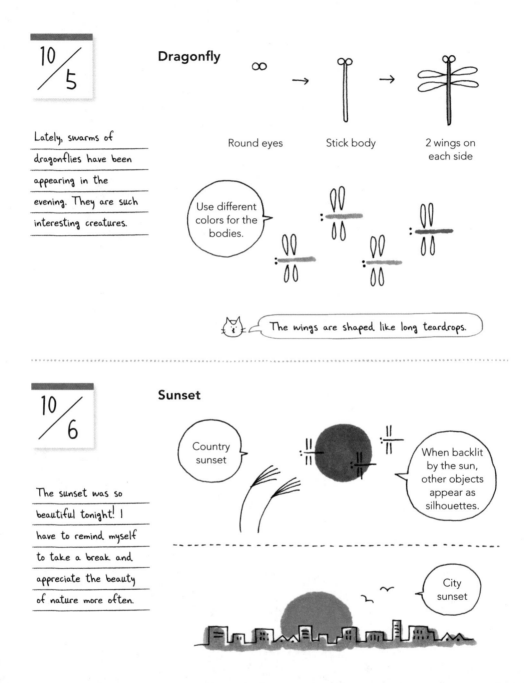

Round eyes

Stick body

2 wings on each side

Use different colors for the bodies.

The wings are shaped like long teardrops.

Sunset

The sunset was so beautiful tonight! I have to remind myself to take a break and appreciate the beauty of nature more often.

Country sunset

When backlit by the sun, other objects appear as silhouettes.

City sunset

10 / 7

Mushrooms

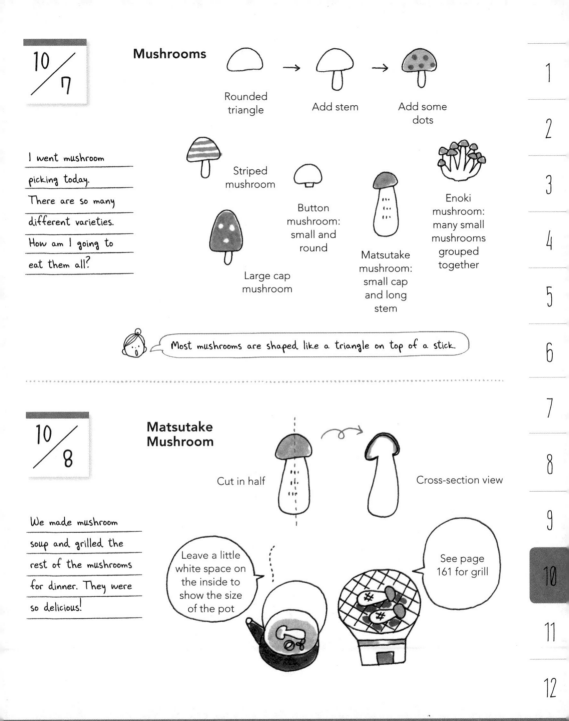

Rounded triangle → Add stem → Add some dots

I went mushroom picking today. There are so many different varieties. How am I going to eat them all?

Striped mushroom

Button mushroom: small and round

Large cap mushroom

Matsutake mushroom: small cap and long stem

Enoki mushroom: many small mushrooms grouped together

Most mushrooms are shaped like a triangle on top of a stick.

10 / 8

Matsutake Mushroom

Cut in half

Cross-section view

We made mushroom soup and grilled the rest of the mushrooms for dinner. They were so delicious!

Leave a little white space on the inside to show the size of the pot

See page 161 for grill

Sweet Osmanthus

I smelled the delicious fragrance of sweet osmanthus when I was walking down the street. These colorful flowers brightened an otherwise ordinary day.

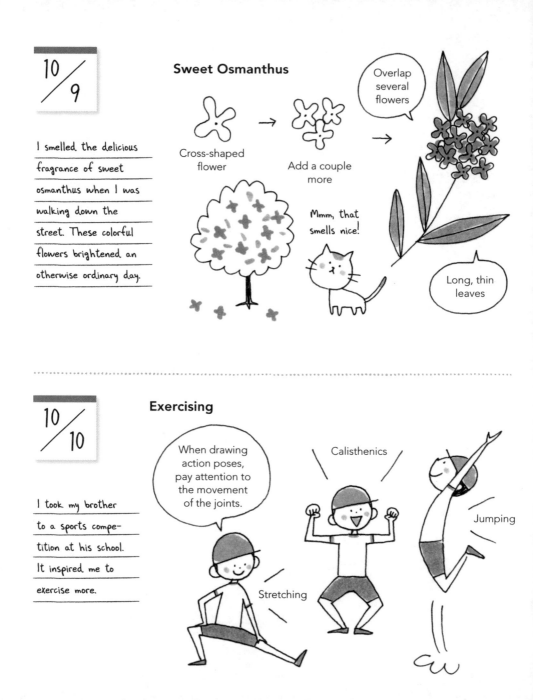

Cross-shaped flower

Add a couple more

Overlap several flowers

Mmm, that smells nice!

Long, thin leaves

10 / 10

Exercising

I took my brother to a sports competition at his school. It inspired me to exercise more.

When drawing action poses, pay attention to the movement of the joints.

Calisthenics

Jumping

Stretching

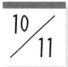

My friend took a trip to Russia and brought me back a set of matryoshka dolls as a souvenir. They will look so cute in my room.

Matryoshka Dolls

Convex

Concave

Decorate with bright colors and pretty patterns.

Large Medium Small

Draw several different sizes for the classic nesting doll look.

Churches in Russia have onion-shaped domes.

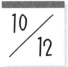

I found a copy of Alice in Wonderland when I was cleaning my room. It was one of my childhood favorites. I think I'll read it again!

Alice in Wonderland

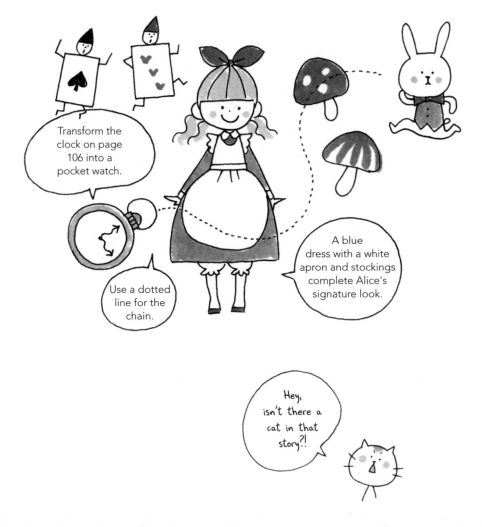

I bought some mystery novels from the used bookstore. They were in bad shape so I recovered them with paper. My personal library is growing.

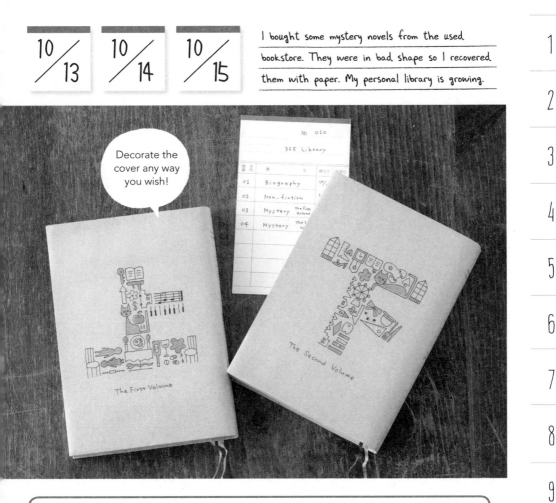

Decorate the cover any way you wish!

The First Volume

The Second Volume

How to Make a Book Cover

1. Fold the top and bottom edges so the paper matches the width of the book.

2. Fold the left and right edges around the flaps of the book.

3. Tape a couple pieces of ribbon to the center of the book cover to make a bookmark.

Close up view of the bookmark

10/16

Autumn Foliage

It's peak foliage season. All the trees are beautiful shades of orange, red, and yellow.

Draw the mountains on page 122, but change the color scheme.

Draw the tree on page 86, but change the color scheme. Experiment with the shape too!

Use dots to represent trees growing on the mountain.

10/17

I collected some fallen leaves and pressed them. I'm going to use these preserved leaves as bookmarks. Maybe it will inspire me to read more!

Leaf

One point → Tilted point on each side → 2 horizontal points and 2 small points at the bottom

Ginkgo leaf

Include a missing chunk from a bug bite for a cute touch!

10 / 18

We went apple picking! Maybe I'll bake a pie.

Apple

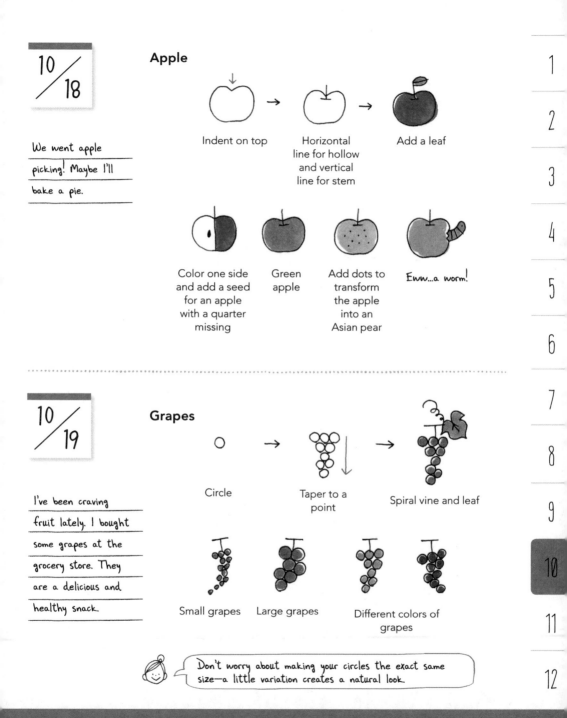

Indent on top

Horizontal line for hollow and vertical line for stem

Add a leaf

Color one side and add a seed for an apple with a quarter missing

Green apple

Add dots to transform the apple into an Asian pear

Eww...a worm!

10 / 19

I've been craving fruit lately. I bought some grapes at the grocery store. They are a delicious and healthy snack.

Grapes

Circle

Taper to a point

Spiral vine and leaf

Small grapes

Large grapes

Different colors of grapes

Don't worry about making your circles the exact same size—a little variation creates a natural look.

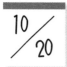

10 / 20

I went to the zoo today. I haven't been there since I was a little kid—I forgot how much fun it is to see all the animals.

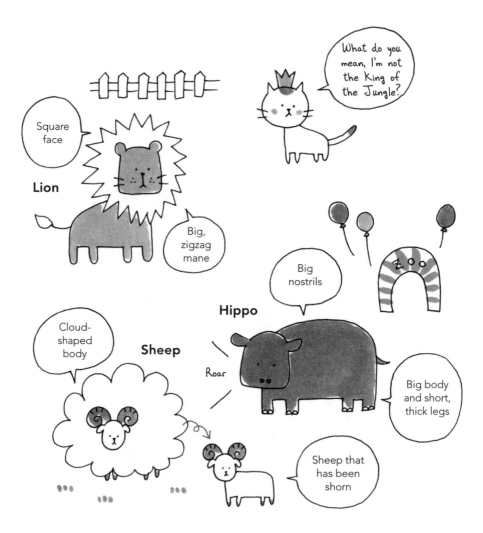

What do you mean, I'm not the King of the Jungle?

Square face

Lion

Big, zigzag mane

Big nostrils

Hippo

Cloud-shaped body

Sheep

Roar

Big body and short, thick legs

Sheep that has been shorn

Horse

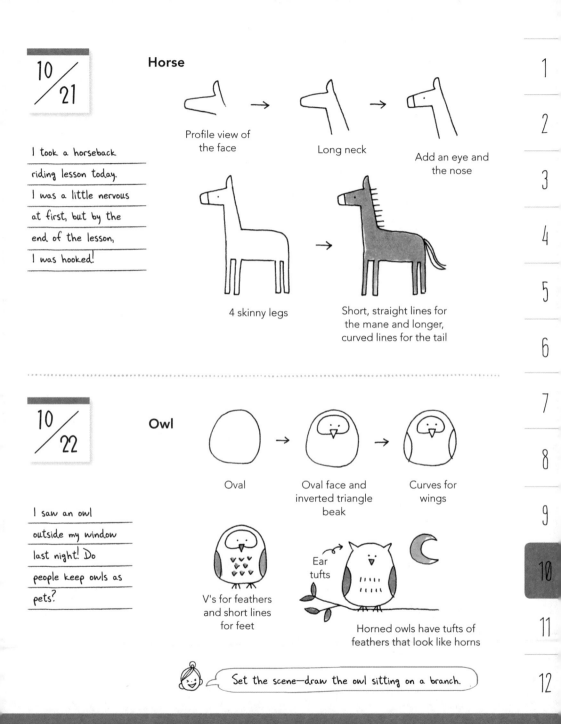

I took a horseback riding lesson today. I was a little nervous at first, but by the end of the lesson, I was hooked!

Profile view of the face

Long neck

Add an eye and the nose

4 skinny legs

Short, straight lines for the mane and longer, curved lines for the tail

Owl

I saw an owl outside my window last night! Do people keep owls as pets?

Oval

Oval face and inverted triangle beak

Curves for wings

V's for feathers and short lines for feet

Ear tufts

Horned owls have tufts of feathers that look like horns

Set the scene—draw the owl sitting on a branch.

My father is playing
his favorite record
in the living room. It
reminds me of when
I was a child.

Vinyl Record

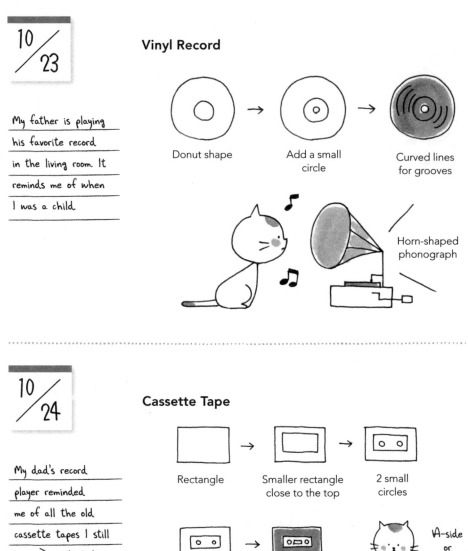

Donut shape

Add a small circle

Curved lines for grooves

Horn-shaped phonograph

My dad's record
player reminded
me of all the old
cassette tapes I still
have. Do kids today
know what they
are?

Cassette Tape

Rectangle

Smaller rectangle close to the top

2 small circles

Trapezoid on bottom

Color the outside

A-side or B-side?

10/25

I held a yard sale to get rid of some of the old things I no longer use. I actually made a little money!

Hanger

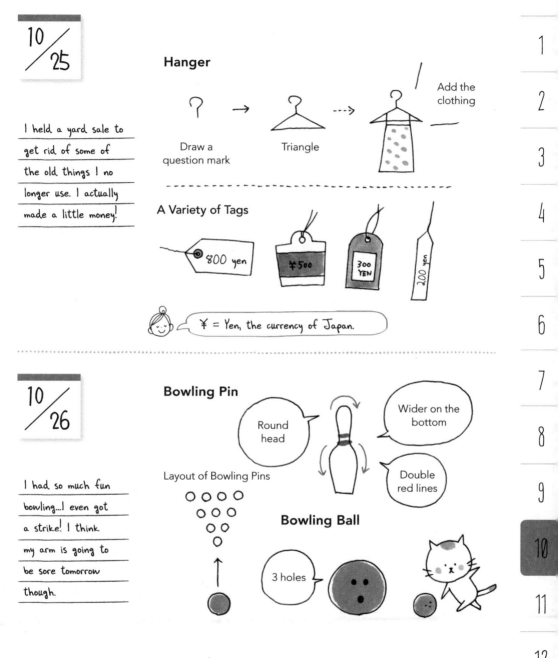

Draw a question mark

Triangle

Add the clothing

A Variety of Tags

800 yen

¥500

300 YEN

200 yen

¥ = Yen, the currency of Japan.

10/26

I had so much fun bowling...I even got a strike! I think my arm is going to be sore tomorrow though.

Bowling Pin

Round head

Wider on the bottom

Double red lines

Layout of Bowling Pins

Bowling Ball

3 holes

1
2
3
4
5
6
7
8
9
10
11
12

I've been making an effort to read more novels, but I still like reading fashion and gossip magazines too!

Reading

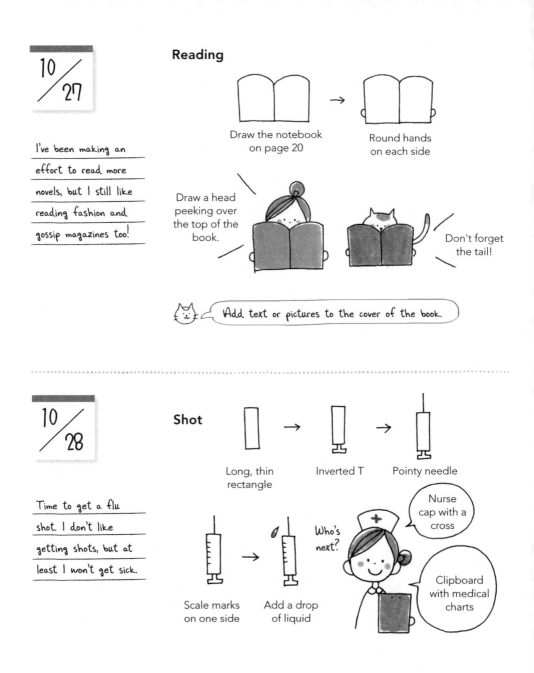

Draw the notebook on page 20

Round hands on each side

Draw a head peeking over the top of the book.

Don't forget the tail!

Add text or pictures to the cover of the book.

Time to get a flu shot. I don't like getting shots, but at least I won't get sick.

Shot

Long, thin rectangle

Inverted T

Pointy needle

Scale marks on one side

Add a drop of liquid

Who's next?

Nurse cap with a cross

Clipboard with medical charts

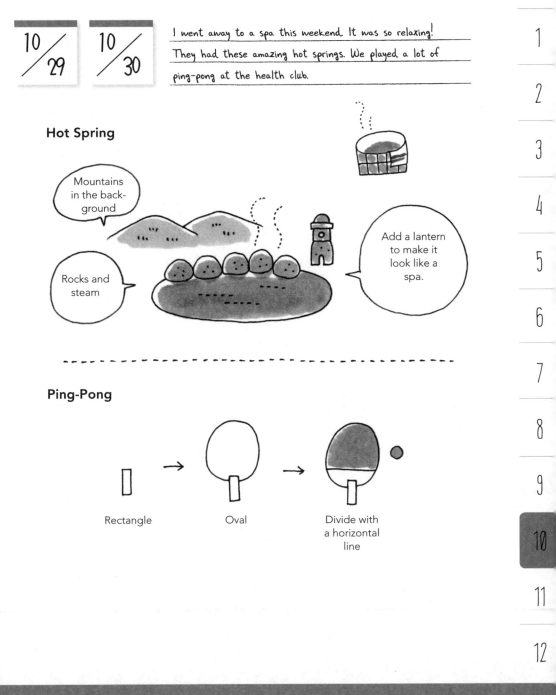

I went away to a spa this weekend. It was so relaxing!
They had these amazing hot springs. We played a lot of
ping-pong at the health club.

Hot Spring

Mountains in the back-ground

Add a lantern to make it look like a spa.

Rocks and steam

Ping-Pong

Rectangle → Oval → Divide with a horizontal line

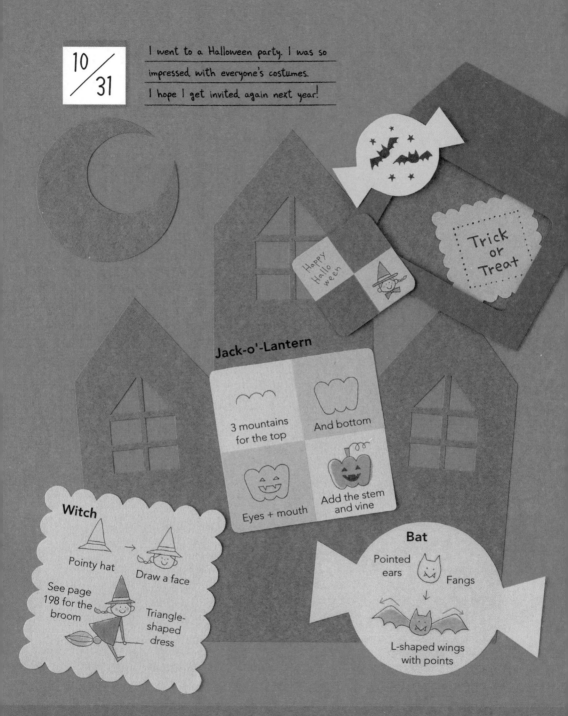

I went to a Halloween party. I was so impressed with everyone's costumes. I hope I get invited again next year!

Happy Halloween

Trick or Treat

Jack-o'-Lantern

3 mountains for the top

And bottom

Eyes + mouth

Add the stem and vine

Witch

Pointy hat

Draw a face

See page 198 for the broom

Triangle-shaped dress

Bat

Pointed ears

Fangs

L-shaped wings with points

190

11 / 1

The temperature is getting chilly. We brought out the portable heater to warm up the house.

Heater

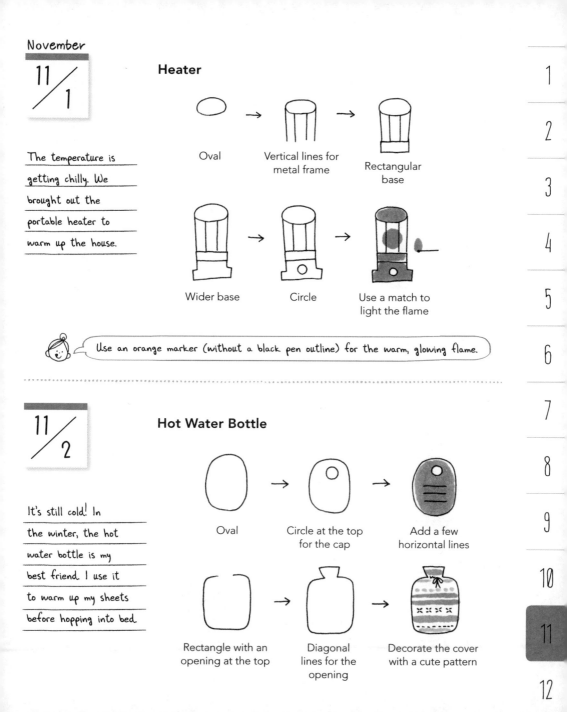

Oval

Vertical lines for metal frame

Rectangular base

Wider base

Circle

Use a match to light the flame

Use an orange marker (without a black pen outline) for the warm, glowing flame.

11 / 2

It's still cold! In the winter, the hot water bottle is my best friend. I use it to warm up my sheets before hopping into bed.

Hot Water Bottle

Oval

Circle at the top for the cap

Add a few horizontal lines

Rectangle with an opening at the top

Diagonal lines for the opening

Decorate the cover with a cute pattern

1
2
3
4
5
6
7
8
9
10
11
12

191

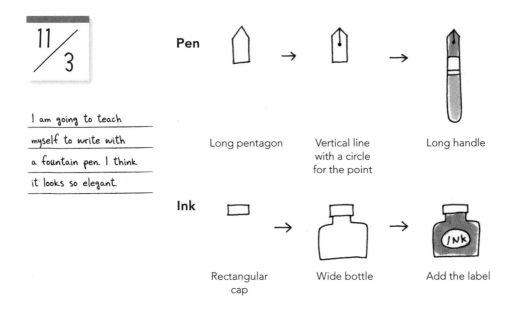

11/3

I am going to teach myself to write with a fountain pen. I think it looks so elegant.

Pen

Long pentagon

Vertical line with a circle for the point

Long handle

Ink

Rectangular cap

Wide bottle

Add the label

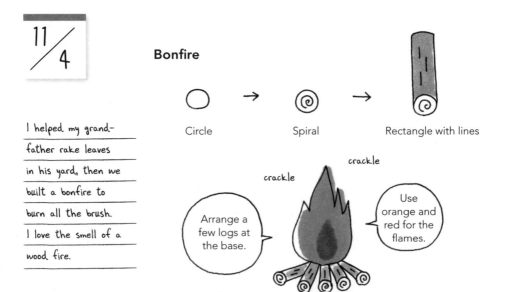

11/4

I helped my grand-father rake leaves in his yard, then we built a bonfire to burn all the brush. I love the smell of a wood fire.

Bonfire

Circle

Spiral

Rectangle with lines

crackle

crackle

Arrange a few logs at the base.

Use orange and red for the flames.

11/5

I found a bunch of acorns when I was walking through the park. They're so cute!

Acorn

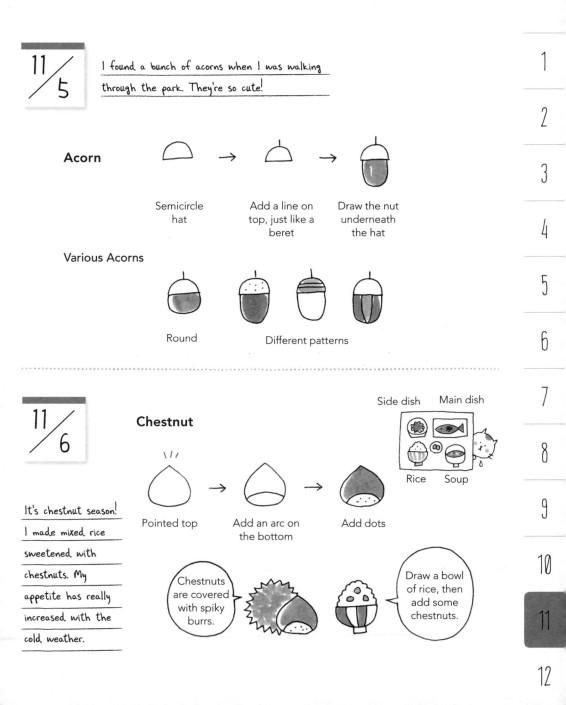

Semicircle hat → Add a line on top, just like a beret → Draw the nut underneath the hat

Various Acorns

Round

Different patterns

11/6

It's chestnut season! I made mixed rice sweetened with chestnuts. My appetite has really increased with the cold weather.

Chestnut

Side dish Main dish

Rice Soup

Pointed top → Add an arc on the bottom → Add dots

Chestnuts are covered with spiky burrs.

Draw a bowl of rice, then add some chestnuts.

1
2
3
4
5
6
7
8
9
10
11
12

| 11 / 7 | 11 / 8 | I can't believe how cold and windy the weather has been lately. I better bundle up before I catch a cold. |

Winter Tree

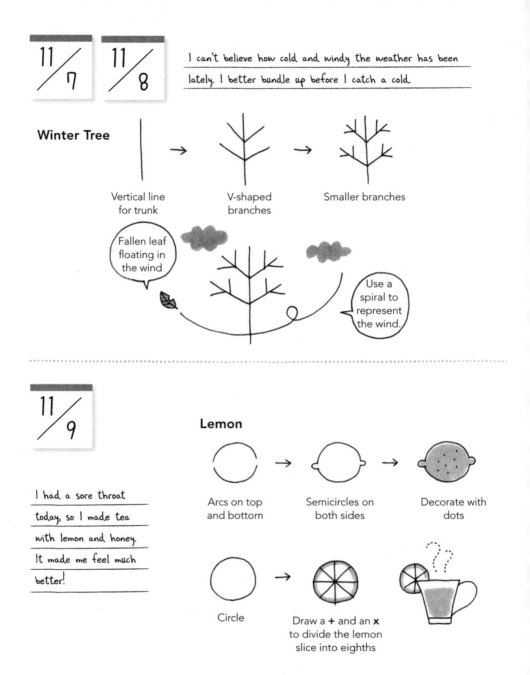

Vertical line for trunk

V-shaped branches

Smaller branches

Fallen leaf floating in the wind

Use a spiral to represent the wind.

11 / 9

I had a sore throat today, so I made tea with lemon and honey. It made me feel much better!

Lemon

Arcs on top and bottom

Semicircles on both sides

Decorate with dots

Circle

Draw a **+** and an **x** to divide the lemon slice into eighths

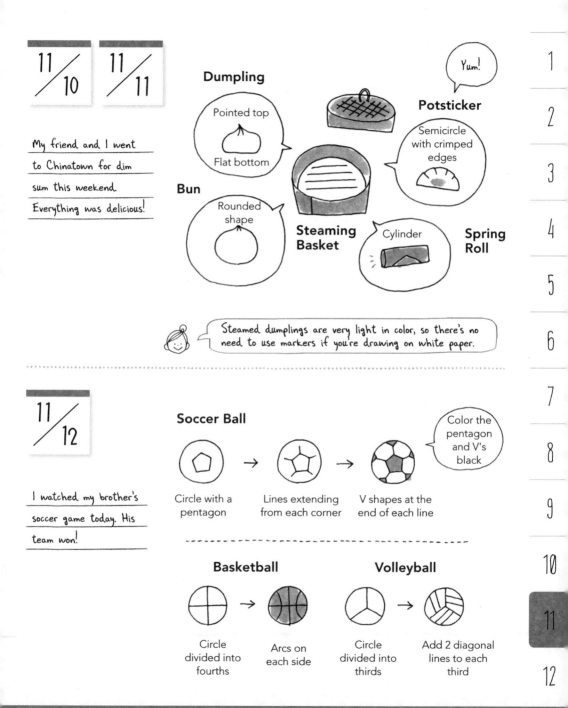

11/10 **11/11**

My friend and I went to Chinatown for dim sum this weekend. Everything was delicious!

Dumpling
Pointed top
Flat bottom

Potsticker
Yum!
Semicircle with crimped edges

Bun
Rounded shape

Steaming Basket

Cylinder

Spring Roll

Steamed dumplings are very light in color, so there's no need to use markers if you're drawing on white paper.

11/12

I watched my brother's soccer game today. His team won!

Soccer Ball
Circle with a pentagon → Lines extending from each corner → V shapes at the end of each line
Color the pentagon and V's black

Basketball
Circle divided into fourths → Arcs on each side

Volleyball
Circle divided into thirds → Add 2 diagonal lines to each third

1
2
3
4
5
6
7
8
9
10
11
12

My cousin is having a baby! We went to the department store to buy a gift. There were so many cute things that it was hard to choose.

Stroller

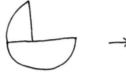 →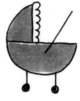

Semicircle base Add wheels
and sun shade and a handle

Bottle

 → →

Rectangle Rectangle + Add scale marks
 oval for top on the side

I met my cousin's newborn baby for the first time! She was so small that I was nervous to hold her. She's so cute!

Baby

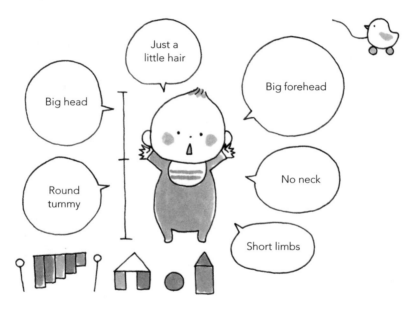

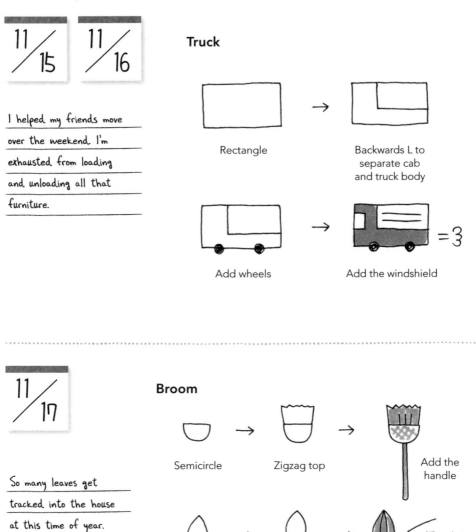

11/15 11/16

I helped my friends move over the weekend. I'm exhausted from loading and unloading all that furniture.

Truck

Rectangle

Backwards L to separate cab and truck body

Add wheels

Add the windshield

= 3

11/17

So many leaves get tracked into the house at this time of year. I'm constantly sweeping them up.

Broom

Semicircle

Zigzag top

Add the handle

Teardrop

Small circle

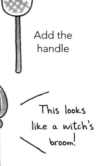

This looks like a witch's broom!

Add the handle

I bought my parents a bottle of wine as a gift. I hope they like it!

Wine Bottle

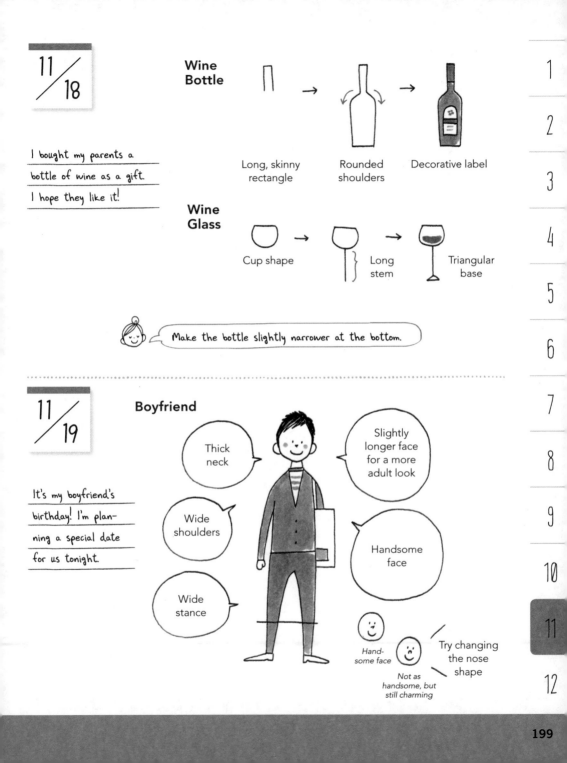

Long, skinny rectangle → Rounded shoulders → Decorative label

Wine Glass

Cup shape → Long stem → Triangular base

Make the bottle slightly narrower at the bottom.

It's my boyfriend's birthday! I'm planning a special date for us tonight.

Boyfriend

Thick neck

Slightly longer face for a more adult look

Wide shoulders

Handsome face

Wide stance

Hand-some face

Not as handsome, but still charming

Try changing the nose shape

1
2
3
4
5
6
7
8
9
10
11
12

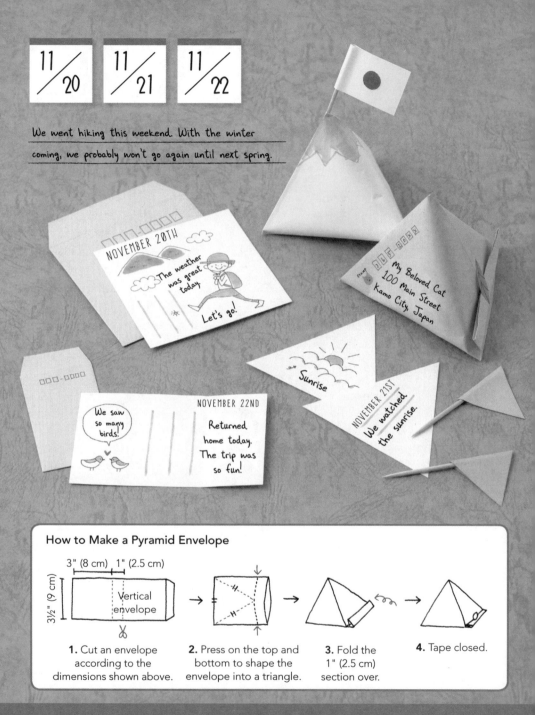

| 11/20 | 11/21 | 11/22 |

We went hiking this weekend. With the winter coming, we probably won't go again until next spring.

NOVEMBER 20TH

The weather was great today.

Let's go!

My Beloved Cat
100 Main Street
Kamo City, Japan

Sunrise

NOVEMBER 21ST
We watched the sunrise.

NOVEMBER 22ND

We saw so many birds!

Returned home today. The trip was so fun!

How to Make a Pyramid Envelope

3" (8 cm) 1" (2.5 cm)

3½" (9 cm)

Vertical envelope

1. Cut an envelope according to the dimensions shown above.

2. Press on the top and bottom to shape the envelope into a triangle.

3. Fold the 1" (2.5 cm) section over.

4. Tape closed.

11/23

I'm so grateful for my parents. I'm going to make dinner for them tonight to show them how much I appreciate everything they do.

Parents

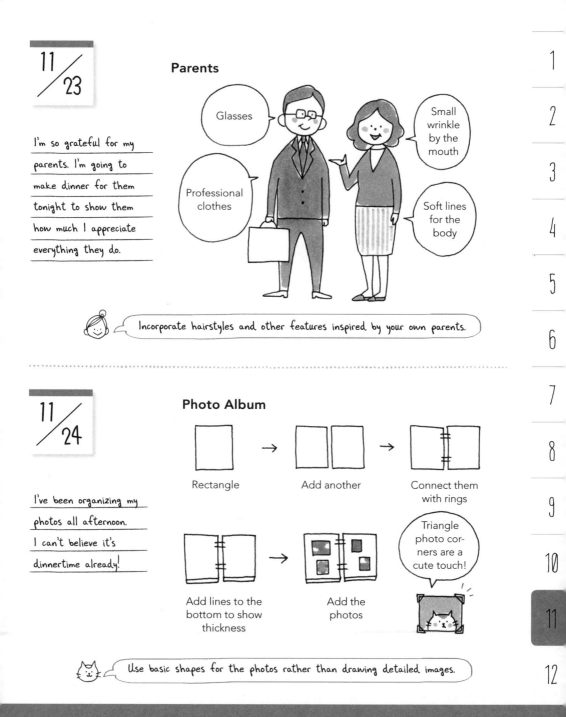

Glasses

Small wrinkle by the mouth

Professional clothes

Soft lines for the body

Incorporate hairstyles and other features inspired by your own parents.

11/24

I've been organizing my photos all afternoon. I can't believe it's dinnertime already!

Photo Album

Rectangle → Add another → Connect them with rings

Add lines to the bottom to show thickness → Add the photos

Triangle photo corners are a cute touch!

Use basic shapes for the photos rather than drawing detailed images.

11/25

I got so hungry while I was shopping that I had to buy myself a snack.

Takoyaki

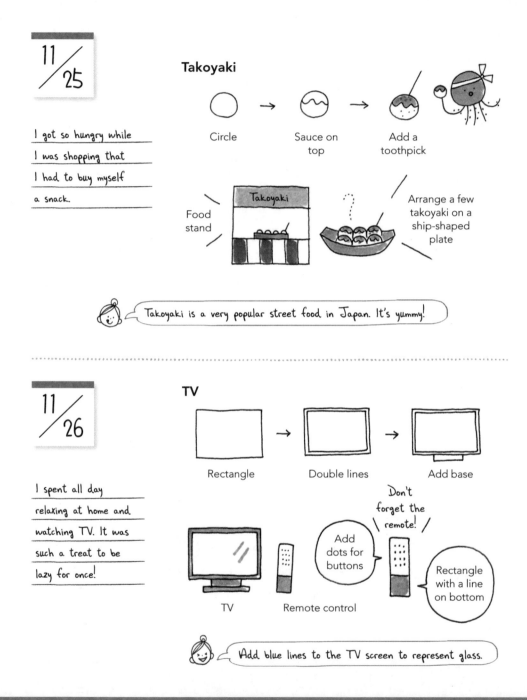

Circle → Sauce on top → Add a toothpick

Food stand

Takoyaki

Arrange a few takoyaki on a ship-shaped plate

Takoyaki is a very popular street food in Japan. It's yummy!

11/26

I spent all day relaxing at home and watching TV. It was such a treat to be lazy for once!

TV

Rectangle → Double lines → Add base

TV

Remote control

Add dots for buttons

Don't forget the remote!

Rectangle with a line on bottom

Add blue lines to the TV screen to represent glass.

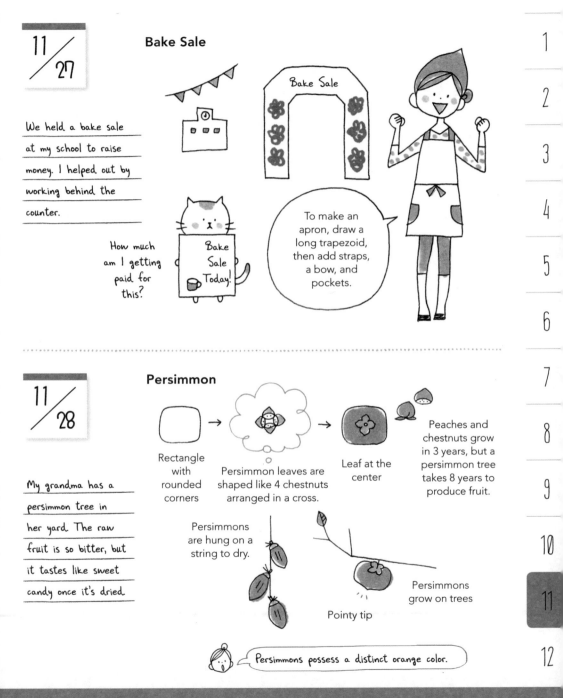

Bake Sale

11 / 27

We held a bake sale at my school to raise money. I helped out by working behind the counter.

How much am I getting paid for this?

Bake Sale Today!

To make an apron, draw a long trapezoid, then add straps, a bow, and pockets.

Persimmon

11 / 28

My grandma has a persimmon tree in her yard. The raw fruit is so bitter, but it tastes like sweet candy once it's dried.

Rectangle with rounded corners

Persimmon leaves are shaped like 4 chestnuts arranged in a cross.

Leaf at the center

Peaches and chestnuts grow in 3 years, but a persimmon tree takes 8 years to produce fruit.

Persimmons are hung on a string to dry.

Pointy tip

Persimmons grow on trees

Persimmons possess a distinct orange color.

11/29

It was my birthday today! I received so many thoughtful presents and cards. I'm so lucky!

Try using different colors and sizes for each letter to create a festive look.

Presents

Different Ways to Tie a Ribbon

Cross | Diagonal | V shape | Simple line

HAPPY BIRTHDAY

HAPPY BIRTHDAY

Happy birthday

Happy Birthday

11/30

My boyfriend gave me the most beautiful earrings for my birthday. I wore them today and received so many compliments.

Dangle Earrings

Curved hook | Flower

Stud Earrings

Vertical line with a sideways B | Triangle + circle

Ring

Hexagon | 1 horizontal and 2 vertical lines | Circle for ring

When coloring, leave white spaces to create a shiny, transparent effect perfect for gemstones.

December

12 / 1

I want to be more in-
formed about current
events, so I've started
reading the newspa-
per every morning.

Newspaper

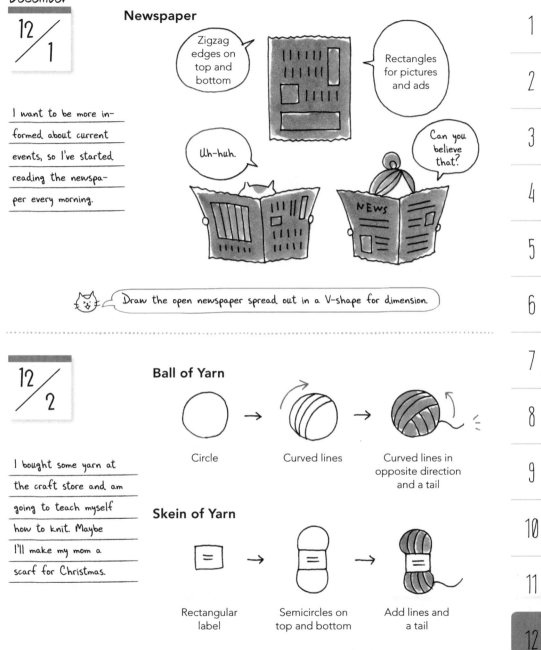

Zigzag edges on top and bottom

Rectangles for pictures and ads

Uh-huh.

Can you believe that?

NEWS

Draw the open newspaper spread out in a V-shape for dimension.

12 / 2

I bought some yarn at
the craft store and am
going to teach myself
how to knit. Maybe
I'll make my mom a
scarf for Christmas.

Ball of Yarn

Circle

Curved lines

Curved lines in opposite direction and a tail

Skein of Yarn

Rectangular label

Semicircles on top and bottom

Add lines and a tail

There was a food truck selling grilled sweet potatoes outside my work. They smelled so delicious that I bought two!

Sweet Potato

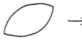

Leaf shape → Lines for roots → Add some color

Grilled Potato

Crosshatch pattern for grill marks

Curved lines for steam

Served wrapped in a newspaper

Grilled sweet potatoes are a popular street food in Japan!

My friend was accepted into a study abroad program in China next year. Maybe I will visit her when she's there.

Chinese Dress

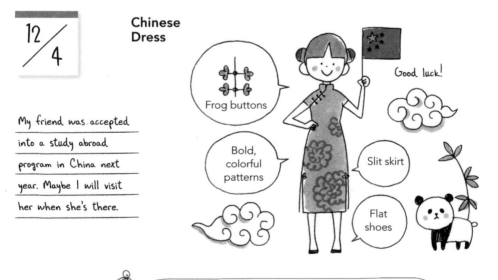

Frog buttons

Bold, colorful patterns

Slit skirt

Flat shoes

Good luck!

Use red and yellow for a classic Chinese color scheme.

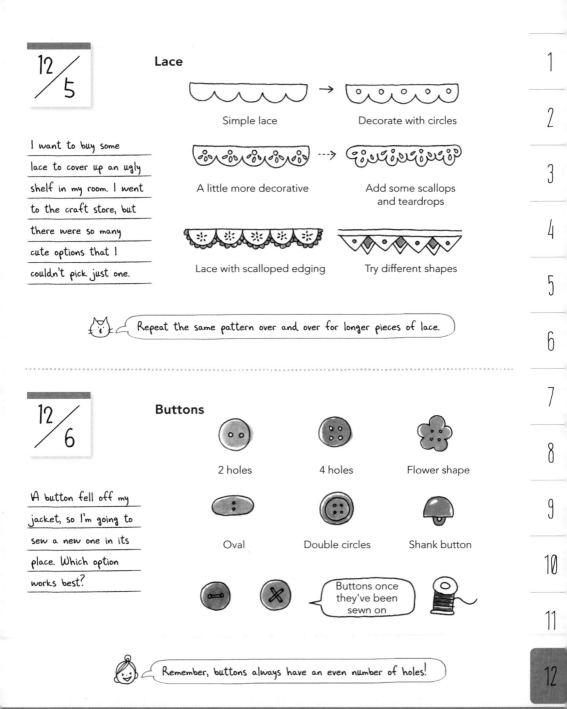

12/5

I want to buy some lace to cover up an ugly shelf in my room. I went to the craft store, but there were so many cute options that I couldn't pick just one.

Lace

Simple lace → Decorate with circles

A little more decorative --→ Add some scallops and teardrops

Lace with scalloped edging

Try different shapes

Repeat the same pattern over and over for longer pieces of lace.

12/6

A button fell off my jacket, so I'm going to sew a new one in its place. Which option works best?

Buttons

2 holes

4 holes

Flower shape

Oval

Double circles

Shank button

Buttons once they've been sewn on

Remember, buttons always have an even number of holes!

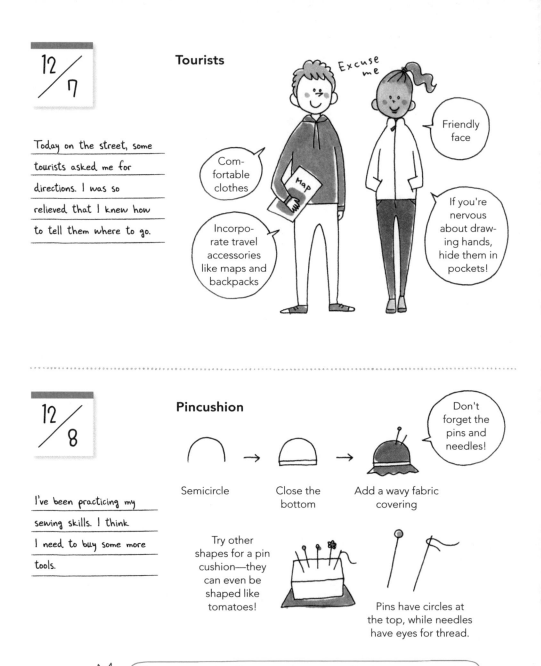

12 / 7

Today on the street, some tourists asked me for directions. I was so relieved that I knew how to tell them where to go.

Tourists

Excuse me

Friendly face

Comfortable clothes

If you're nervous about drawing hands, hide them in pockets!

Incorporate travel accessories like maps and backpacks

Map

12 / 8

I've been practicing my sewing skills. I think I need to buy some more tools.

Pincushion

Don't forget the pins and needles!

Semicircle → Close the bottom → Add a wavy fabric covering

Try other shapes for a pin cushion—they can even be shaped like tomatoes!

Pins have circles at the top, while needles have eyes for thread.

You can use circles, flowers, or other shapes for decorative pin heads.

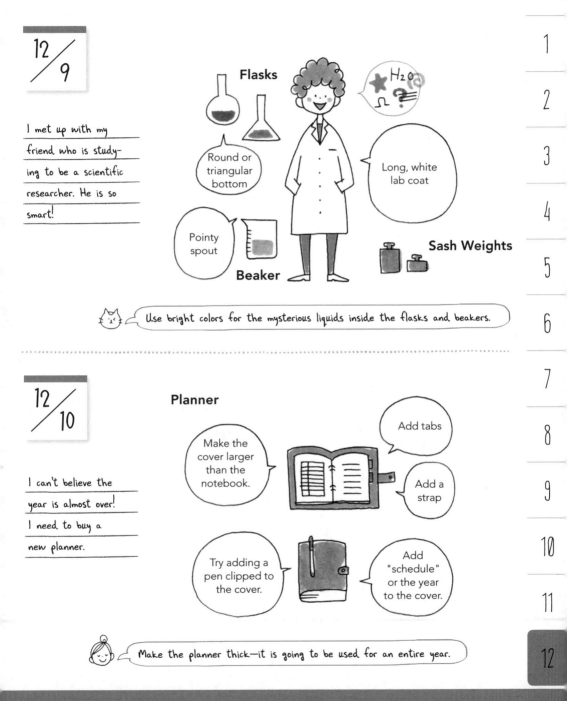

12 / 9

I met up with my friend who is studying to be a scientific researcher. He is so smart!

Flasks

H_2O

Round or triangular bottom

Long, white lab coat

Pointy spout

Sash Weights

Beaker

Use bright colors for the mysterious liquids inside the flasks and beakers.

12 / 10

I can't believe the year is almost over! I need to buy a new planner.

Planner

Make the cover larger than the notebook.

Add tabs

Add a strap

Try adding a pen clipped to the cover.

Add "schedule" or the year to the cover.

Make the planner thick—it is going to be used for an entire year.

12 / 11 I have a big report due soon at work. I've been working on it every day, so I'm almost finished.

Report

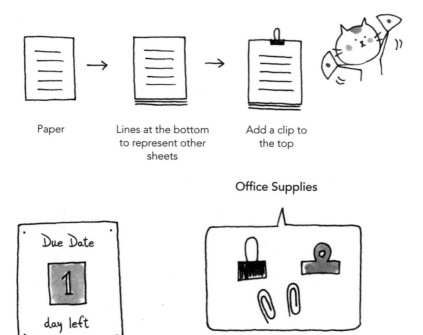

Paper

Lines at the bottom to represent other sheets

Add a clip to the top

Due Date

1

day left

Office Supplies

I proofread the report before I submitted it.

I hope there are no typos or misspellings!

Computer

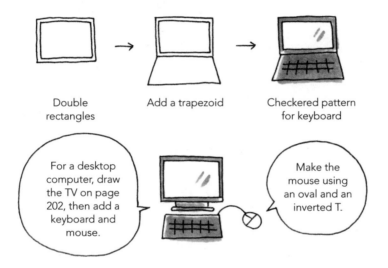

Double rectangles → Add a trapezoid → Checkered pattern for keyboard

For a desktop computer, draw the TV on page 202, then add a keyboard and mouse.

Make the mouse using an oval and an inverted T.

Add blue lines to the screen to represent glass.

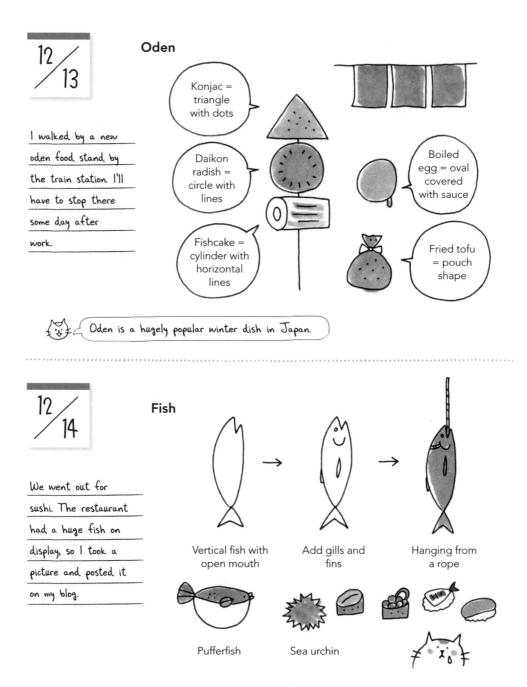

Oden

12/13

I walked by a new oden food stand by the train station. I'll have to stop there some day after work.

Konjac = triangle with dots

Daikon radish = circle with lines

Fishcake = cylinder with horizontal lines

Boiled egg = oval covered with sauce

Fried tofu = pouch shape

Oden is a hugely popular winter dish in Japan.

Fish

12/14

We went out for sushi. The restaurant had a huge fish on display, so I took a picture and posted it on my blog.

Vertical fish with open mouth

Add gills and fins

Hanging from a rope

Pufferfish

Sea urchin

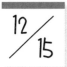

12/15

I got a bonus at work today! I know I should put the money in the bank, but I want to buy myself a treat.

Money Bag

Inverted triangle	Large teardrop shape	Add a yen mark or dollar sign

12/16

Cocktail

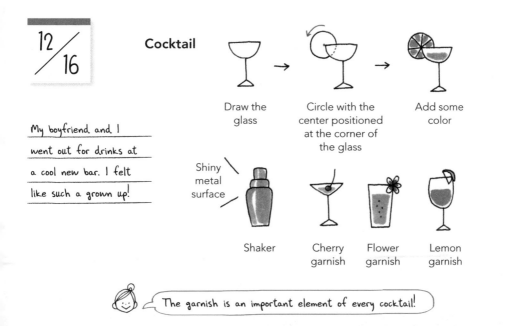

My boyfriend and I went out for drinks at a cool new bar. I felt like such a grown up!

The garnish is an important element of every cocktail!

Airplane

Today marks the anniversary of the first flight by the Wright brothers. I still don't understand how a huge metal object can stay up in the air.

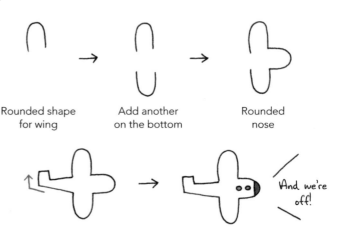

Rounded shape for wing

Add another on the bottom

Rounded nose

Tail points up

Add a couple of windows

And we're off!

Violin

My mom took me to a classical music concert. I didn't expect to like it, but I was amazed by how beautiful the music and performance was.

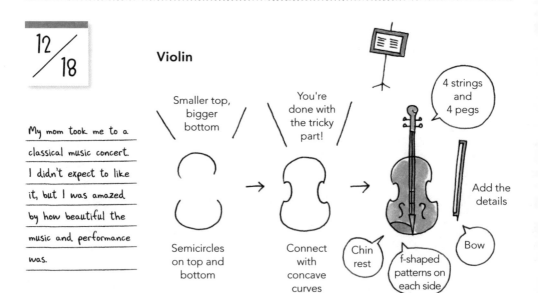

Smaller top, bigger bottom

You're done with the tricky part!

4 strings and 4 pegs

Semicircles on top and bottom

Connect with concave curves

Chin rest

f-shaped patterns on each side

Bow

Add the details

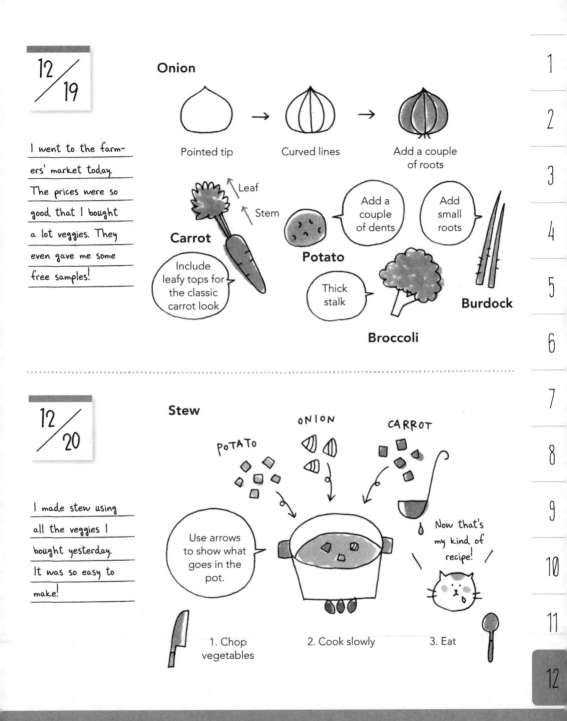

12/19

I went to the farmers' market today. The prices were so good that I bought a lot veggies. They even gave me some free samples!

Onion

Pointed tip → Curved lines → Add a couple of roots

Carrot

Leaf
Stem

Include leafy tops for the classic carrot look

Potato

Add a couple of dents

Add small roots

Broccoli

Thick stalk

Burdock

12/20

I made stew using all the veggies I bought yesterday. It was so easy to make!

Stew

POTATO

ONION

CARROT

Use arrows to show what goes in the pot.

Now that's my kind of recipe!

1. Chop vegetables

2. Cook slowly

3. Eat

12/21

I sent a letter to the host family I stayed with when I studied abroad. I wonder how they are doing?

Airmail

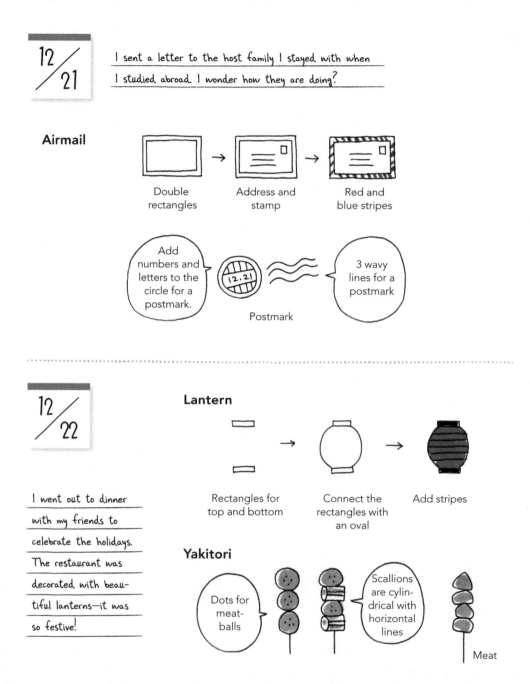

Double rectangles

Address and stamp

Red and blue stripes

Add numbers and letters to the circle for a postmark.

12.21

Postmark

3 wavy lines for a postmark

12/22

I went out to dinner with my friends to celebrate the holidays. The restaurant was decorated with beautiful lanterns—it was so festive!

Lantern

Rectangles for top and bottom

Connect the rectangles with an oval

Add stripes

Yakitori

Dots for meatballs

Scallions are cylindrical with horizontal lines

Meat

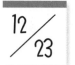

12 / 23

I went Christmas shopping in the city. All the stores had incredible window displays. It really put me in the holiday spirit.

Santa Claus

Triangle hat

Pointed beard with round nose

Add facial features and a round body

Color his suit red and don't forget the sack of toys!

Reindeer

Ears that tilt outward

2 big antlers

Big nose and zigzag pattern on chest

See page 218 to draw the bell

Use red, green, and gold for Christmas-themed drawings.

1
2
3
4
5
6
7
8
9
10
11
12

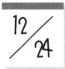

12 / 24 I was so inspired after Christmas shopping yesterday that I decorated
our house for the holiday. I got a tree and hung stockings.

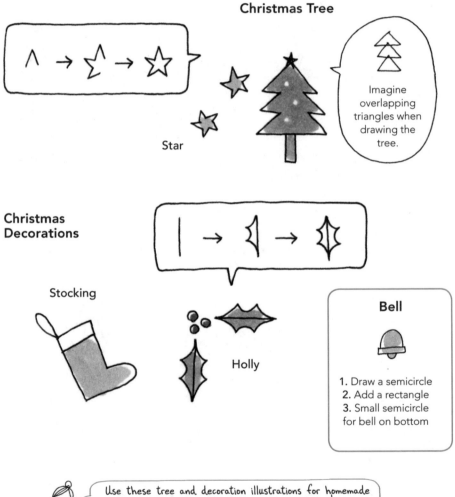

Christmas Tree

∧ → ☆ → ★

Imagine overlapping triangles when drawing the tree.

Star

Christmas Decorations

| → ❬ → ✦

Stocking

Holly

Bell

1. Draw a semicircle
2. Add a rectangle
3. Small semicircle for bell on bottom

Use these tree and decoration illustrations for homemade Christmas cards, like the ones on the next page!

My family really loved the gifts and cards I made for them. We had a nice celebration on Christmas, then relaxed the next day.

Used a paint pen to draw on glass.

Merry Christmas

May you enjoy the special moments of the christmas season!

Roll your drawing up and tie it with a bow.

merry christmas!

HAPPY

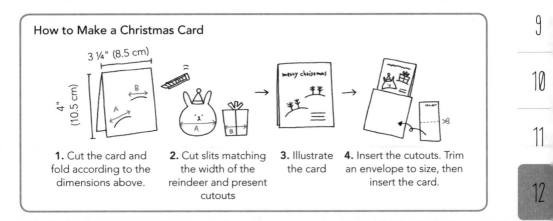

How to Make a Christmas Card

3 ¼" (8.5 cm)

4" (10.5 cm)

merry christmas

1. Cut the card and fold according to the dimensions above.

2. Cut slits matching the width of the reindeer and present cutouts

3. Illustrate the card

4. Insert the cutouts. Trim an envelope to size, then insert the card.

12 / 27	12 / 28

This year, I'm sending my
New Year's cards out on time!

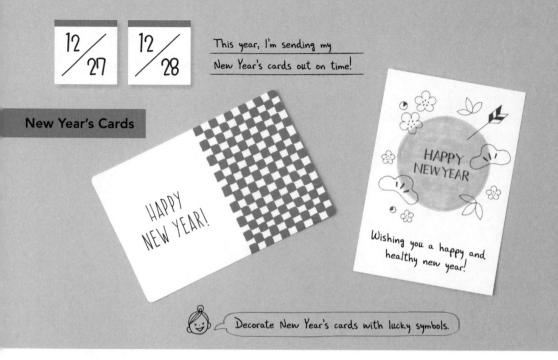

HAPPY
NEW YEAR!

HAPPY
NEW YEAR

Wishing you a happy and
healthy new year!

Decorate New Year's cards with lucky symbols.

12 / 29

We spent all day
cleaning the house so
we'd be able to welcome
the new year with a
fresh start. I donated a
lot of my old clothes to
charity.

Bucket

 → Tapered bottom →

Oval

Tapered
bottom

Add a
handle

Rag

 → Dotted lines →

Rectangle

Dotted lines

Scrub
brush

12 / 30

My mom made soba noodles to celebrate the new year. This dish symbolizes letting go of the troubles from the past year and welcoming the new year with a fresh start.

Soba Noodles

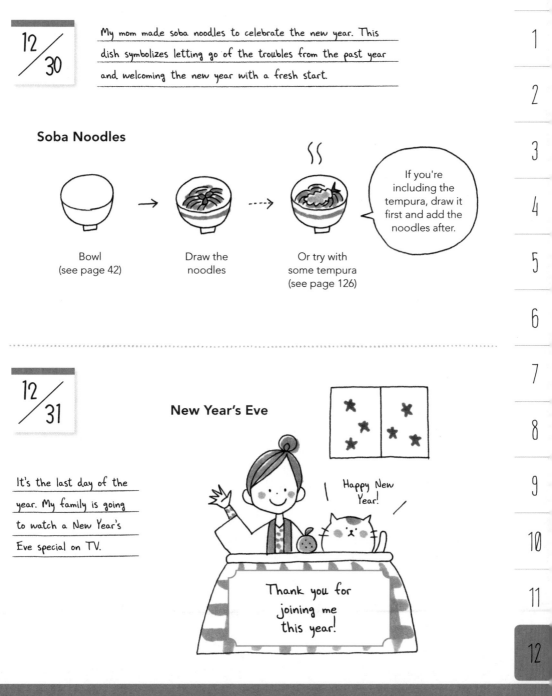

Bowl
(see page 42)

Draw the noodles

Or try with some tempura
(see page 126)

If you're including the tempura, draw it first and add the noodles after.

12 / 31

New Year's Eve

It's the last day of the year. My family is going to watch a New Year's Eve special on TV.

Happy New Year!

Thank you for joining me this year!

1
2
3
4
5
6
7
8
9
10
11
12

221

INDEX

ABOUT THE AUTHOR

Kamo resides in Tokyo, Japan. She worked as a graphic designer at an advertising agency before becoming a freelance illustrator. She is the author of several drawing books in Japan. Check out her website at: http://kamoco.net.